THE

REJECTION
COLLECTION

THE
REJECTION
COLLECTION

Cartoons You Never Saw, and Never Will See, in *The New Yorker*

EDITED BY MATTHEW DIFFEE
FOREWORD BY ROBERT MANKOFF

SIMON SPOTLIGHT ENTERTAINMENT
New York London Toronto Sydney

This book comes straight from the cartoonists themselves and is not authorized or sponsored by *The New Yorker*. So what we're saying is, none of what you're about to see is their fault.

SSE

SIMON SPOTLIGHT ENTERTAINMENT

An imprint of Simon & Schuster

1230 Avenue of the Americas, New York, New York 10020

Copyright © 2006 by Matthew Diffee

All rights reserved, including the right of reproduction in whole or in part in any form.

SIMON SPOTLIGHT ENTERTAINMENT and related logo are trademarks of Simon & Schuster, Inc.

Designed by Michael Nagin

Manufactured in the United States of America

First Edition 10 9 8 7 6 5 4 3 2 1

Library of Congress Cataloging-in-Publication Data

The rejection collection : cartoons you never saw, and never will see, in The New Yorker /

edited by Matthew Diffee ; foreword by Robert Mankoff.

p. cm.

ISBN-13: 978-1-4169-3339-7

ISBN-10: 1-4169-3339-5

[1. American wit and humor, Pictorial. 2. New Yorker (New York, N.Y. : 1925)]

I. Diffee, Matthew. II. New Yorker (New York, N.Y. : 1925)

NC1428.N47 2006a

741.5'6973—dc22

2006019877

Pages 263 and 264 constitute an extension of this copyright page.

CONTENTS

FOREWORD

BY ROBERT MANKOFF

I f memory—or, more accurately, Google—serves me correctly, it was Keats who proclaimed: "Beauty is truth, truth beauty,—that is all / Ye know on earth, and all ye need to know." Well, let me tell ye, Keats was dead wrong. Certainly, he's dead; we can agree on that. But my main point is that if you want to know what makes something funny, it's not beauty. Look, the *Mona Lisa* is beautiful, but until Marcel Duchamp put a mustache and goatee on her, she was no fun at all. Funny isn't about beauty—it's about freedom. Sometimes that freedom leads to disrespect, ridicule, and outright offensiveness. To see the truth of that, you don't have to look any further than this collection of cartoons that happily exploit all that is vile for the sake of a smile.

Furthermore, if you're like me, many of the offensive, obscene, disgusting cartoons here will actually make you laugh out loud—and, in some cases, cause incontinence, nausea, and fainting. So before looking at these cartoons, ask your doctor if incontinence, nausea, and fainting are right for you.

This collection is yet more proof that bad taste and humor are not strange bedfellows but intimate partners whose down-and-dirty doings often delight us against our better judgment, our scruples, and our politically respectable attitudes.

But whereas cartoonists (at least the ones I've known, including myself) are not known for their better judgment, their scruples, and their respectability, *The New Yorker* is. And since I've been the cartoon editor of the magazine for the past ten years, a patina of *The New Yorker's* respectability has unavoidably rubbed off on me. It's just a veneer, of course, but after a decade it's quite thick and, according to my dermatologist, very difficult to remove. Besides, the procedure isn't covered by my health plan.

But thick veneer notwithstanding, if it were really up to just me, some of these cartoons would probably have made it into *The New Yorker*, offending not only the little old lady in Dubuque but perhaps even the cross-dressing CEO in Manhattan. But none of these cartoons did, in fact, make it into *The New Yorker*. That's because others at the magazine have better judgment, more scruples, and greater respectability than I do. How these cartoons got into the hands of the editor of this collection, Matthew Diffee, cartoonist and former friend, I don't know, and he won't tell, even under the threat of extraordinary rendition. So there's nothing to be done but enjoy them and be damned.

INTRODUCTION

BY MATTHEW DIFFEE

Let me tell you how lucky I am. Seven years ago I'm living in Boston, and I hear about this cartoon contest put together by *The New Yorker* and the Algonquin Hotel. You're supposed to come up with a cartoon that has something to do with hotel life. I draw one. My first cartoon ever. I send it in. I win. I meet Bob Mankoff, the magazine's cartoon editor, and he says I should start submitting cartoons regularly. I do. I sell one. And eventually, another. Now I have a cartoon in *The New Yorker* almost every week. I couldn't be happier, except for the small nagging fact that I also have, every week, nine cartoons that don't appear in the magazine. Every silver lining has a cloud.

This book is a collection of cartoons that *The New Yorker* didn't buy. Not just mine. That would get old really quickly, and besides, I'm not the only one who gets rejected. It's something that happens to all of us. It's just an unpleasant, unavoidable part of life, like Britney Spears or dying. This is a collection of the best rejects from thirty of my friends and colleagues—all *New Yorker* cartoonists, all persistently rejected.

Now, why these cartoons have been rejected I can't say for sure. I'd ask Bob, but he's too busy looking at this week's cartoons—and maybe that's the best answer to the question. Sure, some of these cartoons are too racy, rude, or rowdy; some are too politically incorrect or too weird; a few are probably too dumb; but mostly, I think, they're just too many. If *The New Yorker* bought all of these, there wouldn't be room for any of the writing, which is really good, I'm told.

In each issue of *The New Yorker*, there's only room for something like fifteen to twenty cartoons, and there are around fifty regularly contributing cartoonists, who each bring in ten cartoons every week. That's five hundred right there. And that's not counting the slush pile, which, if you don't know, is the colossal scrap heap of cartoons that come in from all over the world from unknown hopefuls, whose chances of being discovered are slim to none. (Nothing personal, I'm just telling you how it is.)

So there are a lot of cartoons competing for those few spots in each week's issue. Bob tells me he looks at more than a thousand cartoons each week. Yonkers, right? I'm surprised he still loves cartoons as much as he does. I'm surprised he likes them at all. It would be like eating nothing but sunflower seeds. Wouldn't you start to hate sunflower seeds? I sort of already do, just thinking about it. But I guess it isn't quite like sunflower seeds, because sunflower seeds are all

the same, and cartoons aren't. Sure, there are similarities and categories that emerge if you've seen enough of them, but there's still some variety. Guess it's more like trail mix. The bulk of cartoon submissions to *The New Yorker* may consist of sunflower seeds and peanuts and almonds, but every now and then you get something good—let's say, a dried banana chip, if you're into that sort of thing. That's what this book is. We've gone through years of rejected trail mix and picked out the dried bananas. And maybe a few raisins, because good as they are, no one wants only dried bananas, am I wrong?

So, I'm guessing you'd probably like to know the actual process for getting cartoons rejected from the magazine. Okay, this is what happens: We cartoonists spend six days a week from Wednesday morning to late Monday night trying to come up with ideas. How do we do it? That's the big question. I'll try my best to answer it here, at least as far as my own routine is concerned.

What I do is, I make myself a pot of coffee. Then I get a black Pilot pen and some blank sheets of paper, and I stare at them. Not kidding. I'm

doing a sort of focused, mind-wandering thing. My success depends simultaneously on how "focused" and how "wandering" my mind remains. Generally, in the first hour or so, my mind wanders mostly into way too well-traveled areas that are full of bad ideas: graceless gags with the wires showing, bad puns, jokes about mimes, or things that Charles Addams did better in 1937. But eventually, if I'm disciplined enough to keep myself focused and loose enough to let my thoughts wander, my mind gets lost and stumbles onto something funny. This doesn't always happen. Sometimes I fall asleep or start watching Court TV.

It's a little like driving around the countryside looking for something to photograph. Maybe you have a list of things to look for, like maybe a red barn, a windmill, a row of fuzzy ducklings, or an old tractor overgrown with wild flowers—yeah, you're one of *those* photographers. Maybe you're on assignment shooting for the new Cracker Barrel calendar.

Anyway, you're out on the road and you don't know where to find any of these things you'd like to take pictures of, so you just drive. You stick to the country roads (you know that much; you're a professional, after all), but most of the day passes and you're still just driving around looking. Along the way you probably take a few uninspired shots of double-wides and clotheslines and maybe some appliances on porches, but nothing you really like. Nothing that works. And then, just as the afternoon sun turns its most mawkish hue, you round a bend and see a black-and-white cow chewing on an old red tennis shoe. You snap the picture. And it's perfect. You've found just what you wanted, but it isn't something you ever could have planned on finding and isn't something you're ever likely to find again. And then someone comes up to you and asks you how they, too, should go about taking a picture of a cow eating a shoe. You'd probably look at them in the same way that a cartoonist looks at a person who asks, "Where do you get your ideas?" You'd like to help, but you just don't know how.

Every Monday night, after spending the previous week looking for our

own version of the cow eating the shoe, we cartoonists gather together our best ideas from the week and sketch them up. A few Goody Two-shoes probably start sketching earlier in the week, but that's no way to live. Seriously. Those people are probably the same kind of people who fold their socks or make their beds or pay bills.

Anyway, we make ten or so of these sketches, which we call "roughs." Collectively these roughs from the week are known as our "batch." If you live out of town, you fax your batch in. Those people are referred to as "batch faxers." (Okay, that one I made up.) Those of us who live in New York go to the offices of *The New Yorker* in the middle of Times Square on Tuesday morning. We clutch our precious pages until it's our turn to sit down with Bob for two to three minutes and watch him rifle through them while he asks, "How ya doin'?" and "Hot enough for ya?" He'll hold a handful for further consideration, usher each of us out and the next one in, and that's it. Until Thursday, when you get a call to tell you that they bought one. Only one. And you're thrilled. With a ninety percent rejection rate, you're on top of the world. Because it could be worse. There are weeks when you get no call at all. More weeks than I'd like to mention, frankly. Sometimes many weeks in a row. And that's when the "shaking" starts, followed closely by the "drinking," which leads quickly to the "reconsidering a cubical career."

On Tuesday, after all the batches have been dropped off, the whole gang usually ambles off to lunch together. People always ask me what we talk about, and as much as I'd like to nurture the illusion that I'm a member of my own sort of Algonquin round table, I have to admit that we're not really that witty a group. I mean, we are, but only as much as any other group. We spend most of the time talking about what we might order, what we saw on television, what we think about the news. It's only when we start talking about work that our conversation becomes unique. Because we can have serious, lengthy, occasionally heated full-table discussions about ridiculous things that are quite important in our business, such as how to draw duck feet or whether "Scranton" is funnier than

"Cleveland" and why. Do dogs have hair or fur? What's the perfect name to use in a caption? Is Buford too funny? What about Doug? Or Edwin? What's the difference in technique between drawing a mustache and drawing an eyebrow? What is that fine line in the drawing of a cartoon that either makes the gag funnier or ruins it?

GROUPS AT LUNCH

KEY: ☐ - How witty they are
 ▨ - How witty they think they are

CARTOONISTS CARPENTERS CLERGY CHILDREN CRIMINALS CONSULTANTS

I wanted this book to have a little of that Tuesday-lunch feel to it—like you're in on one of those discussions about duck feet and mustaches. We've tried to recreate some of that in the questionnaires with handwritten answers that accompany each cartoonist's work. The aim is to show not just these previously unseen cartoons, but also these previously unseen cartoonists—to give you a chance to get to know these characters, who are arguably the most brilliant single-panel-gag cartoonists in the world.

And yet as brilliant as these cartoonists may be, they can't escape the fact that every year, for years and years, they've been creating at least nine cartoons a week that will never see the light of day. And sure, some of them are pretty bad and deserve to be hidden forever, but there are always a few gems that are missed, and believe me, we remember them.

So I figure it's high time we made ourselves a book to put them in. I've asked my fellow cartoonists to dig up their all-time favorite rejects. Some of these lost treasures were excavated from dusty piles, some were released from deep within three-ring binders, and others were simply taken down from the cartoonists' own refrigerators. From this stack of our favorite failures, I've handpicked the standouts. The cream of the crap, you might say. I hope *The Rejection Collection* will give these cartoons a second life—a place where good ideas go when they die. And that begs the question: Where do the bad ideas go? I don't know, maybe Scranton.

And now I can't resist kicking things off with a couple of my own rejects. Hope you don't mind.

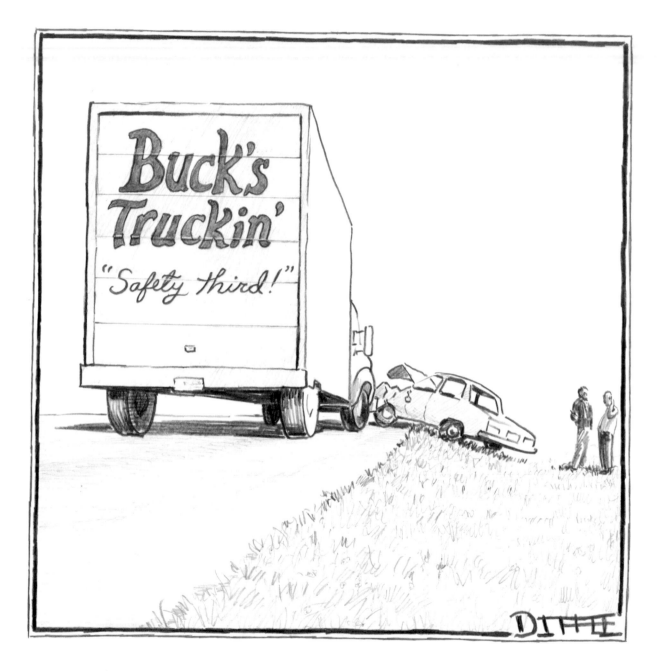

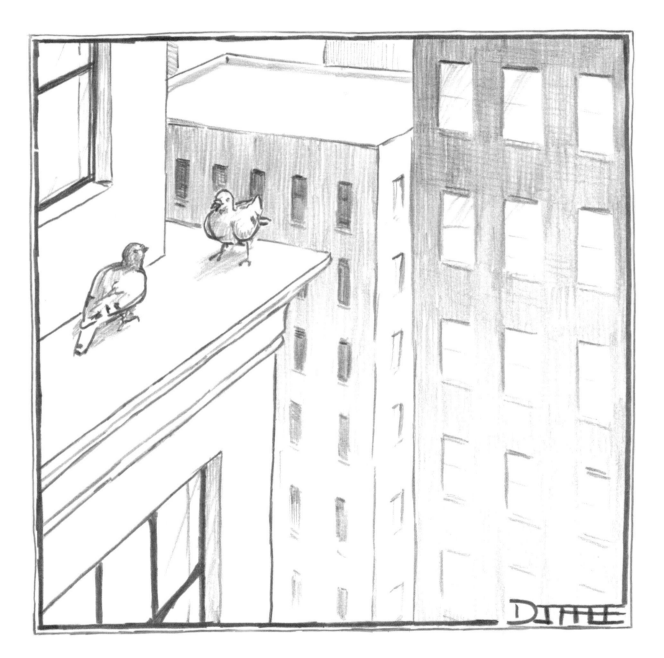

"I'd say my biggest influence is probably Pollock."

LEO
CULLUM

self-portrait

How did you learn to draw that way?

SELF TAUGHT. " THE CARTOONIST WHO TEACHES HIMSELF TO DRAW HAS AN IDIOT FOR A STUDENT " (VOLTAIRE)

My first cartoon . . .

WAS OF LEONARDO DA VINCI RECEIVING A REJECTION SLIP FOR THE MONA LISA. IT WAS REJECTED. I THEN TOLD MY FRIEND DAN BROWN I PROBABLY VIOLATED SOME CODE WITH THE DA VINCI THING.

Why cartooning? A QUESTION I ASK MY SELF EVERY SINGLE DAY.

When I'm not cartooning, I . . . AM WRESTLING, THEN SHOWERING, WITH MY DEMONS.

I admire . . .

THINGS FROM A DISTANCE. USUALLY WITH BINOCULARS.

How has your work, or the way you work, changed over time?

SINCE HAVING KIDS I'VE STOPPED WORKING NAKED.

I'm not crazy about . . .

ANYONE TALLER OR SHORTER THAN I AM.

Write a question to which you might answer "Absolutely not."

DO YOU HAVE A FUNNY ANSWER HERE?

Most cartoonists I know ▄▄ . . .

HAVE THE BANK ACCOUNTS OF PEOPLE HALF THEIR AGE.

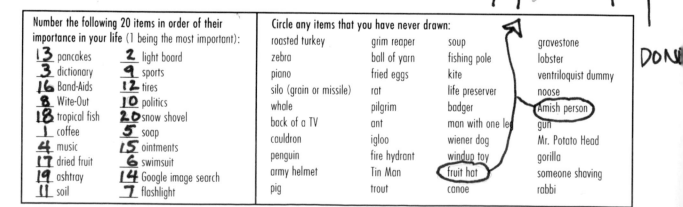

DON

Number the following 20 items in order of their importance in your life (1 being the most important):

13	pancakes	2	light board
3	dictionary	9	sports
16	Band-Aids	12	tires
8	Wite-Out	10	politics
18	tropical fish	20	snow shovel
1	coffee	5	soap
4	music	15	ointments
17	dried fruit	6	swimsuit
19	ashtray	14	Google image search
11	soil	7	flashlight

Circle any items that you have never drawn:

roasted turkey	grim reaper	soup	gravestone
zebra	ball of yarn	fishing pole	lobster
piano	fried eggs	kite	ventriloquist dummy
silo (grain or missile)	rat	life preserver	noose
whale	pilgrim	badger	(Amish person)
back of a TV	ant	man with one leg	gun
cauldron	igloo	wiener dog	Mr. Potato Head
penguin	fire hydrant	windup toy	gorilla
army helmet	Tin Man	(fruit hat)	someone shaving
pig	trout	canoe	rabbi

When I'm having a hard time coming up with ideas, I . . .

READ, BIRDWATCH, EAT, PLAY WITH THE DOGS, PHONE FRIENDS, WONDER IF THIS IS ANY WAY FOR A GROWNUP TO MAKE A LIVING.

What's the hardest part of cartooning?

SPENDING ALL THE MONEY
FILLING OUT ENDLESS QUESTIONNAIRES.

Draw something in this space that will help us understand your childhood:

How do you deal with rejection?

I FIND SOMEONE TO PUBLISH A BOOK OF REJECTED CARTOONS. HEY IT'S WORKING!

Where do you keep your rejected cartoons?

MOSTLY IN THIS BOOK.

My advice to __AL GORE__ would be:

CHECK OUT HOW COLD IT IS IN MY STUDIO!

Where do you see yourself in ten minutes?

CRUMPLING UP THIS PAPER AND THROWING IT IN THE TRASH.

And lastly, what are some things that make you laugh and why?

BEING TICKLED. I GUESS IT'S BECAUSE OF SENSITIVE SKIN OR SOMETHING? ALSO A GOOD CARTOON WILL OCCASIONALLY MAKE ME LAUGH OUT LOUD AND EXP EXCLAIM 'WHY, IN THE NAME OF COSMIC JUSTICE, DIDN'T I THINK OF THAT!'

Diced apple is to Waldorf salad as DRINKING is to my cartoons.	Circle the funniest word: (pants) slacks trousers britches	True or false? T I spend more than three hours a day working on cartoons. F I have always wanted to be a cartoonist. F I have never lived in New York City.
To me, [blot] — looks like SOMETHING ON MY TIE.	Circle the funniest bird: (chicken) penguin pigeon tufted titmouse	I consider myself a __A__ person. (a) dog (b) cat (c) people (d) other _____ I am afraid of __D__. THAT WAS EASY! (a) abandonment (b) commitment (c) rejection (d) bears For me cartooning is __37__% drawing and __81__% writing.

For office use only:

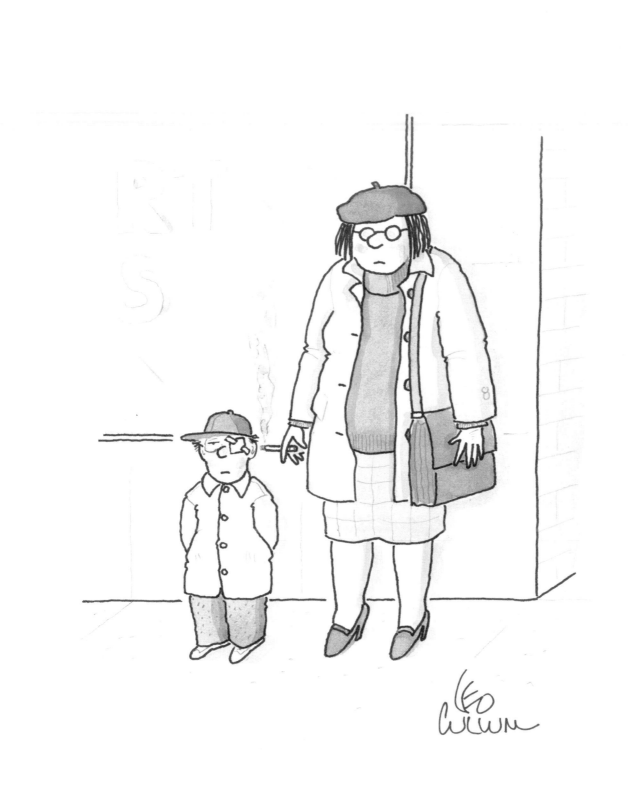

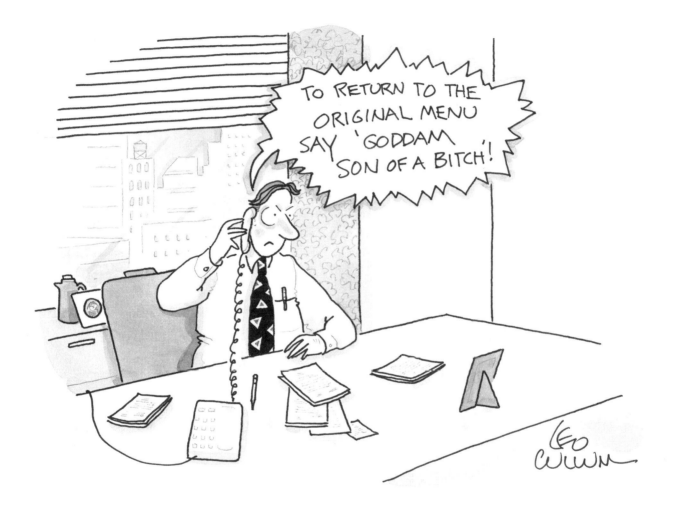

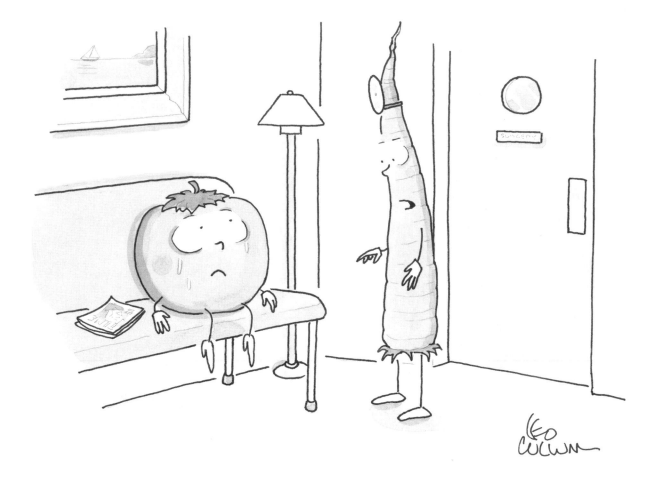

"He's going to be even more of a vegetable."

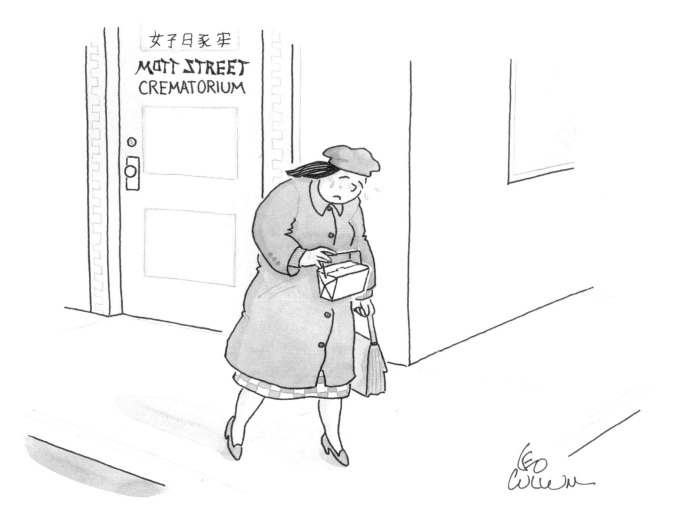

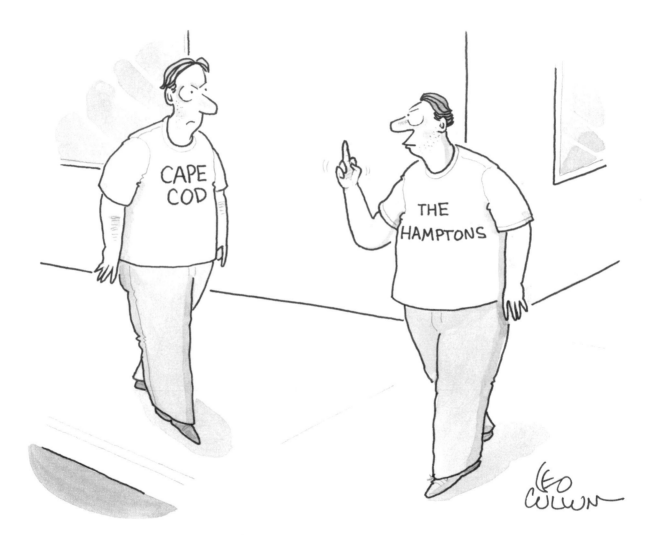

PAT
BYRNES

Self-portrait

ACTUAL SIZE

How did you learn to draw that way?
BY LEARNING NOT TO DRAW ANY OTHER WAY (GRASSHOPPER).

My first cartoon . . .
WELL, THE FIRST THAT I CAN REMEMBER WAS A BOOK I STARTED TO WRITE WHEN I WAS MAYBE FIVE OR SIX. IT WAS CALLED "HAPPY SNAPPY" AND WAS ABOUT A CRAB WHO LIVED ON A BEACH, UNTIL A BOY CAME ALONG AND SAID, "YOU ARE FOUR ME." AND THEN I REALIZED I HAD MISSPELLED "FOR," BUT MY PENCIL DIDN'T HAVE AN ERASER. SO I WENT OUTSIDE AND PLAYED.

Why cartooning?
BECAUSE A CARTOONIST IS THE ONLY THING I HAVE EVER BEEN PROUD TO CALL MYSELF.

When I'm not cartooning, I . . .
CHASE AFTER THE CUTEST CUTIE IN ALL CUTIEDOM.

I admire . . .
MY CUTIE'S MOMMY.

How has your work, or the way you work, changed over time?
FOUR ONE THING, MY SPELING HAS IMPROOVED.

I'm not crazy about . . .
MUSTARD.

Write a question to which you might answer "Absolutely not."
ARE YOU A VERY TALL PERSON?

Most cartoonists I know are . . .
CHARACTERS.

MY WIFE THOUGHT THIS WAS ESPECIALLY FUNNY

THIS IS THE ONLY ONE I CAN'T SPECIFICALLY REMEMBER DRAWING

Number the following 20 items in order of their importance in your life (1 being the most important):	
16 pancakes	3 light board
1 dictionary	18 sports
13 Band-Aids	6 tires
12 Wite-Out	17 politics
15 tropical fish	10 snow shovel
19 coffee	4 soap
2 music	8 ointments
7 dried fruit	11 swimsuit
666 ashtray	9 Google image search
5 soil	14 flashlight

Circle any items that you have never drawn: I'VE DRAWN THE TOY BUT NOT THE BIRD

roasted turkey	grim reaper	soup	gravestone
zebra	ball of yarn	fishing pole	lobster
piano	fried eggs	kite	ventriloquist dummy
silo (grain or missile)	rat	life preserver	noose
whale	pilgrim	badger	Amish person
back of a TV	ant	man with one leg	gun
cauldron	igloo	wiener dog	Mr. Potato Head
penguin	fire hydrant	windup toy	gorilla
army helmet	Tin Man	fruit hat	someone shaving
pig	trout	canoe	rabbi

I USED TO DRAW THESE PROFESSIONALLY

NOT SINCE COLLEGE

When I'm having a hard time coming up with ideas, I . . .
HAVE TIME TO WORK WITH THE ONES I'VE ALREADY GOT.

IDEAS SKITTERING AROUND IN MY HEAD LIKE SQUIRRELS

Draw something in this space that will help us understand your childhood:

What's the hardest part of cartooning?
TELLING YOUR MOTHER YOU WANT TO GIVE UP A JOB AS A ROCKET SCIENTIST TO BECOME A CARTOONIST.

How do you deal with rejection?
I'VE BEEN AN AD WRITER, A COMEDIAN, AN ACTOR, AND I COULDN'T FIND A WOMAN TO MARRY ME UNTIL I WAS 43. I DEAL WITH REJECTION LIKE YOU DEAL WITH AN OLD FRIEND.

Where do you keep your rejected cartoons?
ONLY THE NSA KNOWS FOR SURE.

My advice to ___SPAMMERS___ would be:
I'D FEEL A LOT BETTER TRUSTING YOU WITH MY HOUSE IF YOU WOULD SIMPLY SPELL "REFINANCE" CORRECTLY.

Where do you see yourself in ten minutes?
PEDALLING MY BIKE TO THE MAILBOX TO SEND THIS OFF, BECAUSE TEN MINUTES IS PRACTICALLY THE DEADLINE DIFFEE GAVE US TO FILL THIS OUT.

And lastly, what are some things that make you laugh and why?

• CORPORATE JARGON, BECAUSE IT DOESN'T FOOL ME.

• THE THREE STOOGES' "O ELAINE" SKETCH, BECAUSE IT IS A MAGICAL BLEND OF THE HIGH AND THE LOW.

• THE WAY MY DAUGHTER INSTANTLY IMITATES PEOPLE'S EMBARRASSING NOISES, BECAUSE SHE IS ONLY 16 MONTHS OLD AND CAN GET AWAY WITH IT — AND SHE KNOWS IT!

Diced apple is to Waldorf salad as ___MONKEYS___ is to my cartoons.	Circle the (funniest) word: pants, slacks, trousers, britches	True or false? ✱ I'M A CARTOONIST, NOT A LAWYER. I DON'T KEEP TIMESHEETS. _✱_ I spend more than three hours a day working on cartoons. _T_ I have always wanted to be a cartoonist. _T_ I have never lived in New York City.
To me, [inkblot] looks like ___KSCHPLLT!___	Circle the funniest bird: (chicken, RUBBER) penguin, pigeon, tufted titmouse	I consider myself a ___D___ person. (a) dog (b) cat (c) people (d) other ___OTHER___ I am afraid of ___D___. (I'VE BEEN CHASED A COUPLE TIMES.) For office use only: (a) abandonment (b) commitment (c) rejection (d) bears For me cartooning is _Y_ % drawing and _X_ % writing, WHERE y = f(x)

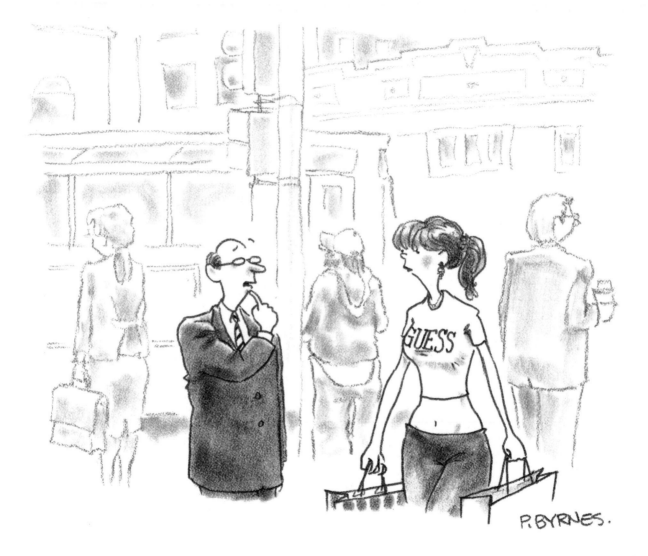

"34-C?"

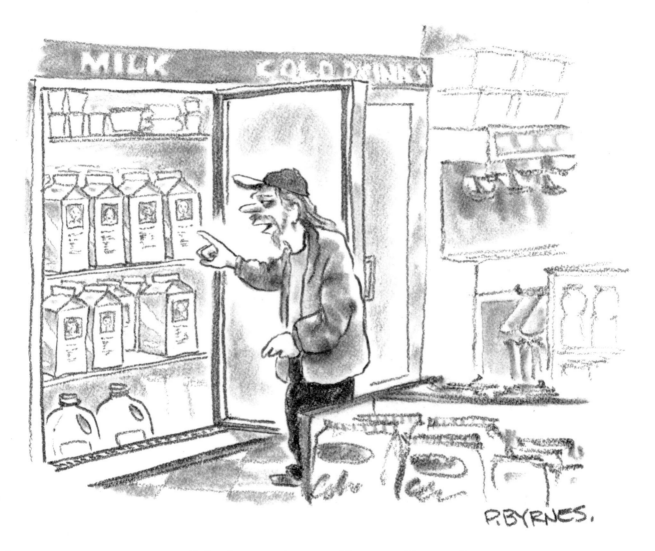

"Got 'im, got 'im, need 'im, need 'im . . ."

ZEN LITTER BOX

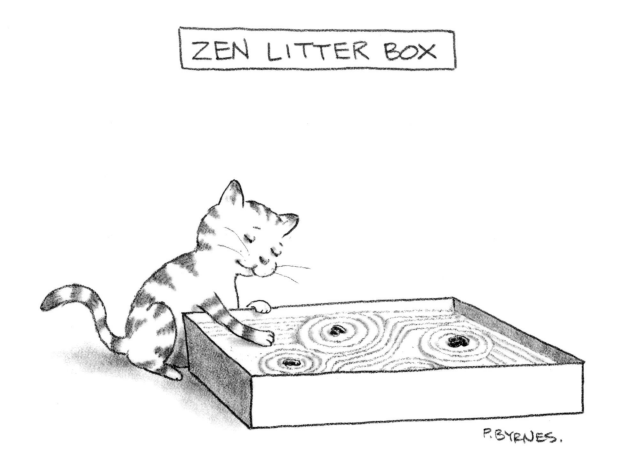

P. BYRNES.

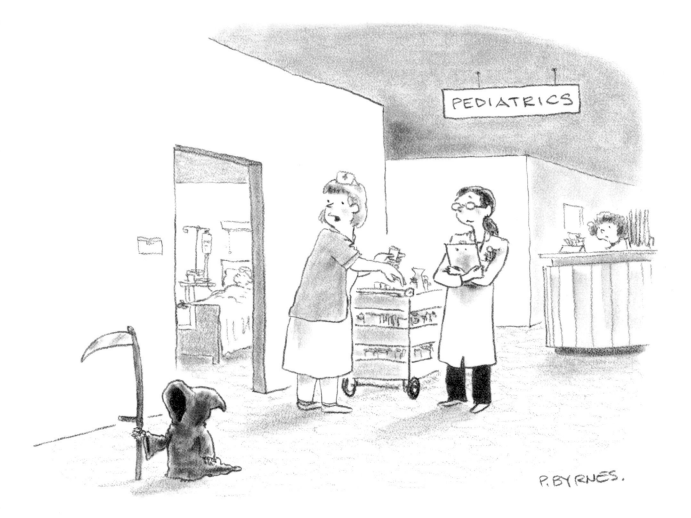

"It would be sad if he wasn't so damned cute."

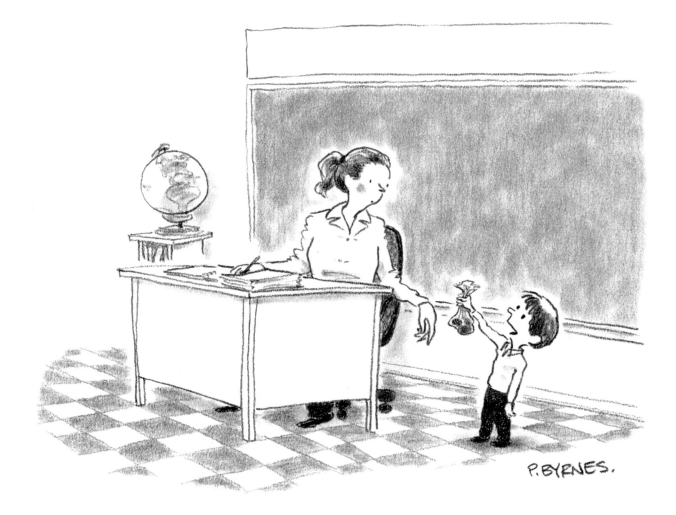

"Remember how I said my dog ate it and you said that was no excuse?"

SAM
GROSS

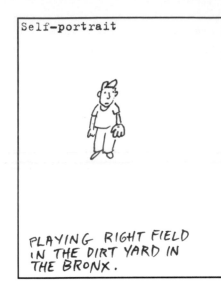

Self-portrait

PLAYING RIGHT FIELD IN THE DIRT YARD IN THE BRONX.

How did you learn to draw that way? WHICH WAY?

My first cartoon . . . WAS DRAWN DIRECTLY ON MY DESK IN FIRST GRADE. MY MOTHER HAD TO COME IN TO SCHOOL WITH KIRKMAN SOAP AND I HAD TO SCRUB IT OFF. THAT WAS MY FIRST CONTACT WITH AN EDITOR.

Why cartooning? IT ENABLES ME TO WORK ALONE AND IT GIVES ME THE FREEDOM TO TAKE MY HEAD ANYWHERE.

When I'm not cartooning, I . . . READ, I WALK, I OBSERVE

I admire . . . LOU MYERS AND HAP KLIBAN. THEY WERE WORKING AT A LEVEL THAT I'M TRYING TO ATTAIN

How has your work, or the way you work, changed over time? IT'S GOTTEN LESS STUPID AND I HOPE THE DRAWING HAS IMPROVED.

I'm not crazy about . . . DUMB QUESTIONNAIRES.

Write a question to which you might answer "Absolutely not." "COULD YOU NUMBER THE FOLLOWING 20 ITEMS IN ORDER OF THEIR IMPORTANCE IN YOUR LIFE (1 BEING THE MOST IMPORTANT)?"

Most cartoonists I know are . . . PRETTY DAMN SMART.

Number the following 20 items in order of their importance in your life (1 being the most important):

____ pancakes	____ light board
____ dictionary	____ sports
____ Band-Aids	____ tires
____ Wite-Out	____ politics
____ tropical fish	____ snow shovel
____ coffee	____ soap
____ music	____ ointments
____ dried fruit	____ swimsuit
____ ashtray	____ Google image search
____ soil	____ flashlight

Circle any items that you have never drawn:

roasted turkey	grim reaper	soup	gravestone
zebra	ball of yarn	fishing pole	lobster
piano	fried eggs	kite	ventriloquist dummy
silo (grain or missile)	rat	life preserver	noose
whale	pilgrim	badger	Amish person
back of a TV	ant	man with one leg	gun
cauldron	igloo	wiener dog	Mr. Potato Head
penguin	fire hydrant	windup toy	gorilla
army helmet	Tin Man	fruit hat	someone shaving
pig	trout	canoe	rabbi

When I'm having a hard time coming up with ideas, I . . .
JUST KEEP WORKING

What's the hardest part of cartooning?
DRAWING HORSES

How do you deal with rejection?
IT DOESN'T BOTHER ME AT ALL

Where do you keep your rejected cartoons?
IN FILES IN MY STUDIO

My advice to ___ANYBODY___ would be: - STOP TRYING TO GIVE ME
 IDEAS FOR CARTOONS

Where do you see yourself in ten minutes?
HERE

And lastly, what are some things that make you laugh and why?
PRETTY MUCH EVERYTHING AND I DON'T KNOW WHY AND I
DON'T WANT TO KNOW WHY.

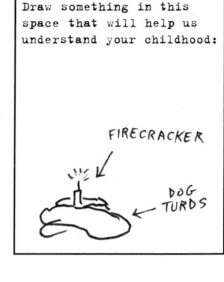

Draw something in this space that will help us understand your childhood:

FIRECRACKER

DOG TURDS

Diced apple is to Waldorf salad as **DICED APPLE** is to my cartoons. To me, ⬛— looks like **MY RAPIDOGRAPH PEN LEAKED**	Circle the funniest word: pants slacks trousers (britches) Circle the funniest bird: (chicken) penguin pigeon tufted titmouse	True or false? **T** I spend more than three hours a day working on cartoons. **T** I have always wanted to be a cartoonist. **F** I have never lived in New York City. I consider myself a **d** person. (a) dog (b) cat (c) people (d) other **SNAIL** I am afraid of **d**. (a) abandonment (b) commitment (c) rejection (d) bears For me cartooning is **50** % drawing and **50** % writing.

For office use only:
This guy is a brilliant iconoclast

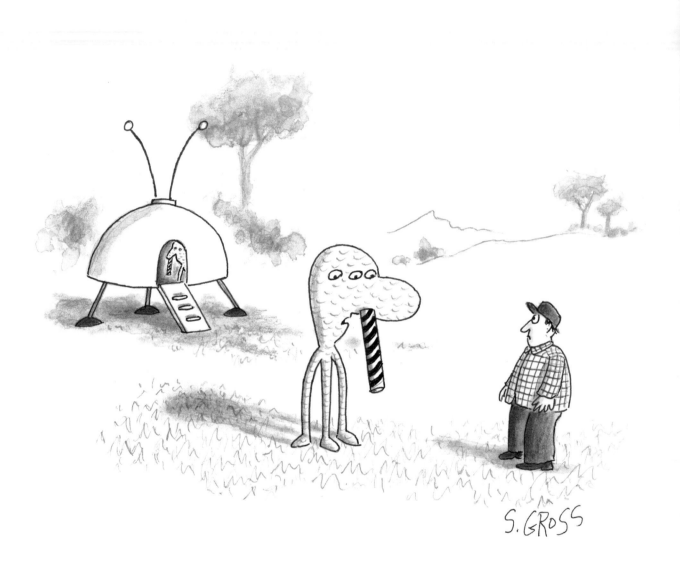

"Our planet has run out of cocaine."

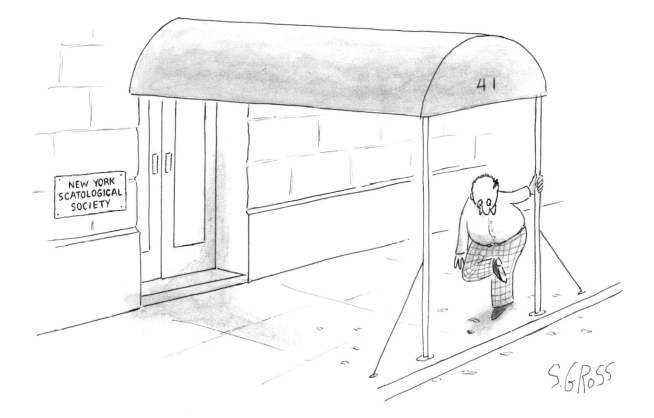

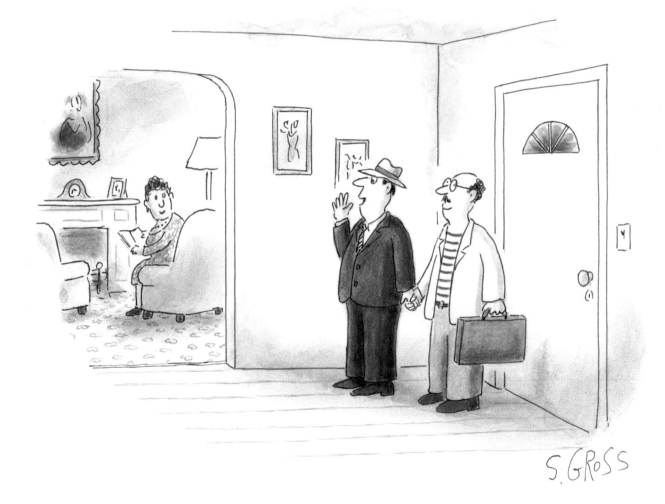

"Oh honey, I'm homo!"

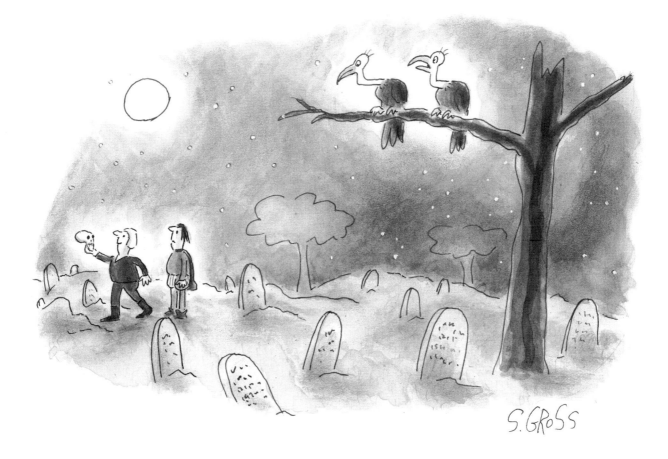

"I knew Yorick also. He gave me diarrhea."

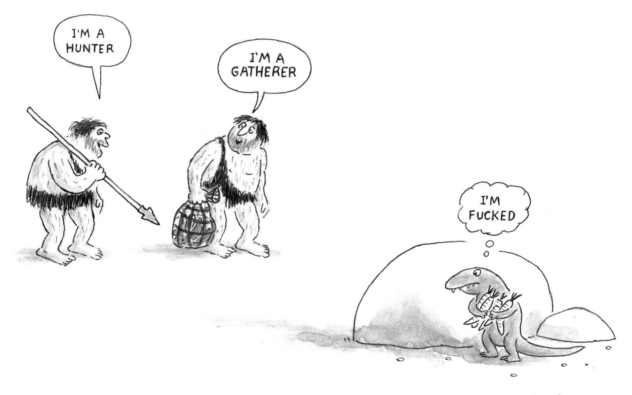

MIKE
TWOHY

Self-portrait

How did you learn to draw that way?

Compulsive doodling

My first cartoon . . .

Was a copy of a cartoon my dad drew for me when I was a little kid. It was of a man in a bathtub washing his back with a long brush.

Why cartooning? Genetically pre-disposed.

When I'm not cartooning, I . . .

enjoy movies, gardening, opera, basketball and railing at right-wing talk radio.

I admire . . .

Paul Klee, Dr. Seuss, Abraham Lincoln.

How has your work, or the way you work, changed over time?

I recently looked at some drawings I did when I was 12. My style has changed surprisingly little.

I'm not crazy about . . .

All the stuff I watch on TV.

Write a question to which you might answer "Absolutely not."

If you won the lottery would you stop drawing?

Most cartoonists I know are . . .

very sane.

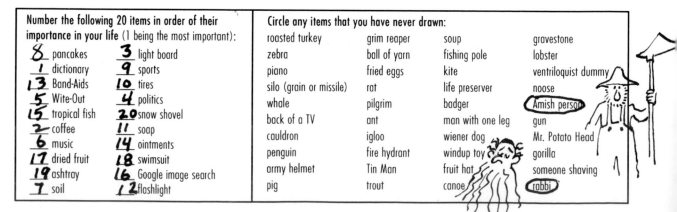

Number the following 20 items in order of their importance in your life (1 being the most important):

8	pancakes	3	light board
1	dictionary	9	sports
13	Band-Aids	10	tires
5	Wite-Out	4	politics
15	tropical fish	20	snow shovel
2	coffee	11	soap
6	music	14	ointments
17	dried fruit	18	swimsuit
19	ashtray	16	Google image search
7	soil	12	flashlight

Circle any items that you have never drawn:

roasted turkey	grim reaper	soup	gravestone
zebra	ball of yarn	fishing pole	lobster
piano	fried eggs	kite	ventriloquist dummy
silo (grain or missile)	rat	life preserver	noose
whale	pilgrim	badger	(Amish person)
back of a TV	ant	man with one leg	gun
cauldron	igloo	wiener dog	Mr. Potato Head
penguin	fire hydrant	windup toy	gorilla
army helmet	Tin Man	fruit hat	someone shaving
pig	trout	canoe	(rabbi)

When I'm having a hard time coming up with ideas, I . . .

Keep working until it's time to punch out.

What's the hardest part of cartooning?

Groupies.

Draw something in this space that will help us understand your childhood:

How do you deal with rejection?

DENIAL

Yes-s-s! Another sale!!!

Where do you keep your rejected cartoons?

In my Rejectatorium.

My advice to <u>young cartoonists</u> would be:

Become tech-savvy. Get yourself a computer and one of those things called a "mouse."

Where do you see yourself in ten minutes?

Checking my watch to prove my prediction.

And lastly, what are some things that make you laugh and why?

Political satire
Cauliflower ears
Bushisms
Pit toilets

Diced apple is to Waldorf salad as <u>coffee</u> is to my cartoons.	Circle the funniest word: pants slacks (trousers) britches	True or false? T I spend more than three hours a day working on cartoons. T I have always wanted to be a cartoonist. T I have never lived in New York City.
To me, oops! sorry- looks like whited out the inkblot before I realized it wasn't mine.	Circle the funniest bird: (chicken) penguin pigeon tufted titmouse	I consider myself a __a__ person. (a) dog (b) cat (c) people (d) other _____
		I am afraid of **d, a, c, b.** (a) abandonment (b) commitment (c) rejection (d) bears
		For me cartooning is **100**% drawing and **110**% writing.

For office use only:

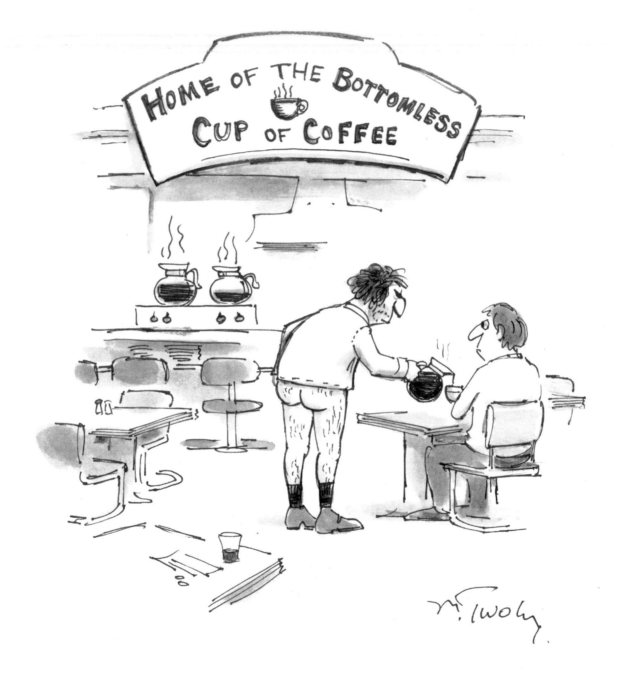

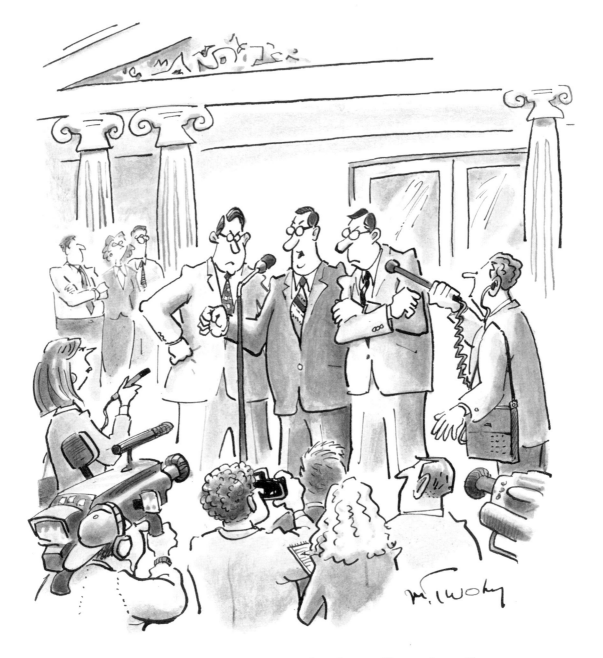

"And if nepotism exists, my brothers will root it out!"

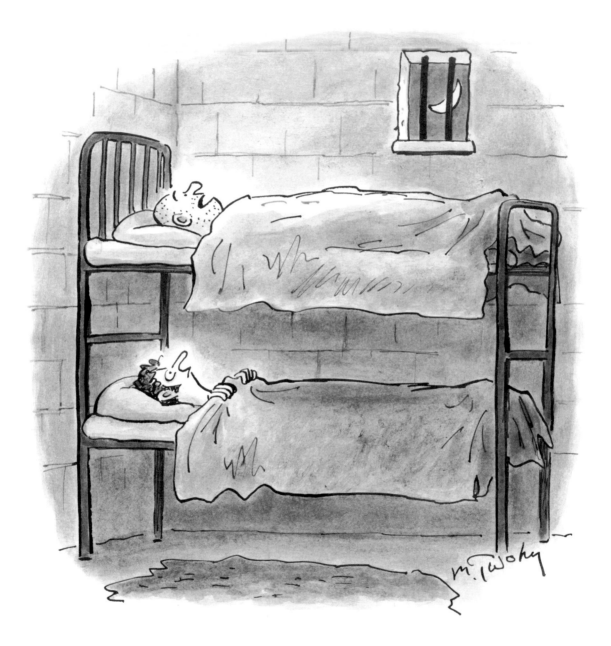

"Nighty-night, sleep tight—don't let the bedbugs rape."

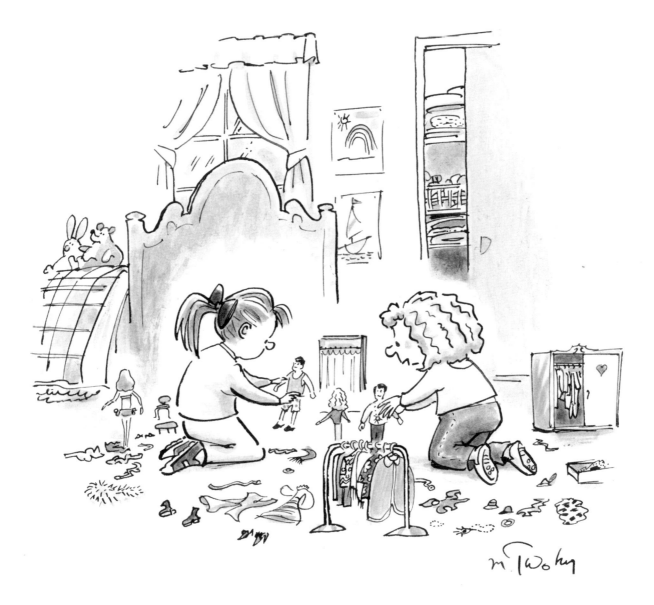

"*You get the most accessories with the bi Kens.*"

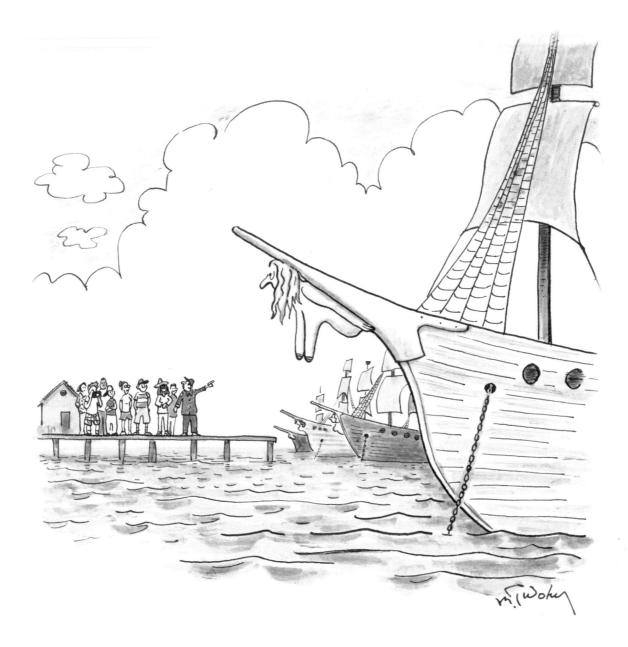

"Anchored on the far side, we have the oldest ship in the fleet."

C. COVERT
DARBYSHIRE

Self-portrait

6'

5'

Z4601

How did you learn to draw that way? MY STYLE IS A COLLECTIVE FAILURE AT TRYING TO MIMIC ALL THE CARTOONISTS THAT I ~~AM~~ ADMIRED GROWING UP.

My first cartoon . . . APPEARED IN 8TH GRADE IN SOMETHING CALLED A 'SLAMBOOK'. IT WAS ESSENTIALLY A SPIRAL NOTEBOOK WITH THE NAMES OF ALL THE POPULAR KIDS ON EACH PAGE WHERE YOU WERE SUPPOSED TO WRITE WHAT YOU THOUGHT OF EACH PERSON — GOOD OR BAD. I DECIDED TO DRAW CARTOONS OF EACH PERSON IN DIFFERENT SITUATIONS. THEN I PUT WHAT I THOUGHT WERE CLEVER CAPTIONS BELOW. MOST PEOPLE THOUGHT THEY WERE HILARIOUS — EXCEPT THE ONES THAT GOT TOGETHER AND DECIDED TO BEAT ME UP. GOOD TIMES!

Why cartooning? I MOVED TO NEW YORK CITY IN 1998 TO PURSUE A CAREER IN BOTH PAINTING & TV COMEDY WRITING. I ENDED UP AT THE NEW YORKER WHICH PROVED TO BE A NICE BLEND OF THE TWO.

When I'm not cartooning, I . . . MAKE FILMS AND OCCASIONALLY WRITE AND DIRECT TV COMMERCIALS. I JUST WORKED AS THE STORY EDITOR ON A FILM CALLED 'CHALK', A COMEDY ABOUT TEACHERS.

I admire . . . THE WORK OF CHARLES SCHULZ (PEANUTS), GARY LARSON (THE FAR SIDE) MATT GROENING (LIFE IN HELL) & THE CARTOONISTS AT THE NEW YORKER WHO CONTINUALLY CRANK OUT GREAT WORK — LIKE JACK ZIEGLER.

How has your work, or the way you work, changed over time? I USED TO DRAW A LOT SMALLER BECAUSE, BEFORE I WAS PUBLISHED, I USED TO THINK THAT PUBLISHED CARTOONS HAD TO BE SMALL IN SCALE.

I'm not crazy about . . . TOMATOES, POLITICAL PARTIES.

Write a question to which you might answer "Absolutely not." "IS IT TRUE YOU BRIBED MATT DIFFEE TO BE INCLUDED IN THIS BOOK?"

Most cartoonists I know are . . . NEUROTIC, PARANOID, HILARIOUS — MY KIND OF PEOPLE.

Number the following 20 items in order of their importance in your life (1 being the most important):

8 pancakes
7 dictionary
16 Band-Aids
9 Wite-Out
15 tropical fish
6 coffee
4 music
18 dried fruit
20 ashtray
10 soil
3 light board
13 sports
11 tires
14 politics
19 snow shovel
5 soap
17 ointments
1 swimsuit
2 Google image search
12 flashlight

Circle any items that you have never drawn:

roasted turkey	grim reaper	soup	gravestone
(zebra)	(ball of yarn)	fishing pole	(lobster)
piano	fried eggs	kite	(ventriloquist dummy)
silo (grain or missile)	rat	life preserver	noose
whale	(pilgrim)	★ badger	(Amish person)
back of a TV	ant	man with one leg	gun
(cauldron)	igloo	wiener dog	Mr. Potato Head
penguin	fire hydrant	windup toy	gorilla
army helmet	Tin Man	fruit hat	someone shaving
pig	(trout)	canoe	(rabbi)

★ = INDICATES A PARTICULAR FETISH.

When I'm having a hard time coming up with ideas, I . . . (1) WEEP LIKE A SCHOOL GIRL (2) CURSE THOSE WHO MAKE IT LOOK EASY. (3) GO SEE A MOVIE (4) TAKE A NAP (5) BACK TO THE OLD DRAWING TABLE [REPEAT]

What's the hardest part of cartooning? IT CAN BE LONELY AT TIMES AND THERE'S A LOT OF REJECTION INVOLVED. AT THE NEW YORKER, I AVERAGE ONE SALE IN SIXTY. BUT MAKING A SALE IS ALWAYS A THRILL!

How do you deal with rejection? FIRST, SHOCK, THEN DENIAL, FOLLOWED BY ANGER, CONFUSION, DEPRESSION AND EVENTUALLY, THROUGH SELF-MEDICATION, ACCEPTANCE.

Where do you keep your rejected cartoons? IN GOLD FRAMES ON THE WALLS OF MY HOUSE.

My advice to _____SHOPPERS_____ would be: VISIT WWW.CARTOONBANK.COM AND BUY MY CARTOONS AS GIFTS FOR ALL YOUR FRIENDS. [BOB MANKOFF MADE ME SAY THAT]

Where do you see yourself in ten minutes? BUYING MY SISTER A NEW HELLO KITTY DOLL.

And lastly, what are some things that make you laugh and why? WILL FERRELL - FUNNIEST MAN ALIVE, SNL SEINFELD RERUNS, THE MOVIE 'RUSHMORE', ANY MOVIE BY PIXAR, AMERICA'S FUNNIEST HOME VIDEOS, CONAN O'BRIEN, MY KIDS, OTHER CARTOONISTS.

Diced apple is to Waldorf salad as _BACON BITS_ is to my cartoons.

To me, [ink blot] looks like YODA'S HEAD REMOVED AND DISCARDED

Circle the funniest word: pants slacks } SHORT PANTS trousers britches

Circle the funniest bird: chicken (penguin) pigeon tufted titmouse

True or false? _D*_ I spend more than three hours a day working on cartoons. _T_ I have always wanted to be a cartoonist. _F_ I have never lived in New York City. * DEPENDS ON THE DAY.

I consider myself a _____ person. (a) dog (b) blue (c) people (d) other LIKABLE DECISIVE

I am afraid of BEING REJECTED BY BEARS. (a) abandonment (b) commitment (c) rejection (d) bears

For office use only:

For me cartooning is _33_% drawing and _33_% writing. AND 33% MATH.

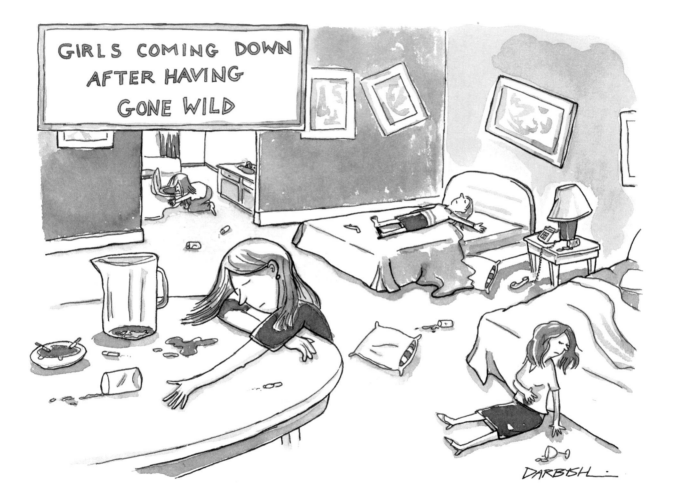

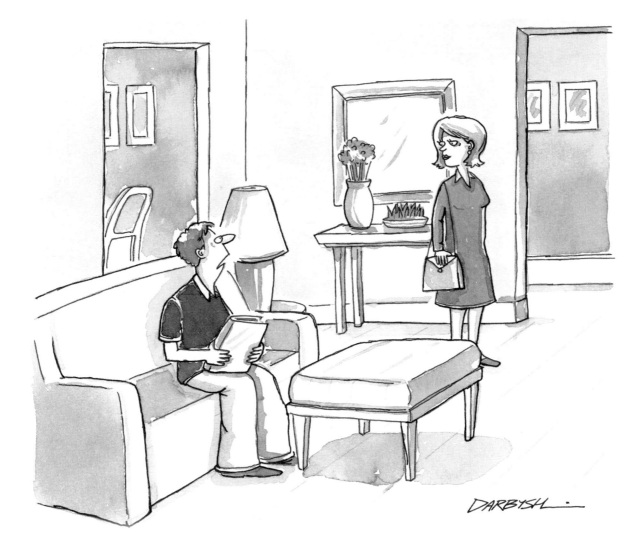

"I was just flippin' through your yearbook and couldn't help noticing that you used to be a dude."

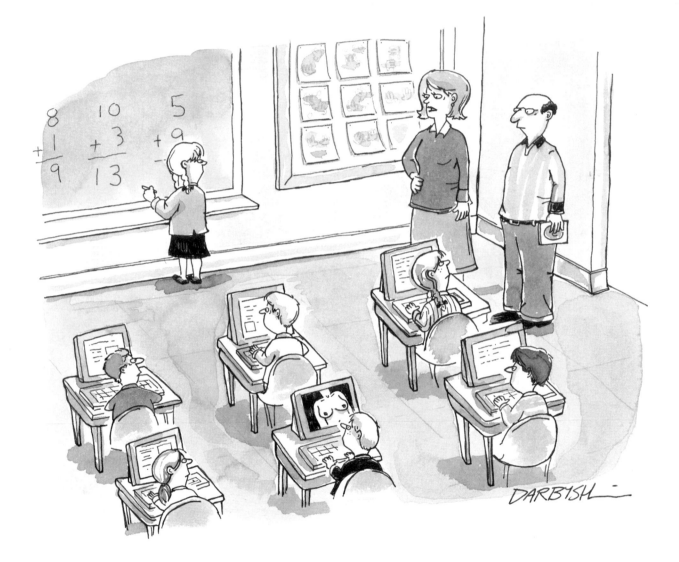

"Who else needs Mr. Cornelson to reinstall the porn filter?"

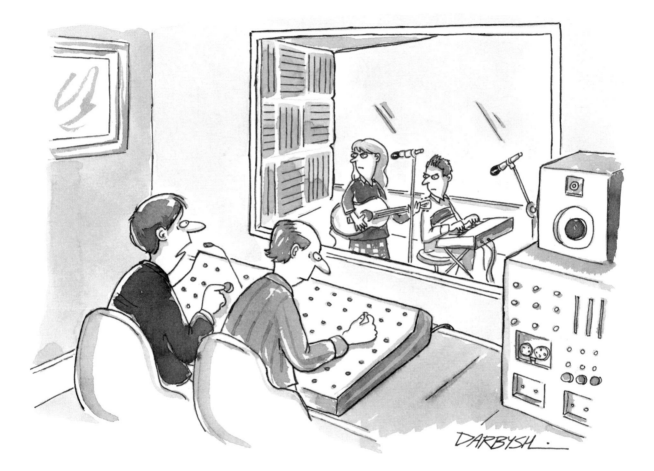

"That was nice—but this time with a little more of that Canadian angst."

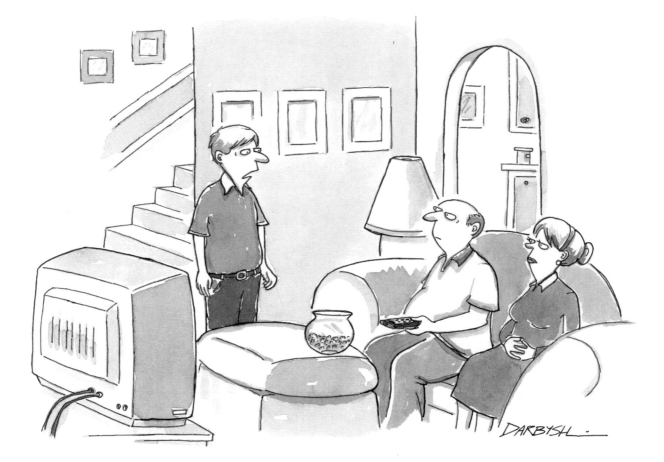

"Mom, Dad, as you both know, I collect vintage dolls and listen to Cher regularly and without irony. I work as a perfume consultant at Bloomingdale's and am currently working on getting a degree in massage therapy. I own four glitter wigs, I use the word 'fabulous' way too much, and I, of course, love a cabaret. I also have a tattoo on the inside of my left ankle that says 'Ronald Forever,' who happens to be my quote unquote roommate going on five and a half years. . . . Oh, and I'm currently wearing stilettos. Stop me if you know where I'm going with this. . . ."

DREW
DERNAVICH

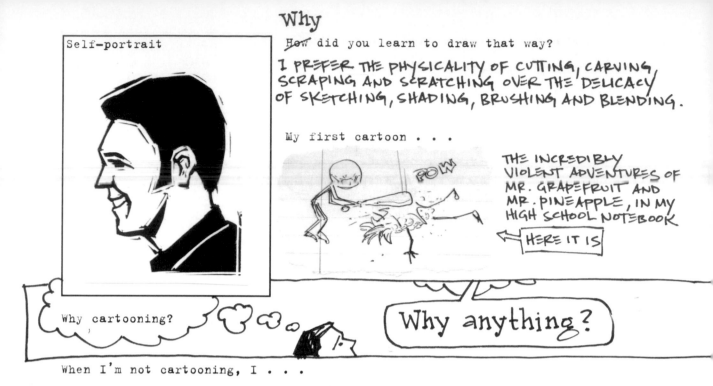

Why

Self-portrait

How did you learn to draw that way?

I PREFER THE PHYSICALITY OF CUTTING, CARVING, SCRAPING AND SCRATCHING OVER THE DELICACY OF SKETCHING, SHADING, BRUSHING AND BLENDING.

My first cartoon . . .

POW

THE INCREDIBLY VIOLENT ADVENTURES OF MR. GRAPEFRUIT AND MR. PINEAPPLE, IN MY HIGH SCHOOL NOTEBOOK

HERE IT IS

Why cartooning?

Why anything?

When I'm not cartooning, I . . . PRECISELY.

I admire . . . ANYONE WHOSE JOB IT IS TO MAKE DECISIONS OTHER THAN WHETHER THE WORD 'WEDNESDAY' IS FUNNIER THAN THE WORD 'THURSDAY.'

How has your work, or the way you work, changed over time? ① I WORK FASTER ② I'M HARDER ON MYSELF ③ IT'S EASIER TO FALL INTO BAD HABITS

I'm not crazy about . . . CARS, AIRPLANES, COUNTRY MUSIC, POLITICS, POETRY AFTER 1922, ANYTHING THAT HAPPENS BEFORE 9 A.M.

Write a question to which you might answer "Absolutely not."

"DO YOU KNOW WHAT YOU'RE DOING?"

Most cartoonists I know are . . .

~~COMPLETELY SCREWED~~ UP KIND, FRIENDLY, INTELLIGENT, AND FUN. THEY MAY CALL YOU TO SEE IF YOU WANT TO DO SOMETHING THIS WEEK-END. DON'T REJECT US!

TRUE FACT

I DRAW ON GRAVESTONES

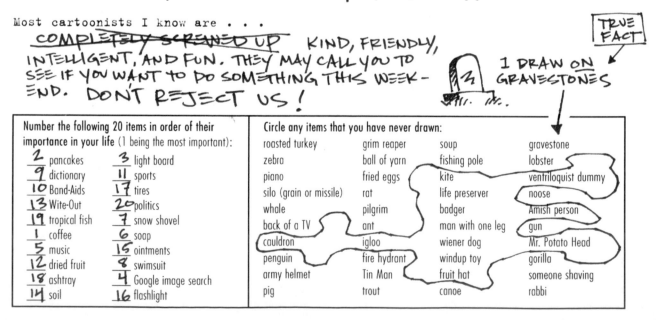

Number the following 20 items in order of their importance in your life (1 being the most important):

2	pancakes	3	light board
9	dictionary	11	sports
10	Band-Aids	17	tires
13	Wite-Out	20	politics
19	tropical fish	7	snow shovel
1	coffee	6	soap
5	music	15	ointments
12	dried fruit	8	swimsuit
18	ashtray	4	Google image search
14	soil	16	flashlight

Circle any items that you have never drawn:

roasted turkey	grim reaper	soup	gravestone
zebra	ball of yarn	fishing pole	lobster
piano	fried eggs	kite	ventriloquist dummy
silo (grain or missile)	rat	life preserver	noose
whale	pilgrim	badger	Amish person
back of a TV	ant	man with one leg	gun
cauldron	igloo	wiener dog	Mr. Potato Head
penguin	fire hydrant	windup toy	gorilla
army helmet	Tin Man	fruit hat	someone shaving
pig	trout	canoe	rabbi

When I'm having a hard time coming up with ideas, I . . .

① BREAK INTO A SWEATY PANIC
② DRINK MORE COFFEE
③ GO RUNNING
④ CALL IT A DAY

What's the hardest part of cartooning?

SEE **THIS** AND **THIS**

How do you deal with rejection?

DENIAL. I BOTTLE UP MY ANGER. SOMEDAY I WILL UNLEASH IT ON SOCIETY. I WILL GIVE YOU A FEW DAYS' NOTICE, THOUGH.

Where do you keep your rejected cartoons?

I KEEP MY FRIENDS CLOSE, BUT MY REJECTED CARTOONS CLOSER. KNOW WHAT I MEAN?

My advice to MATT DIFFEE would be:

CUT THE SELF-REFERENTIAL CRAP

"Where do you see yourself in ten minutes?" SITTING HERE, STILL PONDERING THIS QUESTION, WHILE MY MIND DRIFTS OFF ONTO SOMETHING ELSE

And lastly, what are some things that make you laugh and why?

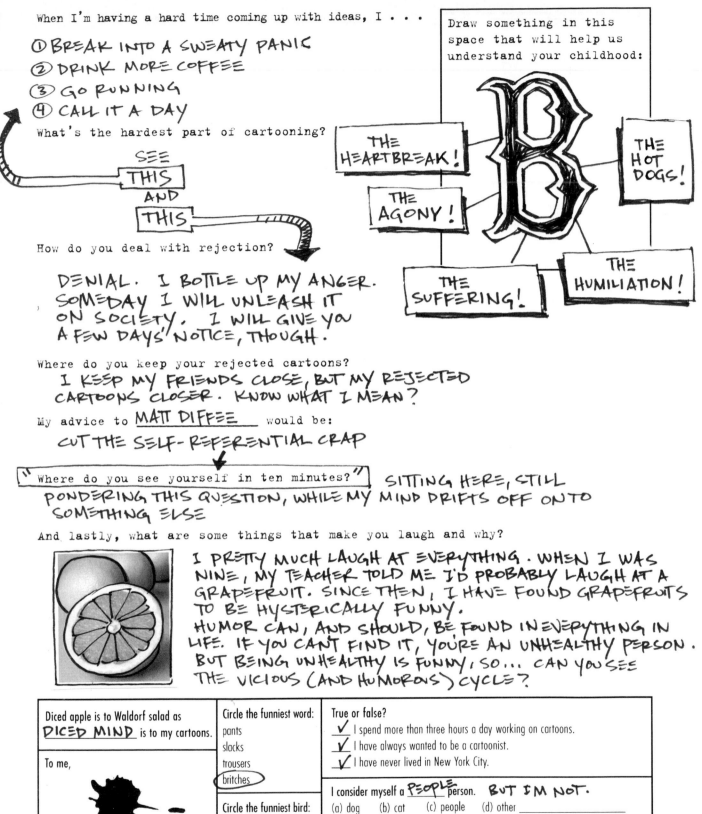

I PRETTY MUCH LAUGH AT EVERYTHING. WHEN I WAS NINE, MY TEACHER TOLD ME I'D PROBABLY LAUGH AT A GRAPEFRUIT. SINCE THEN, I HAVE FOUND GRAPEFRUITS TO BE HYSTERICALLY FUNNY.
HUMOR CAN, AND SHOULD, BE FOUND IN EVERYTHING IN LIFE. IF YOU CAN'T FIND IT, YOU'RE AN UNHEALTHY PERSON. BUT BEING UNHEALTHY IS FUNNY, SO... CAN YOU SEE THE VICIOUS (AND HUMOROUS) CYCLE?

Draw something in this space that will help us understand your childhood:

THE HEARTBREAK!
THE AGONY!
THE HOT DOGS!
THE SUFFERING!
THE HUMILIATION!

Diced apple is to Waldorf salad as DICED MIND is to my cartoons.

To me, [ink blot] — looks like 8 A.M., MONDAY MORNING.

Circle the funniest word:
pants
slacks
trousers
(britches)

Circle the funniest bird:
chicken
(penguin)
pigeon
tufted titmouse

True or false?
✓ I spend more than three hours a day working on cartoons.
✓ I have always wanted to be a cartoonist.
✓ I have never lived in New York City.

I consider myself a PEOPLE person. BUT I'M NOT.
(a) dog (b) cat (c) people (d) other _____

I am afraid of TUFTED TITMICE.
(a) abandonment (b) commitment (c) rejection (d) bears

For me cartooning is 20 % drawing and 50 % writing.
AND 60% THINKING AND 10% HOPING AND 20% DRINKING COFFEE AND 0% CORRECT MATH.

For office use only:

"Give a man an exam and he'll be healthy for a day;
teach a man to examine himself and he'll be healthy for a lifetime."

"Okay, up there, let's give 'er another try."

"We had irreconcilable similarities."

THE PROSTATE MONOLOGUES

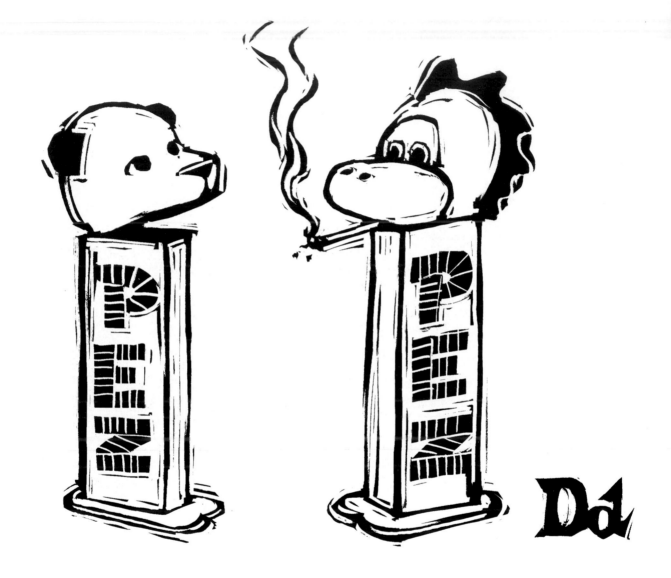

"Are you going to dispense candy with that mouth?"

CHRISTOPHER
WEYANT

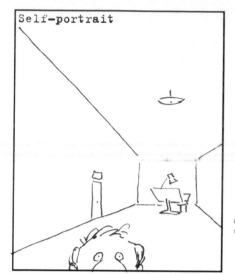

Self-portrait

How did you learn to draw that way?

LA UNIVERSIDAD DEL DOODLING, LIMA, PERU

My first cartoon . . .

WAS A POLITICAL CARTOON. I DREW IT DURING THE ENERGY CRISIS OF THE MID-70's. THE CARTOON SHOWED UNCLE SAM HANDING A BAG OF MONEY (WITH THE ALL-TELLING DOLLAR SIGN ON IT) TO AN OPEC SHEIK. OK — A LITTLE OBVIOUS IN ITS SYMBOLISM BUT I WAS ONLY EIGHT OR NINE YEARS OLD. I DREW IT AT MY DAD'S OFFICE IN NYC — LATER WE WENT TO THE WORLD TRADE CENTER.
MIDDLE EAST TURMOIL, ENERGY CRISIS, TWIN TOWERS — THAT MEMORY RETURNS TO ME OFTEN THESE DAYS...

Why cartooning? WHY, IS THERE SOMETHING ELSE IN LIFE? FOR ME, IT'S ALWAYS BEEN MY FORM OF SELF-EXPRESSION. FOR OTHERS, IT'S MUSIC OR WRITING OR PAINTING ONESELF ORANGE AT A METS GAME. THIS HAPPENS TO BE MINE.

When I'm not cartooning, I . . . AM HAVING A GRAND TIME DANCING THROUGH LIFE WITH TWO TRULY FUNNY PEOPLE, MY WIFE, ANNA, AND MY DAUGHTER, KATE. AND IN THE BACKGROUND THERE'S MY LOVE OF JAZZ.

I admire . . . IN THE CARTOON WORLD, I WAS RAISED ON THE PERVERSE BRILLIANCE OF SAM GROSS AND GAHAN WILSON. LIMITLESS IMAGINATIONS. BOB WEBER IS STUNNING — I'VE LEARNED SO MUCH FROM HIS LYRICAL LINE.

How has your work, or the way you work, changed over time?
AFTER SO MANY CARTOONS, I'M MORE EFFICIENT. I THINK MY ART, CHARACTERS AND WRITING REFLECT MY VOICE MORE CLEARLY NOW.

I'm not crazy about . . .
TIP JARS. THEY'RE EVERYWHERE. HOW MUCH CHANGE AM I SUPPOSED TO CARRY ???

Write a question to which you might answer "Absolutely not."
DO YOU THINK GEORGE W. BUSH AND DICK 'DICK' CHENEY WILL ESCAPE THE GREAT KARMA MACHINE IN THE SKY?

Most cartoonists I know are . . .
SIGNIFICANTLY HAIRIER THAN YOU'D THINK. NOT MISSING LINK HAIRY, BUT CLOSE. SOMETHING TO PONDER ON YOUR DAY OFF.

Number the following 20 items in order of their importance in your life (1 being the most important):

14 pancakes	6 light board 2 OXYGEN
12 dictionary	20 sports
8 Band-Aids	9 tires
16 Wite-Out	4 politics
10 tropical fish	15 snow shovel
1 coffee	7 soap
3 music	11 ointments
5 dried fruit	17 swimsuit
19 ashtray	6 Google image search
13 soil	18 flashlight

Circle any items that you have never drawn:

roasted turkey	grim reaper	soup	gravestone
zebra	ball of yarn	fishing pole	lobster
piano	fried eggs	kite	ventriloquist dummy
silo (grain or missile)	rat	life preserver	noose
whale	pilgrim	badger	Amish person
back of a TV	ant	man with one leg	gun
cauldron	igloo	wiener dog	Mr. Potato Head
penguin	fire hydrant	windup toy	gorilla
army helmet	Tin Man	fruit hat	someone shaving
pig	trout	canoe	rabbi

When I'm having a hard time coming up with ideas, I . . .

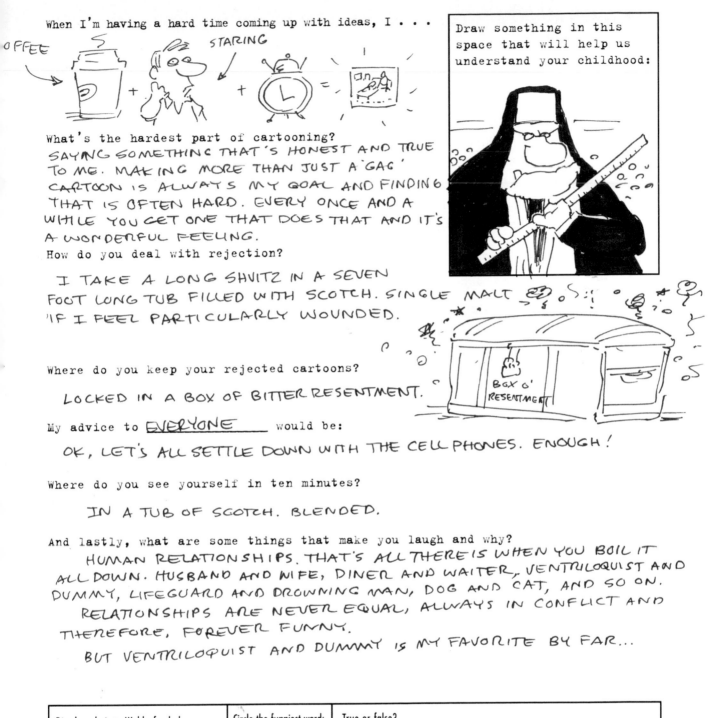

COFFEE + STARING + L = [drawing]

Draw something in this space that will help us understand your childhood:

What's the hardest part of cartooning?
SAYING SOMETHING THAT'S HONEST AND TRUE TO ME. MAKING MORE THAN JUST A 'GAG' CARTOON IS ALWAYS MY GOAL AND FINDING THAT IS OFTEN HARD. EVERY ONCE AND A WHILE YOU GET ONE THAT DOES THAT AND IT'S A WONDERFUL FEELING.

How do you deal with rejection?

I TAKE A LONG SHVITZ IN A SEVEN FOOT LONG TUB FILLED WITH SCOTCH. SINGLE MALT IF I FEEL PARTICULARLY WOUNDED.

Where do you keep your rejected cartoons?

LOCKED IN A BOX OF BITTER RESENTMENT.

BOX O' RESENTMENT

My advice to __EVERYONE__ would be:

OK, LET'S ALL SETTLE DOWN WITH THE CELL PHONES. ENOUGH!

Where do you see yourself in ten minutes?

IN A TUB OF SCOTCH. BLENDED.

And lastly, what are some things that make you laugh and why?
HUMAN RELATIONSHIPS. THAT'S ALL THERE IS WHEN YOU BOIL IT ALL DOWN. HUSBAND AND WIFE, DINER AND WAITER, VENTRILOQUIST AND DUMMY, LIFEGUARD AND DROWNING MAN, DOG AND CAT, AND SO ON.
RELATIONSHIPS ARE NEVER EQUAL, ALWAYS IN CONFLICT AND THEREFORE, FOREVER FUNNY.
BUT VENTRILOQUIST AND DUMMY IS MY FAVORITE BY FAR...

Diced apple is to Waldorf salad as __BALDING__ is to my cartoons.

To me, [ink blot] looks like SEE 'CHILDHOOD' ABOVE.

Circle the funniest word:
pants
~~slacks~~ (circled)
trousers
britches

Circle the funniest bird:
chicken (circled)
penguin
pigeon
tufted titmouse

True or false?
__T__ I spend more than three hours a day working on cartoons.
__T__ I have always wanted to be a cartoonist.
__F__ I have never lived in New York City.

I consider myself a _____ person.
(a) dog (b) cat (c) people (d) other __BIPEDAL__

I am afraid of _____. *(TO BEARS)
(a) abandonment (b) commitment✗ (c) rejection (d) bears

For office use only:

For me cartooning is __49__% drawing and __51__% writing.

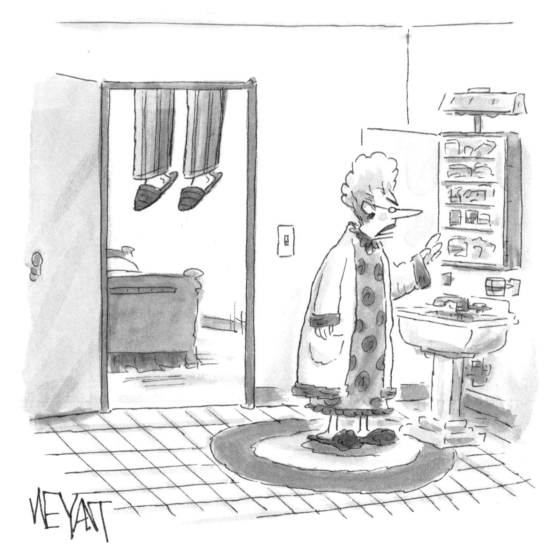

"Richard, did you use all of the dental floss?"

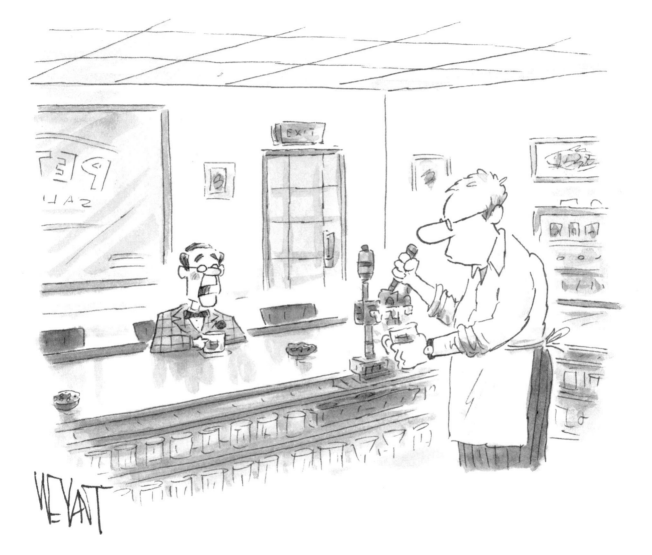

"Mostly, I just miss his hand."

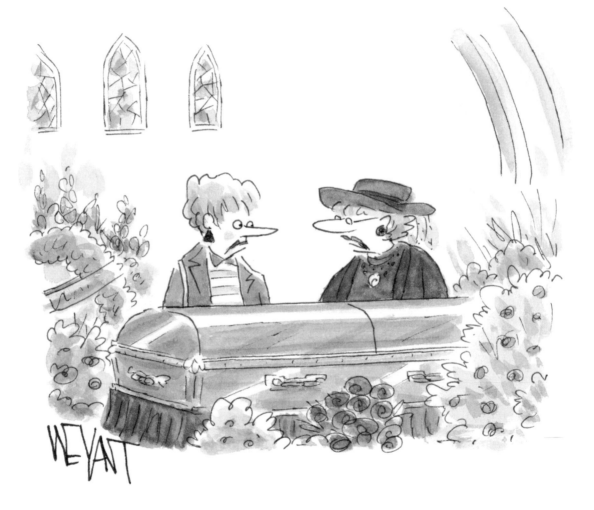

"It would have been an open casket, but he overdosed on Viagra."

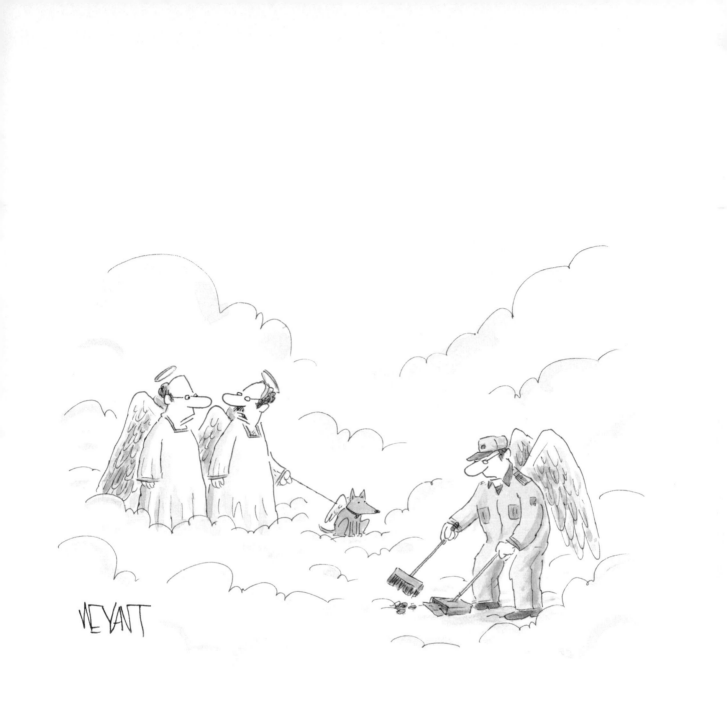

"Atheist."

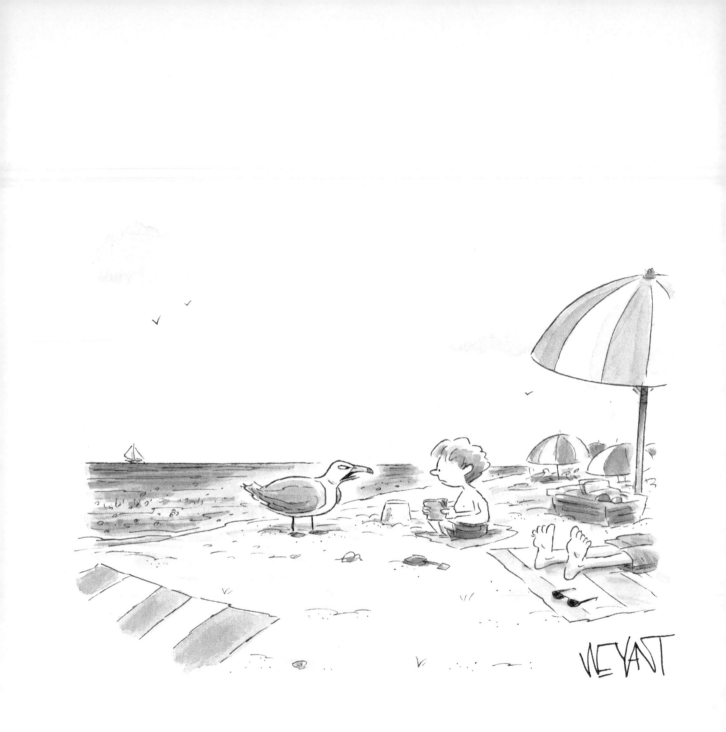

"Hand over the sandwich or I'll crap on your parents."

KIM
WARP

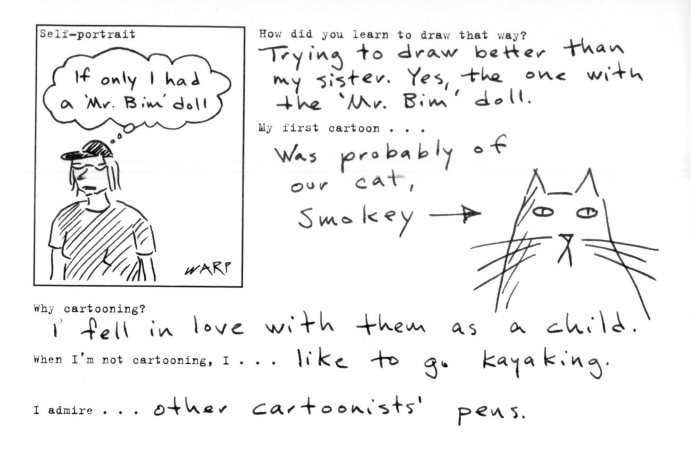

Self-portrait

If only I had a 'Mr. Bim' doll

wARP

How did you learn to draw that way?

Trying to draw better than my sister. Yes, the one with the 'Mr. Bim' doll.

My first cartoon . . .

Was probably of our cat, Smokey →

Why cartooning?

I fell in love with them as a child.

When I'm not cartooning, I . . . like to go kayaking.

I admire . . . other cartoonists' pens.

How has your work, or the way you work, changed over time?

I use the computer for research and roughs

I'm not crazy about . . . cubicles.

Write a question to which you might answer "Absolutely not."

Do you want to go on the roller coaster?

Most cartoonists I know are . . . good dancers.

No one told me there would be tests.

Number the following 20 items in order of their importance in your life (1 being the most important).✱	
O pancakes	I light board
I dictionary	O sports
I Band-Aids	I tires
O Wite-Out	I politics
O tropical fish	O snow shovel
O coffee	I soap
I music	I ointments
O dried fruit	I swimsuit
O ashtray	I Google image search
O soil	O flashlight

✱ It's important or it's not —

Circle any items that you have never drawn:

roasted turkey	grim reaper	soup	gravestone
zebra	(ball of yarn)	fishing pole	lobster
piano	fried eggs	kite	(ventriloquist dummy)
silo (grain or missile)	rat	life preserver	noose
whale	pilgrim	(badger)	(Amish person)
back of a TV	ant	man with one leg	gun
cauldron	igloo	wiener dog	Mr. Potato Head
penguin	fire hydrant	(windup toy)	gorilla
army helmet	(Tin Man)	fruit hat	someone shaving
pig	trout	canoe	(rabbi)

When I'm having a hard time coming up with ideas, I . . .

Take a walk or read the paper.

What's the hardest part of cartooning?

Waiting for the check.

Draw something in this space that will help us understand your childhood:

— My Toy Chimp —
Not quite as nice
as my sister's doll,
'Mr. Bim.'

How do you deal with rejection?

I don't think about it.
I just draw more.

Where do you keep your ~~rejected~~ available cartoons?

On the computer.

My advice to ___kids___ would be:

If you want a 'Mr. Bim' don't settle for 'Zip.'

Where do you see yourself in ten minutes?

Doing laundry

And lastly, what are some things that make you laugh and why?

I laugh at everything—
it's a problem.

Diced apple is to Waldorf salad as
___people___ is to my cartoons.
are

To me,

looks like
___a turkey___.

Circle the funniest word:
(pants) No
slacks Contest
trousers
britches

Circle the funniest bird:
(chicken) A
(penguin) tie
pigeon
tufted titmouse

True or false? KINDA
T I spend more than three hours a day working on cartoons.
T I have always wanted to be a cartoonist.
T I have never lived in New York City.

I consider myself a __b__ person.
(a) dog (b) cat (c) people (d) other _____

I am afraid of __d__.
(a) abandonment (b) commitment (c) rejection (d) bears

For me cartooning is _49_% drawing and _51_% writing.

For office use only:
cheater

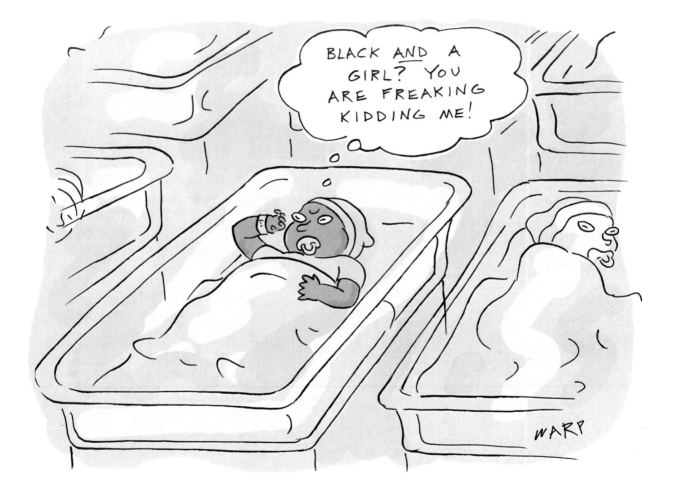

Corvette With Spoiler

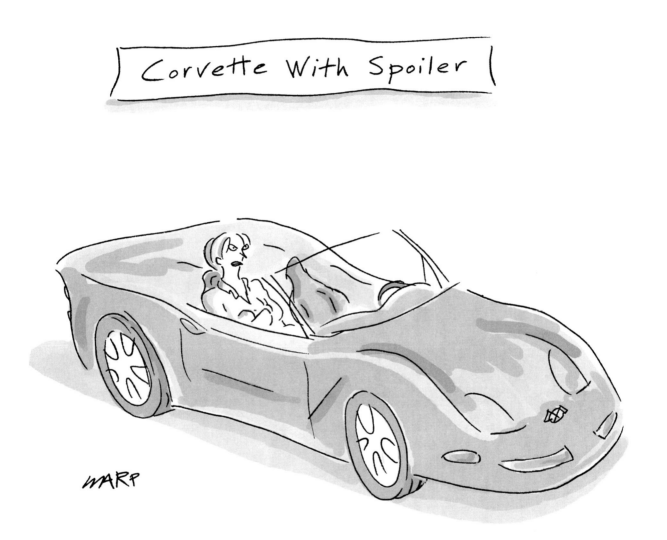

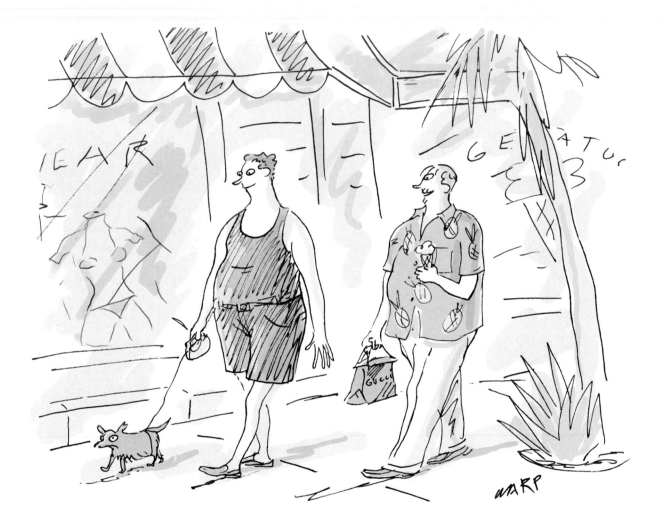

"Who even knew they made dog thongs?"

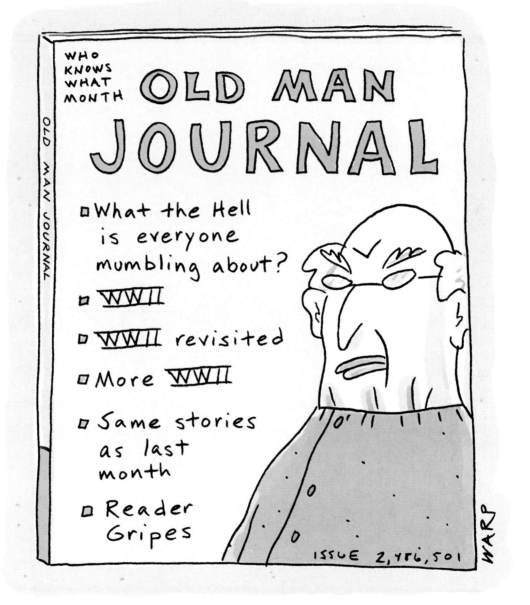

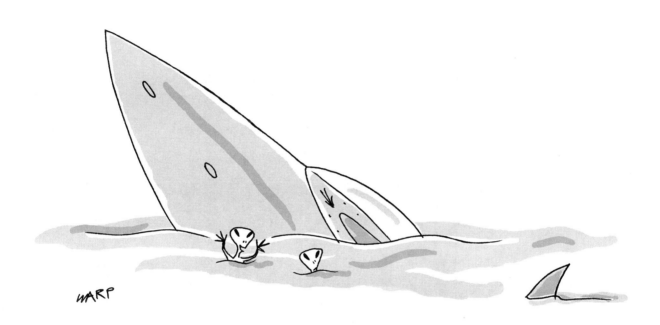

"We're saved! We're saved!"

WILLIAM
HAEFELI

I find it un-natural to write this small. Please don't judge me by this tiny printing. Thank you.

Self-portrait

circa 1990
(Based on self-portrait that ran in <u>Punch</u>)

How did you learn to draw that way?
My style evolved over the years like handwriting does. And I hear the advice of old art instructors ("Pay attention to white space" etc.) in my head.

My first cartoon . . .
was purchased in 1978 by <u>Saturday Review</u> and its very nice cartoon editor Clarence Brown who appreciated my work from the first batch I sent him. In my earliest weeks I assumed all my work would be rejected so I didn't pay any attention to my drawings. I had some really bad drawings published.

Why cartooning?
For me, it's all about self-expression and cartooning offers a high degree of creative control.

When I'm not cartooning, ■ . . . my drawing hand/arm/shoulder appreciate the rest.

I admire the cartoonists Charles Saxon, for the lushness of his drawings and the keenness of his observations, and Gluyas Williams, for how well he captured his times and the precision of his drawing (I can't catch him cheating). For diplomacy I'm not mentioning living cartoonists.

How has your work, or the way you work, changed over time?
My drawings have gotten much tighter and take a lot longer to draw. My sense of humor is much more focused – it used to be all over the place.

I'm not crazy. ▬▬▬
It's the world that's crazy. That's why I rarely need to stretch much past real life to find something that's funny.

Write a question to which you might answer "Absolutely not."
"Would you have included this question in this questionnaire?"

Most cartoonists I know are . . . "interesting" – although I would say the same about most human beings I have observed.

NOTES:
A: 1. Few things are tastier than buckwheat sunflower seed pancakes w/ real maple syrup. I haven't had them in years.
2. You don't want to know how often I need this.
3. Actually for me it's white tempra paint that's saved many a drawing.
4. I have never forgiven coffee for not tasting as good as it smells. It is not a part of my life.
5. Music is my coffee.
6. I love old ashtrays for their decorative value, <u>not</u> for their intended purpose.
7. I live in the Sun Belt.
8. Excuse me?
9. Very helpful, along with the Web sites of major retailers.

A.

Address and

▬▬▬ the following ▬ items ▬▬▬ their importance in your life ▬▬▬▬▬

___ pancakes 1.	~~tight board~~
___ dictionary 2.	~~sports~~
~~Band-Aids~~	~~tires~~
___ Wite-Out 3.	~~politics~~
~~tropical fish~~	___ snow shovel 7.
___ coffee 4.	~~soap~~
___ music 5.	___ ointments 8.
~~dried fruit~~	~~swimsuit~~
___ ashtray 6.	___ Google image search 9.
~~soil~~	~~flashlight~~

B.

Circle any items that you have never drawn:

roasted turkey	grim reaper	soup	gravestone
(zebra)	ball of yarn	fishing pole	(lobster)
piano	fried eggs 2.	kite	(ventriloquist dummy)
(silo (grain or missile))	(rat)	(life preserver)	(noose)
(whale)	(pilgrim)	(badger)	(Amish person)
back of a TV 1.	(ant)	man with one leg	gun
(cauldron)	(igloo)	(wiener dog)	(Mr. Potato Head) 3.
penguin	(fire hydrant)	(windup toy)	(gorilla)
(army helmet)	(Tin Man)	(fruit hat)	someone shaving
(pig)	(trout)	(canoe)	(rabbi)

I circled so many of these that I am beginning to wonder if I am actually a cartoonist.

B:
1. Too many times!
2. They may have been poached eggs.
3. I've never drawn Mr. Potato Head but I once drew what <u>appeared</u> to be Mr. Potato Head but was actually Mr. S--- Head. It was a charming comment on the innocence of children. (You had to see it.)

When I'm having a hard time coming up with ideas, I . . . sit quietly in a chair for one hour, consciously trying to come up with ideas. I may not get any ideas during that hour but within 12 hours or so I usually have a spontaneous flood of ideas.

What's the hardest part of cartooning? Each year it gets harder to come up with new ideas on topics I've treated many, many times before. Fortunately, though the themes stay the same, the details change with the years.
 Also: I find it boring to do rough drawings. The fun of drawing is getting all the elements to work together. This really doesn't matter in a rough.

How do you deal with rejection? No cartoon is ever definitively rejected. There's always a chance to resubmit it at a later date or sell it elsewhere. However some cartoons and their topics have a certain shelf life and it is always sad when they don't get sold by their "sell by" date.

Where do you keep your rejected cartoons? My "rejected" (see above) cartoons are filed on shelves underneath my desk.

My advice to ___drivers___ would be: to remember that they are behind the wheel of a deadly weapon and pay attention to their driving. (Sorry, this is not a funny answer.)

Where do you see yourself in ten minutes? Still working on this questionnaire, answering the questions I skipped.

And lastly, what are some things that make you laugh and why?
 TV SHOWS: <u>Newsradio</u>: The funny comes from so many directions: character comedy, verbal humor, slapstick, obscure cultural references. It can be subtle, broad, off-the-wall. <u>The Mary Tyler Moore Show</u>: Mary is so nice. <u>Fawlty Towers</u>: Basil is so awful.
 MOVIES: • Harold Lloyd and his wonderful 1920s American energy.
 • I love when attractive and sophisticated people are nonchalantly goofy. e.g. Cary Grant in most of his comedies e.g. Capucine in the original <u>Pink Panther</u> when she hits her head on the bar or falls into the closet.
 BOOKS: I can't say because my taste in humorous writing keeps changing. What I found funny 20 years ago seems tedious now.

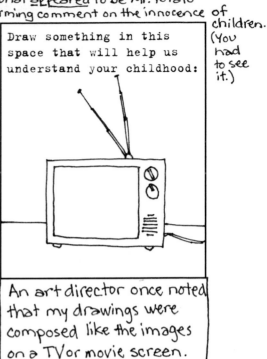

Draw something in this space that will help us understand your childhood:

An art director once noted that my drawings were composed like the images on a TV or movie screen.

Diced apple is to Waldorf salad as __Prismacolor__ is to my cartoons. black pencil

To me, answering what [ink blot] looks like is a no-win situation

Circle the funniest word: pants (slacks) trousers britches So Rob Petrie!

Circle the funniest bird: chicken penguin pigeon (tufted titmouse) It tries way too hard.

True or false? "three hours average": true "three hours every day": false
● I spend more than three hours a day working on cartoons.
T I have always wanted to be a cartoonist.
T I have never lived in New York City.

I consider myself a _____ person, even though I have never owned a dog. (a) dog (b) cat (c) people (d) other

I am afraid of picking the wrong answer. (a) abandonment (b) commitment (c) rejection (d) bears

For office use only:

For me cartooning is __100__ % drawing and __100__ % writing.

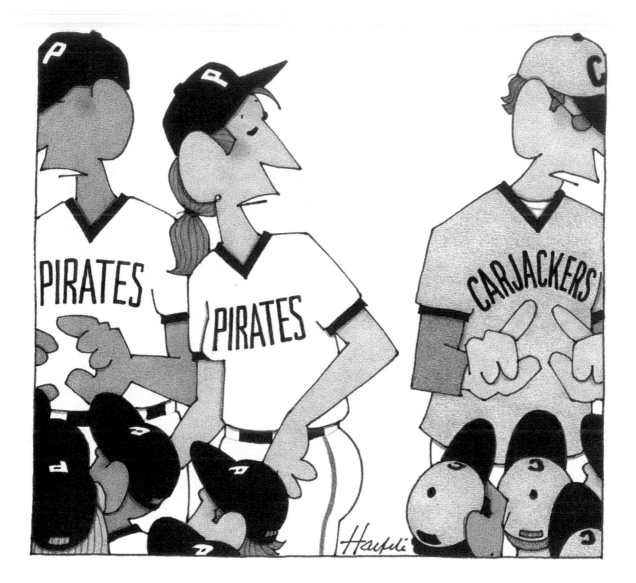

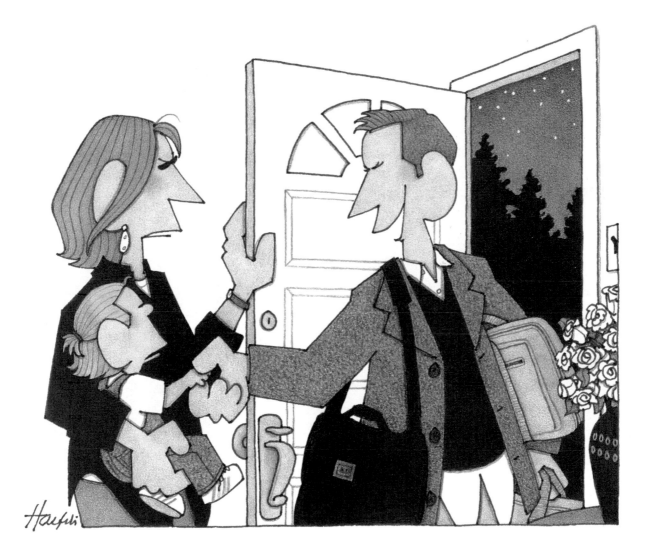

*"Mommy wants you to have everything she had when
she was growing up—starting with divorced parents."*

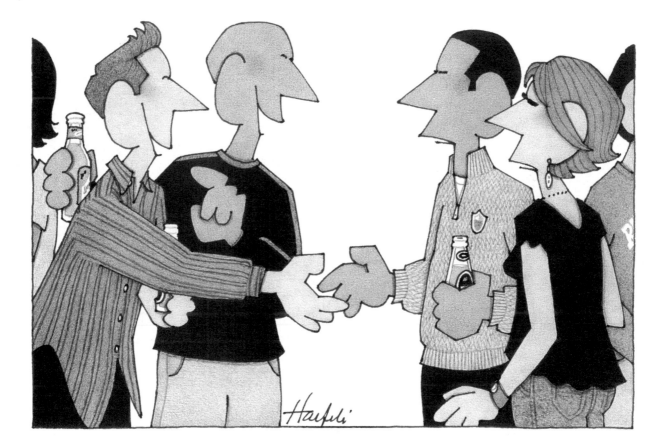

"This is Jerry. His family used to own my family."

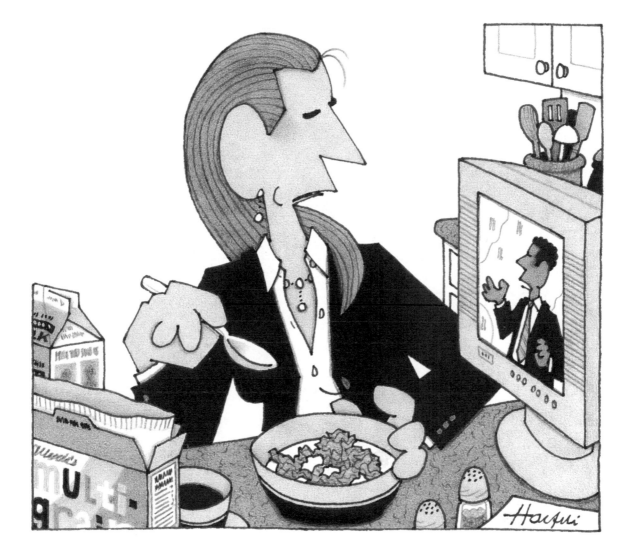

"For those of you headed to the office, today will be 68 degrees and fluorescent."

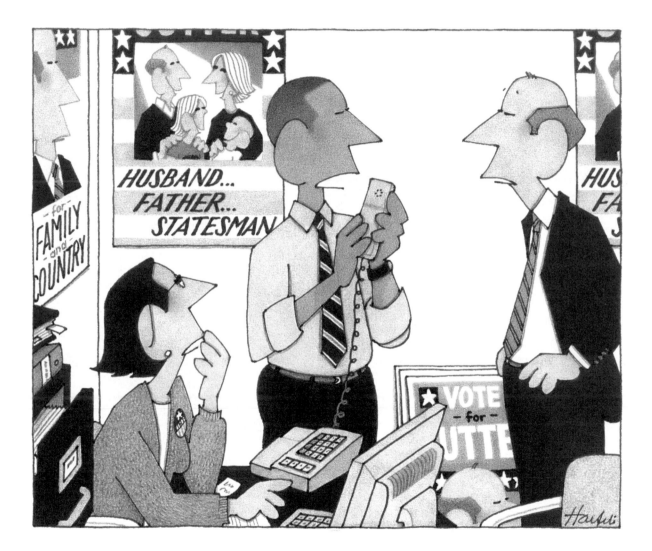

"He claims he has you on video—how can I put this?—'courting the gay vote.'"

JOHN
O'BRIEN

Self-portrait

How did you learn to draw that way?
I LOOKED AT TOO MANY 15TH TO 19TH CENTURY WOODCUTS AND ENGRAVING, WHICH MIGHT SEEM ODD BUT NOT FOR AN ART STUDENT AT PHILADELPHIA COLLEGE OF ART IN THE 70's . . .

My first cartoon . . .
I DON'T REMEMBER BUT IT WAS RECEIVED LIKE THIS —

IS THIS YOUR IDEA OF A JOKE?

SIR, I HAD NO WHERE ELSE TO GO. SIR!

Why cartooning?

When I'm not cartooning, I . . .

I admire . . .
PRANKSTERS, WISEGUYS, AND CHEAPSHOT ARTISTS

How has your work, or the way you work, changed over time?
THE PAPER TENDS TO YELLOW AND THE COLOR FADES IN SUNLIGHT UNLIKE MYSELF ON THE BEACH.

I'm not crazy about . . . SIX HOURS A DAY. USUALLY WHILE I'M SLEEPING

Write a question to which you might answer "Absolutely not."
IS THE CUP HALF FULL OR HALF EMPTY?
AM I BLUE? DO YOU WANNA DANCE?

Most cartoonists I know are . . .
EITHER IN THIS BOOK OR AT PARTIES IN NEW YORK AND PHILADELPHIA.

Number the following 20 items in order of their importance in your life (1 being the most important):

____ pancakes
____ dictionary
____ Band-Aids
____ Wite-Out
____ tropical fish
____ coffee
____ music
____ dried fruit
____ ashtray
____ soil
____ light board
____ sports
____ tires
____ politics
____ snow shovel
____ soap
____ ointments
____ swimsuit
____ Google image search
____ flashlight

(DID I DO THIS RIGHT?)

Circle any items that you have never drawn:

roasted turkey	grim reaper	soup	gravestone
zebra	ball of yarn	fishing pole	lobster
piano	fried eggs	kite	ventriloquist dummy
silo (grain or missile)	rat	life preserver	noose
whale	pilgrim	badger	Amish person
back of a TV	ant	man with one leg	gun
cauldron	igloo	wiener dog	Mr. Potato Head
penguin	fire hydrant	windup toy	gorilla
army helmet	Tin Man	fruit hat	someone shaving
pig	trout	canoe	rabbi

THERE

I'M BEING SERIOUS HERE IT'S SCARY — THINK THAT I'VE EVEN DR BOTH TY OF SILOS

When I'm having a hard time coming up with ideas, I . . .

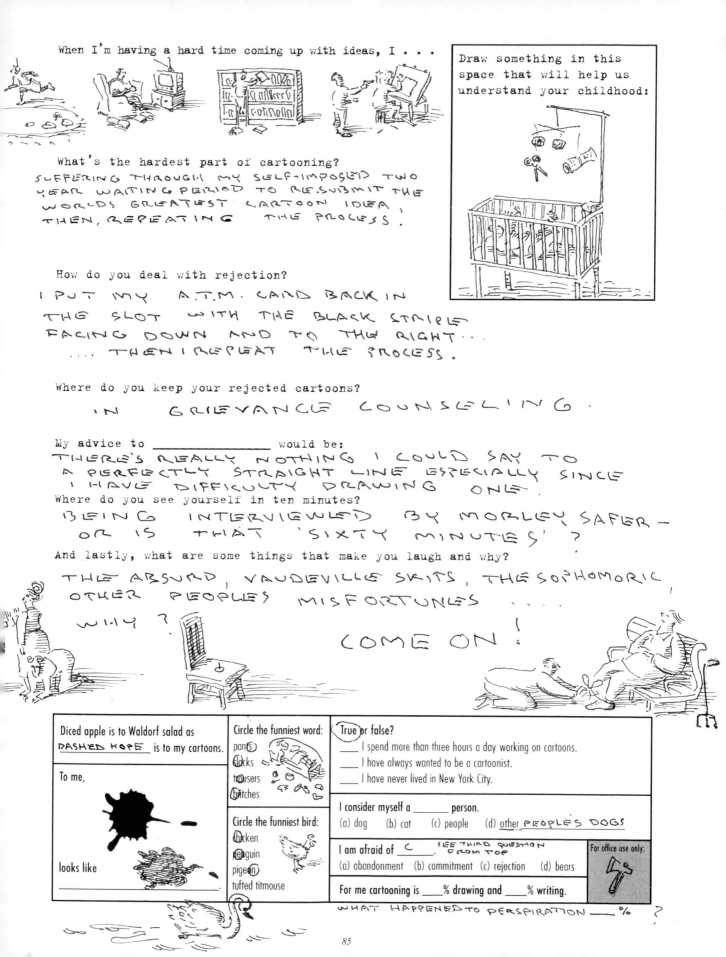

Draw something in this space that will help us understand your childhood:

What's the hardest part of cartooning?
SUFFERING THROUGH MY SELF-IMPOSED TWO YEAR WAITING PERIOD TO RESUBMIT THE WORLDS GREATEST CARTOON IDEA, THEN, REPEATING THE PROCESS.

How do you deal with rejection?
I PUT MY A.T.M. CARD BACK IN THE SLOT WITH THE BLACK STRIPE FACING DOWN AND TO THE RIGHT... THEN I REPEAT THE PROCESS.

Where do you keep your rejected cartoons?
IN GRIEVANCE COUNSELING.

My advice to _____ would be:
THERE'S REALLY NOTHING I COULD SAY TO A PERFECTLY STRAIGHT LINE ESPECIALLY SINCE I HAVE DIFFICULTY DRAWING ONE.

Where do you see yourself in ten minutes?
BEING INTERVIEWED BY MORLEY SAFER - OR IS THAT 'SIXTY MINUTES'?

And lastly, what are some things that make you laugh and why?
THE ABSURD, VAUDEVILLE SKITS, THE SOPHOMORIC, OTHER PEOPLES MISFORTUNES
WHY? COME ON!

Diced apple is to Waldorf salad as DASHED HOPE is to my cartoons.

To me,

looks like _____

Circle the funniest word:
pants
clocks
trousers
britches

Circle the funniest bird:
chicken
penguin
pigeon
tufted titmouse

True or false?
____ I spend more than three hours a day working on cartoons.
____ I have always wanted to be a cartoonist.
____ I have never lived in New York City.

I consider myself a _____ person.
(a) dog (b) cat (c) people (d) other PEOPLES DOGS

I am afraid of C SEE THIRD QUESTION FROM TOP
(a) abandonment (b) commitment (c) rejection (d) bears

For office use only:

For me cartooning is ___% drawing and ___% writing.
WHAT HAPPENED TO PERSPIRATION ___% ?

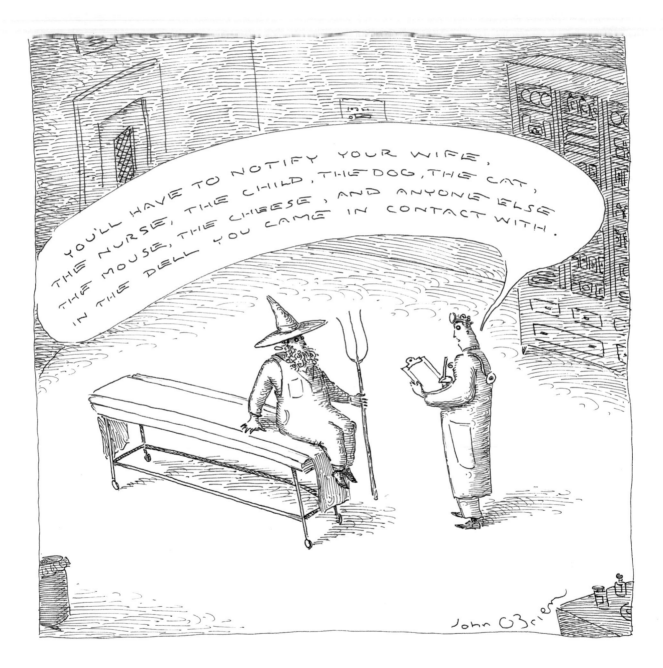

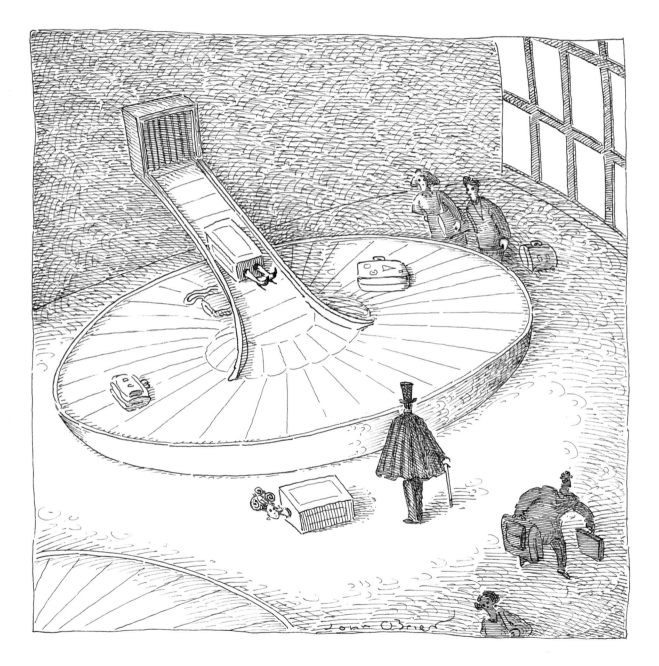

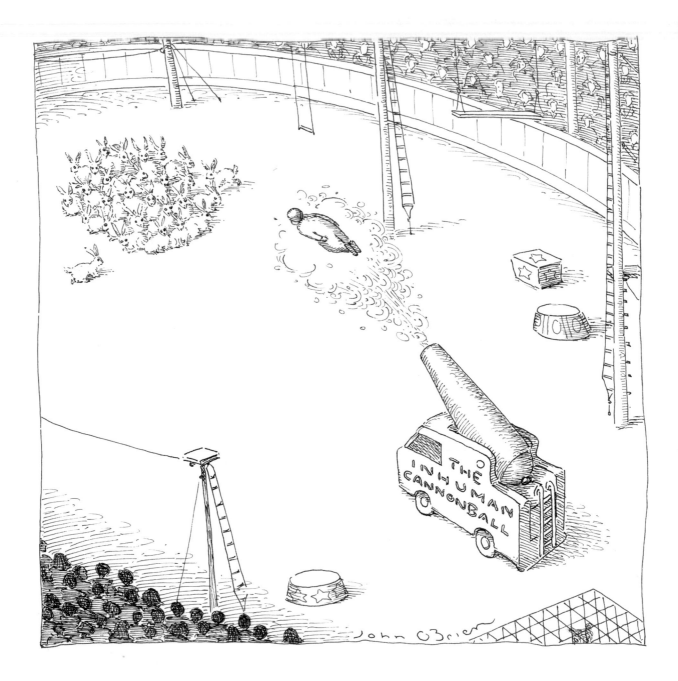

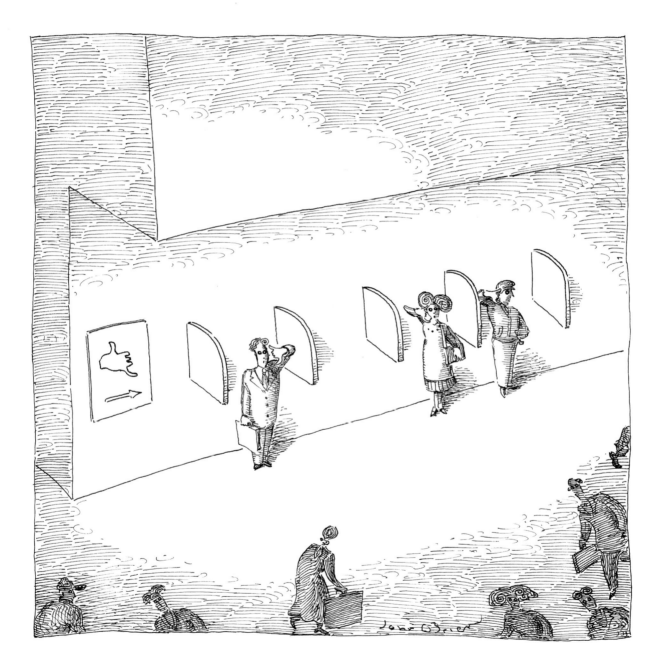

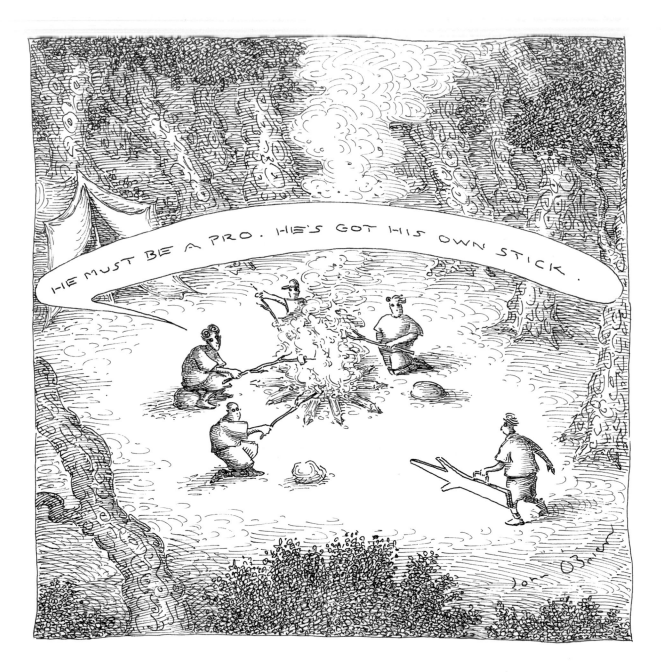

MARISA
ACOCELLA MARCHETTO

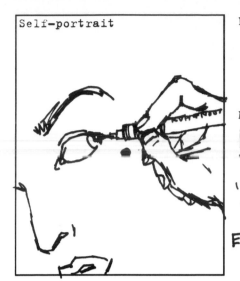

Self-portrait

How did you learn to draw that way?
A SHOE DESIGNER, AND SHE'D DRAW FAB WOMEN WEARING HER FAB SHOES. I STARTED IMITATING HER AT 3. **MY MOTHER WAS**

My first cartoon . . . ME, VOMITING WHILE MY MOTHER HELD MY HEAD. THE HEADLINE: "A MOTHER ALWAYS HELPS YOU WHEN YOU THROW UP." EARLY ON, AT AGE 4 I DREW FROM TRAUMA.

Why cartooning? I HATE FLUORESCENT LIGHTING— IT THROWS OFF A CERTAIN SHADE OF GREEN THAT'S BAD FOR A GIRL'S COMPLEXION.

When I'm not cartooning, I . . . CHECK~~~~ TO SEE HOW THE YANKEES ARE DOING.

I admire . . . ANYONE WHO MAKES ME LAUGH.

How has your work, or the way you work, changed over time? I USED TO BE OBSESSED WITH FASHION, BUT NOW THAT I'VE SURVIVED CANCER I FIND EVERYTHING IS RIDICULOUS.

I'm not crazy about . . .
ANYONE WHO TAKES THEMSELVES TOO SERIOUSLY, I'M SERIOUS.

Write a question to which you might answer "Absolutely not."

WOULD YOU EVER ROOT FOR THE RED SOX?

Most cartoonists I know are . . .
THE MOST BRILLIANT, INSIGHTFUL, PERCEPTIVE, OBSERVANT TWISTED FREAKS I'VE EVER MET.

Number the following 20 items in order of their importance in your life (1 being the most important):	
12 pancakes	5 light board
13 dictionary	3 sports
14 Band-Aids	17 tires
1 Wite-Out	9 politics
18 tropical fish	16 snow shovel
2 coffee	6 soap
11 music	7 ointments
15 dried fruit	10 swimsuit
20 ashtray	4 Google image search
19 soil	8 flashlight

Circle any items that you have never drawn:

roasted turkey	grim reaper	soup	gravestone
zebra	ball of yarn	fishing pole	lobster
piano	fried eggs	kite	(ventriloquist dummy)
silo (grain or missile)	rat	life preserver	noose
whale	pilgrim	(badger)	Amish person
back of a TV	ant	(man with one leg)	gun
cauldron	igloo	(wiener dog)	Mr. Potato Head
penguin	fire hydrant	windup toy	(gorilla)
army helmet	Tin Man	fruit hat	someone shaving
pig	trout	(canoe)	rabbi

When I'm having a hard time coming up with ideas, I . . .

CHECK TO SEE HOW THE YANKEES ARE DOING.

What's the hardest part of cartooning?

SITTING DOWN AND CARTOONING.

Draw something in this space that will help us understand your childhood:

Welcome to NEW JERSEY

How do you deal with rejection? ~~CRACK~~.

REJECTION IS CRACK.

MATT: WHY DIDN'T YOU ASK US WHAT PEN WE TOON WITH?

MY PEN OF CHOICE

2/.60

RAPIDOGRAPH® KOH-I-NOOR®

Where do you keep your rejected cartoons? IN BOXES. AND BOXES. AND BOXES AND BOXES AND BOXES AND BOXES AND BOXES AND BOXES

My advice to __HUMANITY__ would be: LAUGH

Where do you see yourself in ten minutes? HAILING A CAB SO I CAN DROP OFF THIS DAMNED QUESTIONNAIRE BECAUSE THIS BOOK IS BEING PRINTED IN FIVE MINUTES!

And lastly, what are some things that make you laugh and why?

TRAUMA AND EMBARRASSMENT MAKE ME LAUGH — BECAUSE AFTER YOU GET OVER THE INITIAL FEELING OF MORTIFICATION, IT'S ALWAYS THE BEST MATERIAL.

THINKS THEY'RE FUNNY WHEN THEY'RE SCHTUPING. SCHTUPPING? How Do YOU SPELL IT?

Diced apple is to Waldorf salad as NEW YORK is to my cartoons.

To me,

looks like A SNAIL THAT'S BEEN STEPPED ON.

Circle the funniest word:
pants
slacks
trousers
(britches)

Circle the funniest bird:
chicken
penguin
pigeon
(tufted titmouse)

True or false?
T — I spend more than three hours a day working on cartoons.
F — I have always wanted to be a cartoonist.
F — I have never lived in New York City.

I consider myself a __C__ person.
(a) dog (b) cat (c) people (d) other _____

I am afraid of __D__.
(a) abandonment (b) commitment (c) rejection (d) bears

For office use only:

For me cartooning is __100__% drawing and __100__% writing.

L— I BET SAM GROSS CIRCLED CHICKENS. WELL, MAYBE NOT... HE ONLY

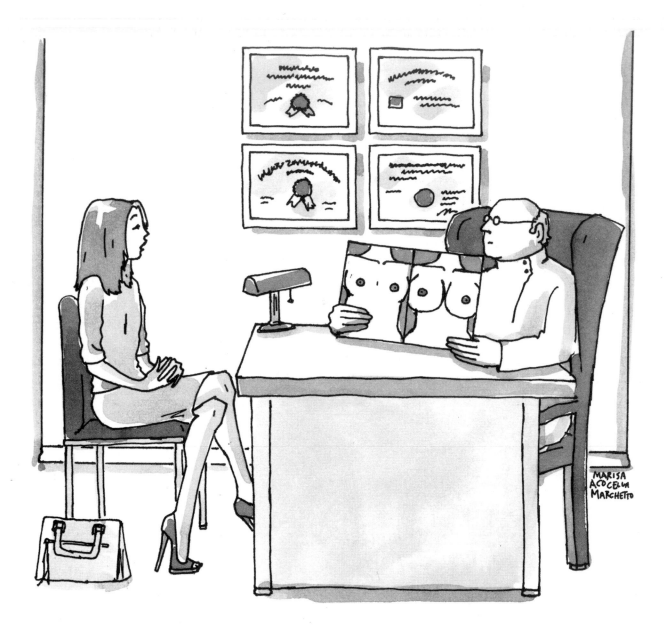

"Supersize me."

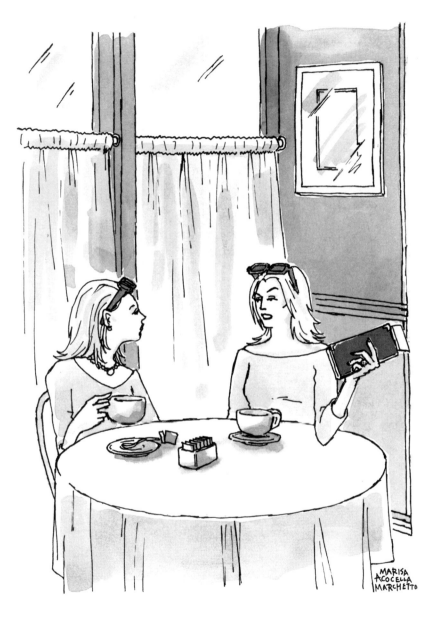

"Your husband got the last one. This one's on mine."

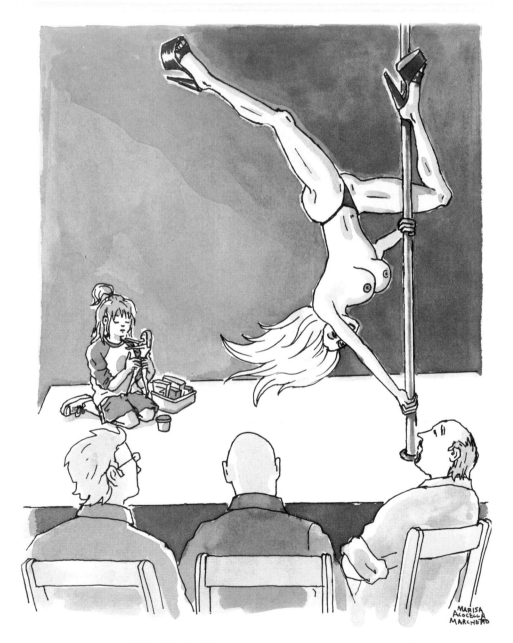

"It's 'Take Your Daughter to Work Day.'"

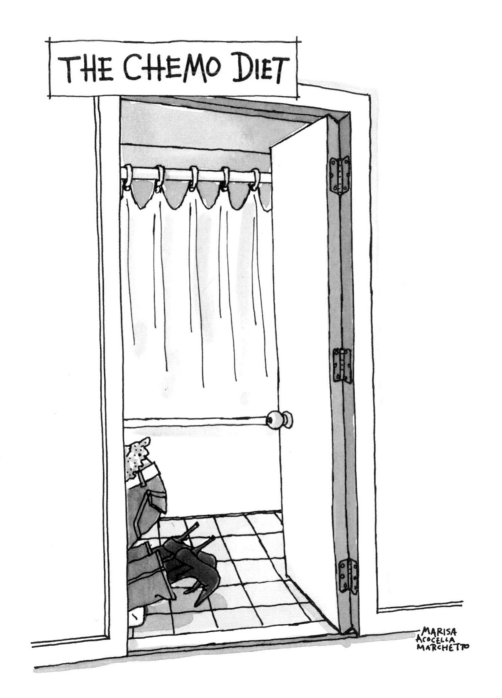

THE CHEMO DIET

MARISA
ACOCELLA
MARCHETTO

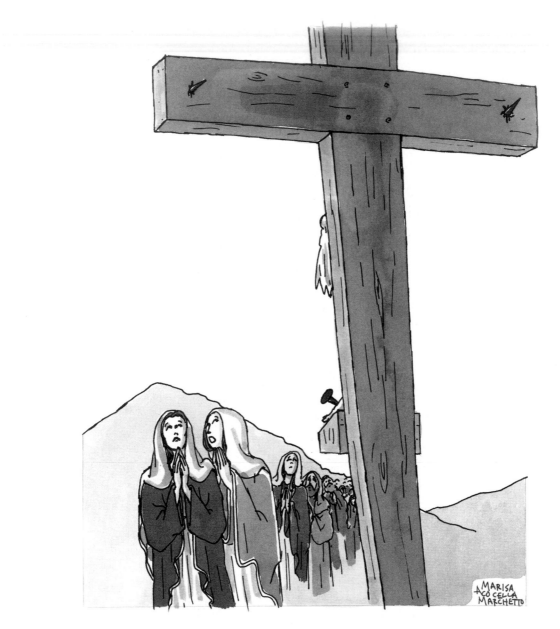

"So much for nepotism."

DANNY
SHANAHAN

Self-portrait

How did you learn to draw that way?
Trial and error, for the most part; some sibling rivalry (10 brothers and sisters) and lots and lots of parental encouragement.

My first cartoon . . .
Was someone else's. I copied a B. Kliban cartoon for my high school yearbook. It involved porcupines. It swiftly grew to include attorneys, or, as we call them "porcupines of justice".

Why cartooning?
Absolutely not.

When I'm not cartooning, I . . . spend time with my family, read, golf, read, hang out with friends, read. Also, do some reading.

I admire . . . the way you hold your knife, they way we danced til three, the way you changed my life, and "the man" can't take that away from me.

How has your work, or the way you work, changed over time? I like to think it has improved. And I do far fewer gags re. the Lindbergh Baby.

I'm not crazy about . . . dogs in restaurants. Cannibals. Cannibal dogs in their cannibal finery, eating and drinking, oblivious to the fact that, hey, that happens to be my usual table!

Write a question to which you might answer "Absolutely not."
See above

Most cartoonists I know are . . . intelligent, talented, decent, generous, loving, bear-fearing people.

Number the following 20 items in order of their importance in your life (1 being the most important):	
20 pancakes	1 light board
20 dictionary	1 sports
1 Band-Aids	20 tires
20 Wite-Out	20 politics
10 tropical fish	20 snow shovel
1 coffee	10 soap
1 music	1 ointments
20 dried fruit	20 swimsuit
20 ashtray	1 Google image search
1 soil	20 flashlight

Circle any items that you have never drawn:

roasted turkey	grim reaper	soup	gravestone
zebra	ball of yarn	fishing pole	lobster
piano	fried eggs	kite	ventriloquist dummy
silo (grain or missile)	rat	life preserver	noose
whale	pilgrim	(badger)	Amish person
back of a TV	ant	man with one leg	gun
cauldron	igloo	wiener dog	Mr. Potato Head
penguin	fire hydrant	windup toy	gorilla
army helmet	Tin Man	fruit hat	someone shaving
pig	trout	canoe	(rabbi)

yet I work primarily in black and white. Go figure.

When I'm having a hard time coming up with ideas, I . . .

Make a little jello. Or talk a walk. Or smoke a cigar. Sometimes I'll look through old college photos and think "whatever happened to that bright, promising, young son-of-a-bitch?" Then I realize I never went to college, and that I'm looking at pictures of a total stranger.

What's the hardest part of cartooning?

The ice cube trays. Especially if two of them get stuck together. You think your life is hard? Consider your frozen amigos, compadre.

How do you deal with rejection?

With my innate, overbearing stubborness. I just keep banging my head against the wall until something happens.

Draw something in this space that will help us understand your childhood:

JELL-O

Where do you keep your rejected cartoons?

In a quiet, safe, compartmentalized part of my brain I call "Susan".

My advice to "Susan" would be:

Get on the stick and sell something, already!

Where do you see yourself in ten minutes?

At the post office, knocking down a tall, cold one.

And lastly, what are some things that make you laugh and why?

People, and the things people do and say (and don't do, and don't say). That includes children and babies. They're all just inherently funny, whether they realize it or not. And questionnaires are freaking hilarious.

Diced apple is to Waldorf salad as applesauce is to my cartoons.

To me,

looks like my uncle Blotti.

Circle the funniest word:
pants
slacks
trousers
(britches)

Circle the funniest bird:
(chicken)
penguin
pigeon
tufted titmouse

True or false?
T I spend more than three hours a day working on cartoons.
F I have always wanted to be a cartoonist.
F I have never lived in New York City.

I consider myself a _____ person.
(a) dog (b) cat (c) people (d) other pod

I am afraid of d .
(a) abandonment (b) commitment (c) rejection (d) bears

For me cartooning is 5 % drawing and 90 % writing.

For office use only:

and 5% theft

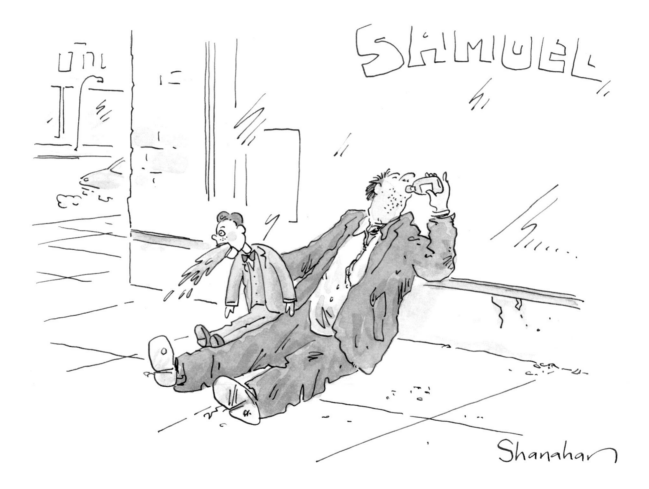

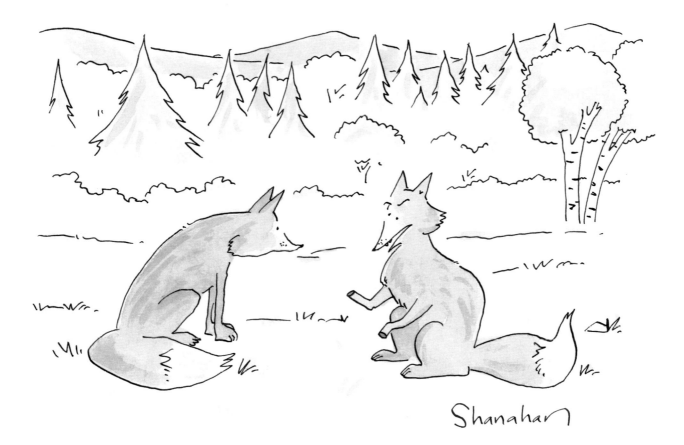

"I chewed the left one out of a trap; this one was pure nervous energy."

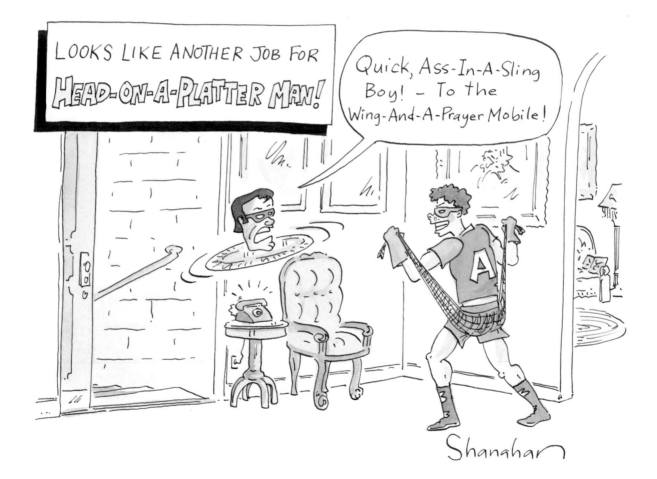

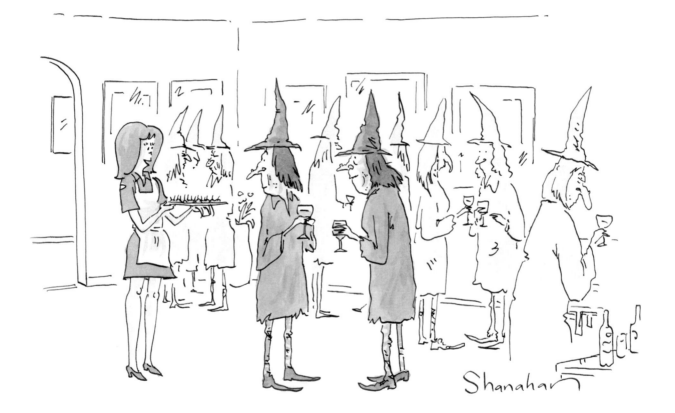

"Fetus?"

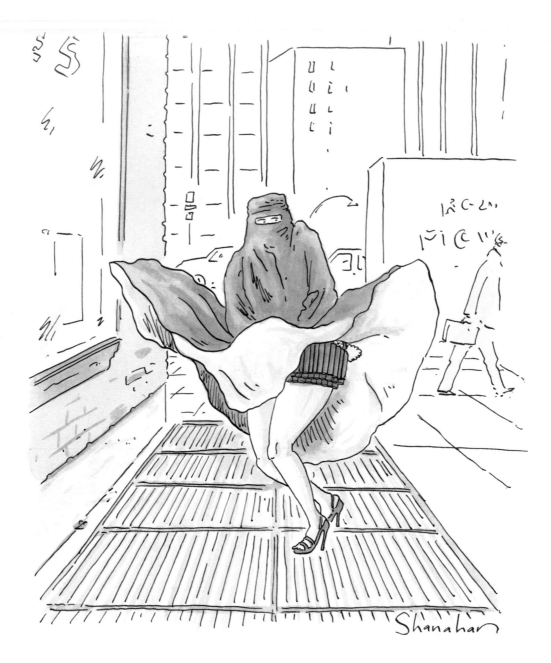

TOM
CHENEY

Self-portrait

How did you learn to draw that way? IT'S AN EVOLUTIONARY PROCESS. I DON'T DRAW THE SAME WAY I DID 30 YEARS AGO. MY VERY FIRST CARTOONS WERE DREADFUL!

My first cartoon . . .

DRAWN WITH A RED CRAYON AT THE AGE OF THREE ON MY MOTHER'S BEST COFFEE TABLE. IT WAS A LARGE OVAL EPITOMIZING MY COMPLETE LACK OF SKILL

Why cartooning? I WANTED TO BE SELF EMPLOYED, BUT I DIDN'T WANT TO ATTEND ROTARY CLUB MEETINGS.

When I'm not cartooning, I . . . LOOK FOR EVERY CONCEIVABLE EXCUSE TO AVOID ANY FORM OF MANUAL LABOR.

I admire . . . LENNY BRUCE, GEORGE CARLIN, AND RICHARD PRYOR

How has your work, or the way you work, changed over time? I'VE LEARNED TO TUNE MY DRAWING STYLE TO FIT MY SENSE OF HUMOR.

I'm not crazy about . . . OBESE CANNIBALS

Write a question to which you might answer "Absolutely not."
WOULD YOU LIKE TO ATTEND CATHOLIC SCHOOL AGAIN?

Most cartoonists I know are . . . PSYCHOTIC SERIAL KILLERS TRAPPED IN THE BODIES OF NORMAL, WELL ADJUSTED MODEL CITIZENS.

Number the following 20 items in order of their importance in your life (1 being the most important):

13 pancakes	9 light board
2 dictionary	15 sports
12 Band-Aids	8 tires
1 Wite-Out	20 politics
4 tropical fish	16 snow shovel
19 coffee	7 soap
3 music	17 ointments
10 dried fruit	5 swimsuit
11 ashtray	6 Google image search
14 soil	18 flashlight

Circle any items that you have never drawn:

roasted turkey	grim reaper	soup	gravestone
zebra	ball of yarn	fishing pole	lobster
piano	fried eggs	kite	ventriloquist dummy
silo (grain or missile)	rat	life preserver	noose
whale	pilgrim	badger	Amish person
back of a TV	ant	man with one leg	gun
cauldron	igloo	wiener dog	Mr. Potato Head
penguin	fire hydrant	windup toy	gorilla
army helmet	Tin Man	fruit hat	someone shaving
pig	trout	canoe	rabbi

When I'm having a hard time coming up with ideas, I . . .
START DOODLING. IT USUALLY GETS ME OUT OF A JAM, BUT THERE ARE DAYS WHEN THE HUMOR MUSE LOCKS HERSELF IN THE JOHN AND REFUSES TO COME OUT.

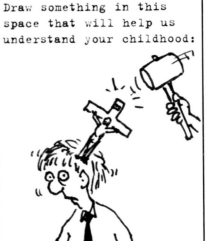
Draw something in this space that will help us understand your childhood:

What's the hardest part of cartooning?
TRYING NOT TO BE REDUNDANT, AND TRYING NOT TO BE REDUNDANT.

How do you deal with rejection? I REGARD IT AS THE NORM. SELLING WORK IS THE EXCEPTION. EVEN AFTER 30 YEARS IN THIS BUSINESS, I STILL THINK OF EACH CARTOON SALE AS A MIRACLE.

Where do you keep your rejected cartoons?
IN A FILE DROWER LABELED "ORPHANS."

My advice to BIN LADEN would be: REMEMBER WHAT HAPPENED TO JIMMY HOFFA.

Where do you see yourself in ten minutes? TRYING TO FIND THE ENVELOPE THIS QUESTIONNAIRE ARRIVED IN.

And lastly, what are some things that make you laugh and why?
PEOPLE WHO TAKE THEMSELVES VERY SERIOUSLY — IT SEEMS THE ONLY THING THEY HAVE GOING FOR THEM IS THEIR OWN IMPORTANCE, AND THAT, IN AND OF ITSELF, IS HYSTERICAL.

Diced apple is to Waldorf salad as WHITE-OUT is to my cartoons.

To me, [ink blot] — looks like MONDAY.

Circle the funniest word:
pants
slacks
trousers
(britches)

Circle the funniest bird:
chicken
penguin
pigeon
(tufted titmouse)

True or false?
T I spend more than three hours a day working on cartoons.
T I have always wanted to be a cartoonist.
T I have never lived in New York City.

I consider myself a **d** person.
(a) dog (b) cat (c) people (d) other CLOSET

I am afraid of **d**.
(a) abandonment (b) commitment (c) rejection (d) bears

For me cartooning is **2** % drawing and **98** % writing.

For office use only:

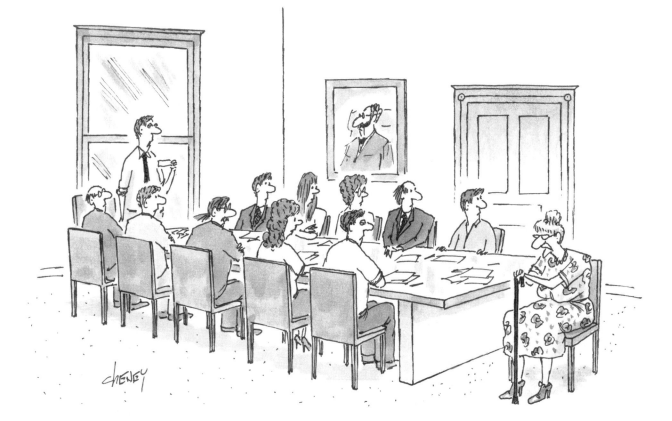

"We're going to be here awhile, folks—I count eleven 'not guilty's' and one 'fry the bastard.'"

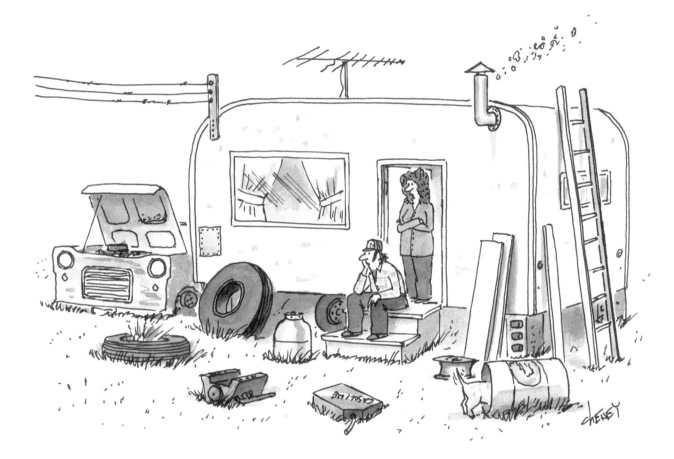

"*What do you say we just kick back and let things slide for a while?*"

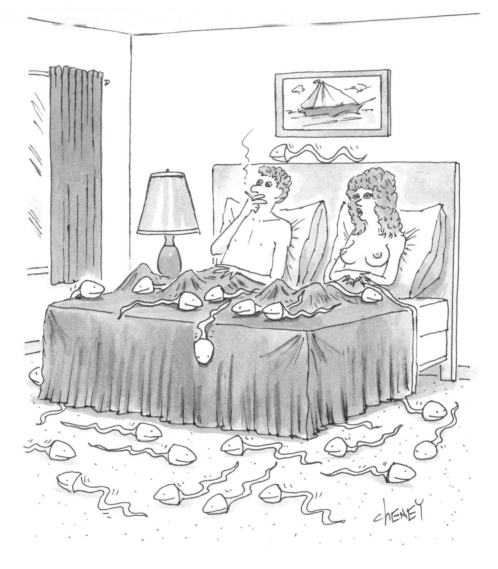

"So, how long have you been working at the plutonium plant?"

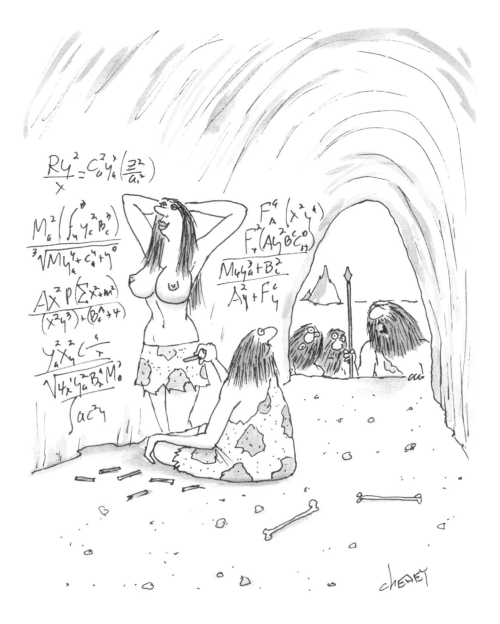

"The conservatives want you to clean it up, and the liberals want you to dumb it down."

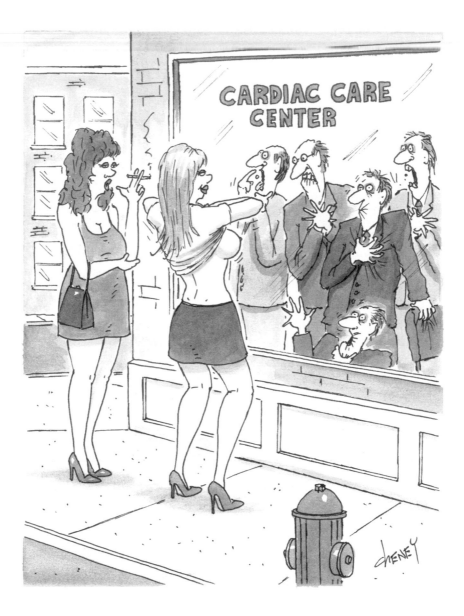

"You're one sick puppy, Nadine."

MICK
STEVENS

How did you learn to draw that way?

PABLO PICASSO.

My first cartoon . . .

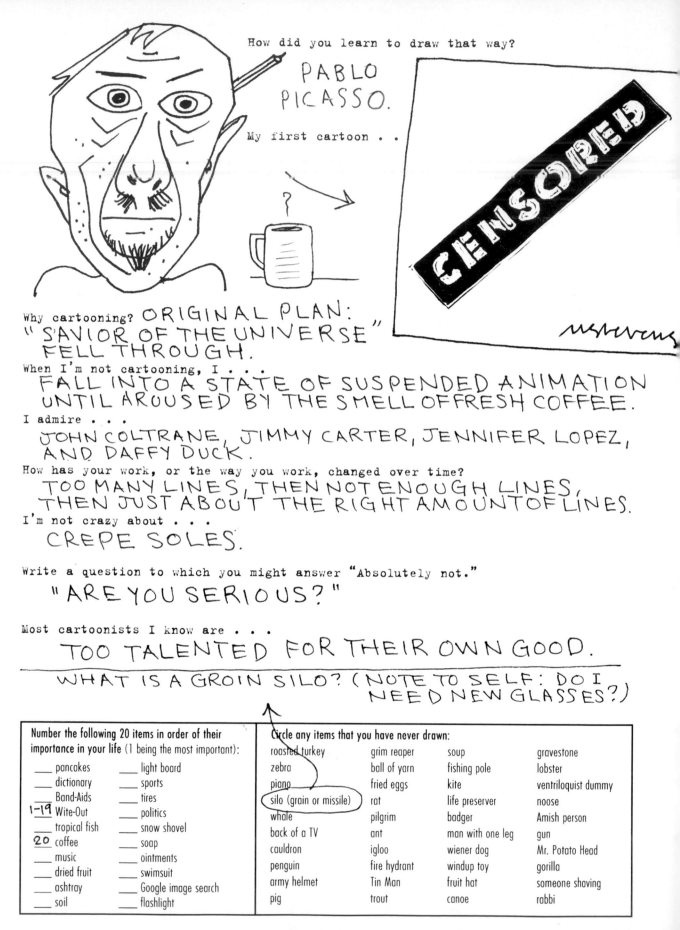

CENSORED

Why cartooning? ORIGINAL PLAN: "SAVIOR OF THE UNIVERSE" FELL THROUGH.

When I'm not cartooning, I . . . FALL INTO A STATE OF SUSPENDED ANIMATION UNTIL AROUSED BY THE SMELL OF FRESH COFFEE.

I admire . . . JOHN COLTRANE, JIMMY CARTER, JENNIFER LOPEZ, AND DAFFY DUCK.

How has your work, or the way you work, changed over time? TOO MANY LINES, THEN NOT ENOUGH LINES, THEN JUST ABOUT THE RIGHT AMOUNT OF LINES.

I'm not crazy about . . . CREPE SOLES.

Write a question to which you might answer "Absolutely not." "ARE YOU SERIOUS?"

Most cartoonists I know are . . . TOO TALENTED FOR THEIR OWN GOOD.

WHAT IS A GROIN SILO? (NOTE TO SELF: DO I NEED NEW GLASSES?)

Number the following 20 items in order of their importance in your life (1 being the most important):	
___ pancakes	___ light board
___ dictionary	___ sports
___ Band-Aids	___ tires
1-19 Wite-Out	___ politics
___ tropical fish	___ snow shovel
20 coffee	___ soap
___ music	___ ointments
___ dried fruit	___ swimsuit
___ ashtray	___ Google image search
___ soil	___ flashlight

Circle any items that you have never drawn:

roasted turkey	grim reaper	soup	gravestone
zebra	ball of yarn	fishing pole	lobster
piano	fried eggs	kite	ventriloquist dummy
silo (grain or missile)	rat	life preserver	noose
whale	pilgrim	badger	Amish person
back of a TV	ant	man with one leg	gun
cauldron	igloo	wiener dog	Mr. Potato Head
penguin	fire hydrant	windup toy	gorilla
army helmet	Tin Man	fruit hat	someone shaving
pig	trout	canoe	rabbi

When I'm having a hard time coming up with ideas, I . . .

LOOK IN THE REFRIGERATOR.

Draw something in this space that will help us understand your childhood:

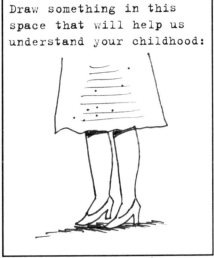

What's the hardest part of cartooning?

FILLING UP ALL THE WHITE SPACE.

How do you deal with rejection?

RANT. RAVE. SHAKE MY FIST AT GOD. THROW THE PHONE ACROSS THE ROOM.

Where do you keep your rejected cartoons?

I'M SUPPOSED TO KEEP MY REJECTED CARTOONS? UH-OH.

My advice to MYSELF would be:

IN FUTURE, KEEP MY REJECTED CARTOONS.

Where do you see yourself in ten minutes?

STILL PONDERING THIS QUESTION.

And lastly, what are some things that make you laugh and why?

THE HUMAN CONDITION, THE STATE OF THE UNION, PRESIDENTIAL POLITICS... BECAUSE IT'S NOT MANLY TO CRY.

(SORRY, I CAN'T ANSWER THIS QUESTION. IT APPEARS SOMEONE HAS SPILLED SOMETHING ON THE QUESTIONNAIRE.)

Diced apple is to Waldorf salad as __WALDORF SALAD__ is to my cartoons.

To me,

looks like

_____ .

Circle the funniest word:
pants
slacks
trousers
britches
(LEOTARDS)

Circle the funniest bird:
chicken
penguin
pigeon
tufted titmouse
(HIPPO)

True or false?
__T__ I spend more than three hours a day working on cartoons.*
__F__ I have always wanted to be a cartoonist.* (*JUST KIDDING.)
__T__ I have never lived in New York City.*

I consider myself a (d) person.
(a) dog (b) cat (c) people (d) other _____

I am afraid of __ANSWERING THIS QUESTION__
(a) abandonment (b) commitment (c) rejection (d) bears

For office use only:

For me cartooning is __100__% drawing and __200__% writing.

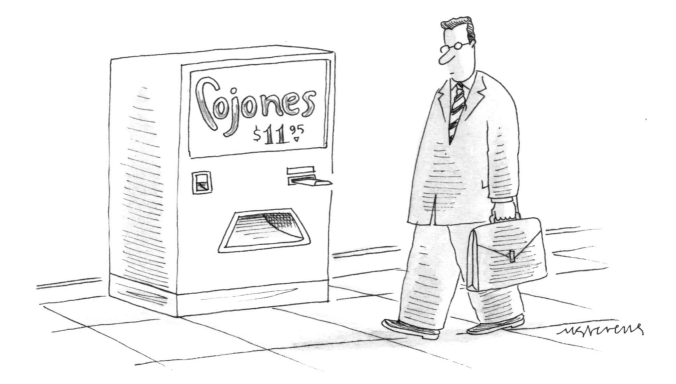

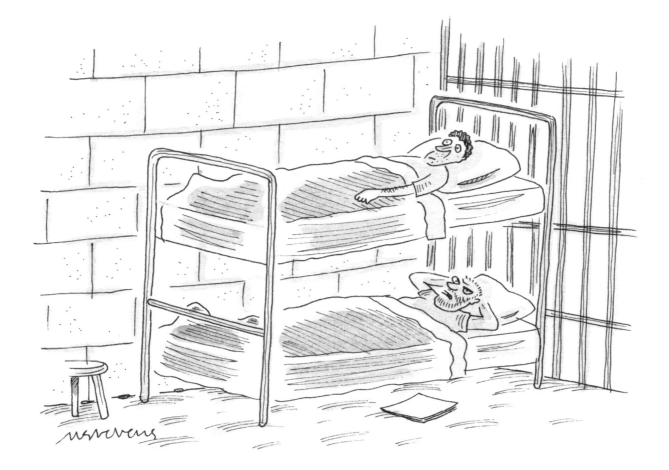

"I'm in for killing a guy for snoring."

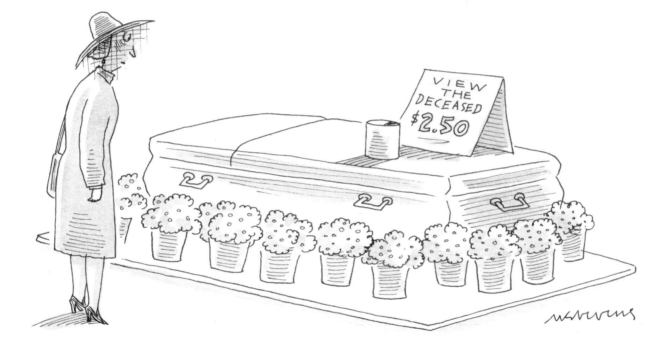

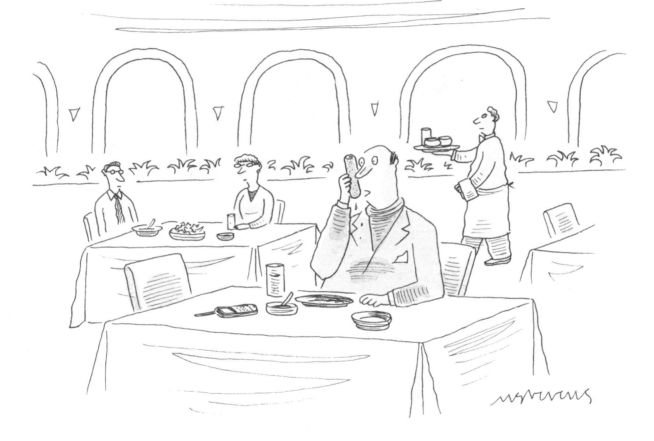

"Sorry about the reception, Lou. I grabbed my enchilada by mistake."

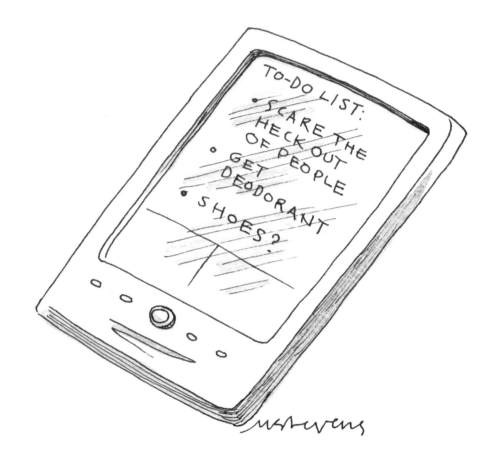

MORT
GERBERG

Self-portrait

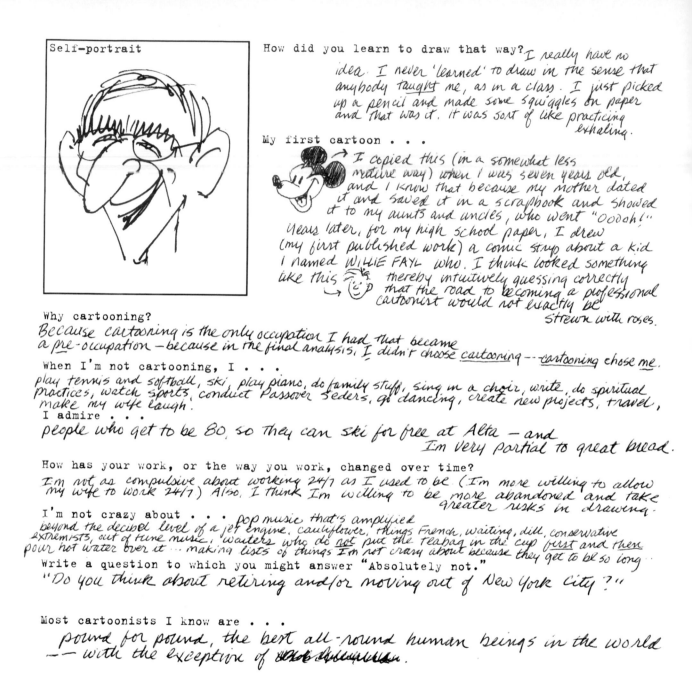

How did you learn to draw that way? I really have no idea. I never 'learned' to draw in the sense that anybody taught me, as in a class. I just picked up a pencil and made some squiggles on paper and that was it. It was sort of like practicing exhaling.

My first cartoon . . .

→ I copied this (in a somewhat less mature way) when I was seven years old, and I know that because my mother dated it and saved it in a scrapbook and showed it to my aunts and uncles, who went "Ooooh!" Years later, for my high school paper, I drew (my first published work) a comic strip about a kid I named WILLIE FAYL who. I think looked something like this → thereby intuitively guessing correctly that the road to becoming a professional cartoonist would not exactly be strewn with roses.

Why cartooning?
Because cartooning is the only occupation I had that became a pre-occupation — because in the final analysis, I didn't choose cartooning -- cartooning chose me.

When I'm not cartooning, I . . .
play tennis and softball, ski, play piano, do family stuff, sing in a choir, write, do spiritual practices, watch sports, conduct Passover seders, go dancing, create new projects, travel, make my wife laugh.

I admire . . .
people who get to be 80, so they can ski for free at Alta — and I'm very partial to great bread.

How has your work, or the way you work, changed over time?
I'm not as compulsive about working 24/7 as I used to be (I'm more willing to allow my wife to work 24/7) Also, I think I'm willing to be more abandoned and take greater risks in drawing.

I'm not crazy about . . . pop music that's amplified beyond the decibel level of a jet engine, cauliflower, things French, waiting, dill, conservative extremists, out of tune music, waiters who do not put the teabag in the cup first and then pour hot water over it ... making lists of things I'm not crazy about because they get to be so long

Write a question to which you might answer "Absolutely not."
"Do you think about retiring and/or moving out of New York City ?"

Most cartoonists I know are . . .
pound for pound, the best all-round human beings in the world — with the exception of ~~that schmuck~~.

Number the following 20 items in order of their importance in your life (1 being the most important):	
3 pancakes	16 light board
5 dictionary	1 sports
11 Band-Aids	19 tires
6 Wite-Out	4 politics
18 tropical fish	17 snow shovel
10 coffee	8 soap
2 music	15 ointments
14 dried fruit	9 swimsuit
20 ashtray	7 Google image search
13 soil	12 flashlight

Circle any items that you have never drawn:

roasted turkey	grim reaper	soup	gravestone
zebra	ball of yarn	fishing pole	lobster
piano	fried eggs	kite	ventriloquist dummy
silo (grain or missile)	rat	life preserver	noose
whale	pilgrim	(badger)	Amish person
back of a TV	ant	man with one leg	gun
cauldron	igloo	wiener dog	Mr. Potato Head
penguin	fire hydrant	windup toy	gorilla
army helmet	Tin Man	fruit hat	someone shaving
pig	(trout)	canoe	rabbi

too many bones in it

unless that's another name for a beaver.

When I'm having a hard time coming up with ideas, I . . .
I kvetch to my wife about how hard a time I'm
having coming up with ideas — then all day
I read the paper, nap, eat, take a walk, play
the piano, watch ball games on TV until it's
after midnight when, just as I'm starting to
zonk out, half asleep, I get that first idea.
What's the hardest part of cartooning?
Selling it

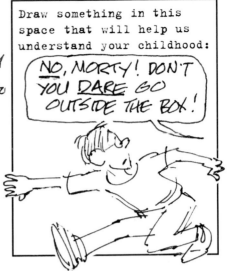

Draw something in this space that will help us understand your childhood:

NO, MORTY! DON'T YOU DARE GO OUTSIDE THE BOX!

How do you deal with rejection?
I try to remember that my wife, the
career counsellor ~~feature~~ keeps telling me
that I am not my work — but I keep
forgetting that.

Where do you keep your rejected cartoons?
There is no such thing as a rejected cartoon—
it is simply an idea whose time has yet to come.

My advice to __my daughter__ would be: to choose
something to do in your life that makes you happy,
and if that stops making you happy, choose to do something else.

Where do you see yourself in ten minutes?
Probably back inside my own head.

And lastly, what are some things that make you laugh and why?
I can't name them because I never know in advance what
they might be — they're 'things' I see or hear in any
random moment, and because, like most cartoonists, my head
is wired weirdly, I simply experience them as 'funny'.

I probably always was one, right from the
start, but it took years before I allowed
myself to be one

Diced apple is to Waldorf salad as healthy irony is to my cartoons.	Circle the funniest word: (pants) slacks trousers britches	True or false? F I spend more than three hours a day working on cartoons. TF I have always wanted to be a cartoonist. F I have never lived in New York City.
To me, [ink blot] looks like a carefully-drawn ink blot	Circle the funniest bird: (chicken) penguin pigeon tufted titmouse	I consider myself a thin person. (a) dog (b) cat (c) people (d) other _____
		I am afraid of telling you what I'm afraid of. (a) abandonment (b) commitment (c) rejection (d) bears
		For me cartooning is 50 % drawing and 65 % writing.

For office use only:

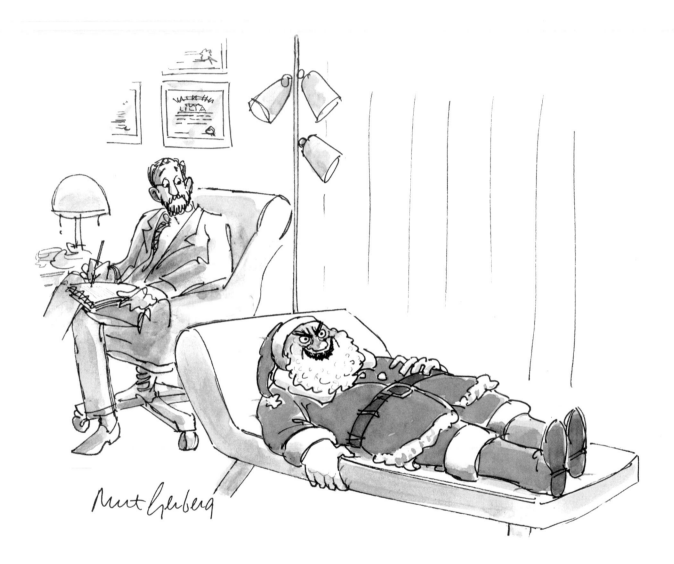

"Lately I've had uncontrollable cravings for venison."

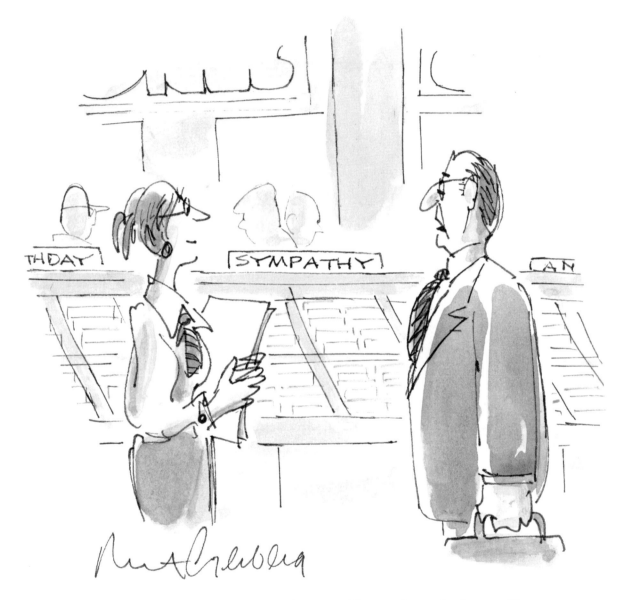

"I'm looking for a card that says 'Sorry about the herpes.'"

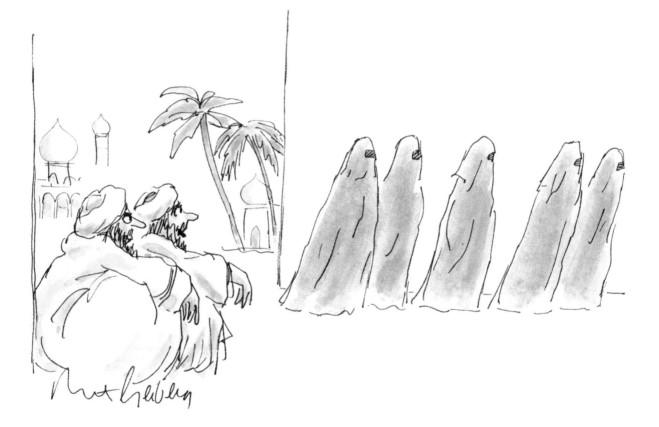

"I'm dating the good-looking one."

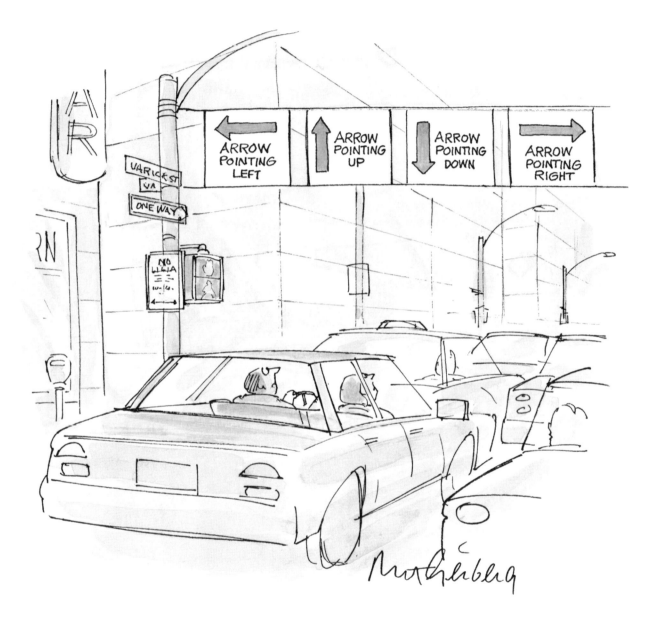

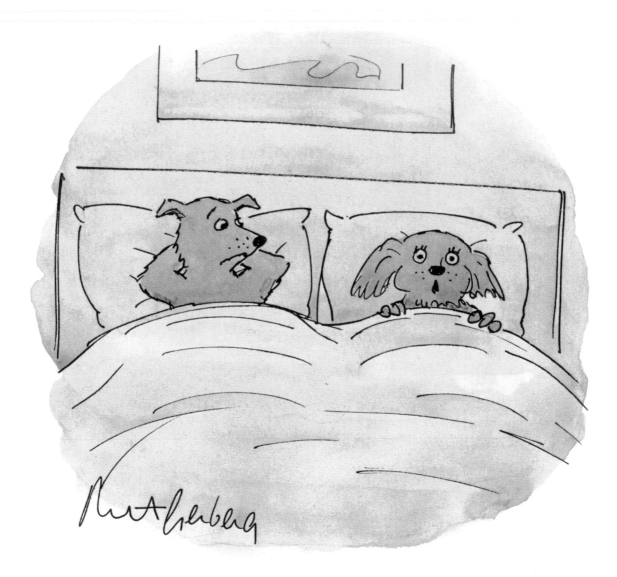

"No, no—it was great. It's just that sometime I'd like to try it missionary style."

MICHAEL
CRAWFORD

Self-portrait

How did you learn to draw that way?

RIDING THE ① TRAIN.

My first cartoon . . .

SOLD FOR FITTY BUCKS.

Why cartooning? MY PARENTS WOULDN'T LET ME BECOME A DOCTOR.

When I'm not cartooning, I . . .

PRACTICE INTERNAL MEDICINE.

I admire . . .

PEOPLE WHO MIND THEIR OWN BEESWAY.

How has your work, or the way you work, changed over time?

I HOPE TO GAWD! DON'T YOU?

I'm not crazy about . . .

NOSY PARKERS.

Write a question to which you might answer "Absolutely not."

"WOULD YOU LIKE TO SUBLET MY APARTMENT ON THE SUN?"

Most cartoonists I know are . . .

COMPLETE STRANGERS TO ME.

Number the following 20 items in order of their importance in your life (1 being the most important):

_____ pancakes
_____ dictionary
_____ Band-Aids
_____ Wite-Out
_____ tropical fish
_____ coffee
_____ music
_____ dried fruit
_____ ashtray
_____ soil
_____ light board
_____ sports
_____ tires
_____ politics
_____ snow shovel
_____ soap
_____ ointments
_____ swimsuit
_____ Google image search
_____ flashlight

SORRY BUT NOTHING HERE OF ANY IMPORTANCE

Circle any items that you have never drawn:

roasted turkey	grim reaper	soup	gravestone
zebra	ball of yarn	fishing pole	lobster
piano	fried eggs	kite	ventriloquist dummy
silo (grain or missile)	rat	life preserver	noose
whale	pilgrim	badger	Amish person
back of a TV	ant	man with one leg	gun
cauldron	igloo	wiener dog	Mr. Potato Head
penguin	fire hydrant	windup toy	gorilla
army helmet	Tin Man	fruit hat	someone shaving
pig	trout	canoe	rabbi

When I'm having a hard time coming up with ideas, I . . .

HOP ON THE Ⓐ TRAIN, NAKED.

Draw something in this space that will help us understand your childhood:

What's the hardest part of cartooning?

WAITING TO GET PAID.

How do you deal with rejection?

I JUST KEEP PINCHING MYSELF!

WHAT ^ DO WITH
Where do you ~~keep~~ your rejected cartoons?

RE-SUB THEM IN 6 MOS. THEY SELL LIKE HOTCAKES!

My advice to _____ You _____ would be:

BUY THIS BOOK.

Where do you see yourself in ten minutes?

I NEVER MAKE PLANS.

And lastly, what are some things that make you laugh and why?

TAKEN A WALK DOWN 8TH AVE LATELY?

Diced apple is to Waldorf salad as _lipstick_ is to my cartoons.	Circle the funniest word:	True or false?
	(pants)	24̶ T I spend more than ~~three hours~~ a day working on cartoons.
To me, ⬛— looks like PARTLY INKY	slacks trousers britches	NEVER T I have ~~always wanted~~ to be a cartoonist. T I have never lived in ~~New York City.~~ Brooklyn
	Circle the funniest bird:	I consider myself a _d_ person. (a) dog (b) cat (c) people (d·other) Sturgeon
	chicken (penguin) pigeon tufted titmouse	I am afraid of tedium (a) abandonment (b) commitment (c) rejection (d) bears
		For me cartooning is _?_ % drawing and _?_ % writing.

For office use only:

"*Going to be long over there, Mr. Happy? I need to get my casserole in.*"

"Give me a hint. I'm sleeping with a lot of lobbyists."

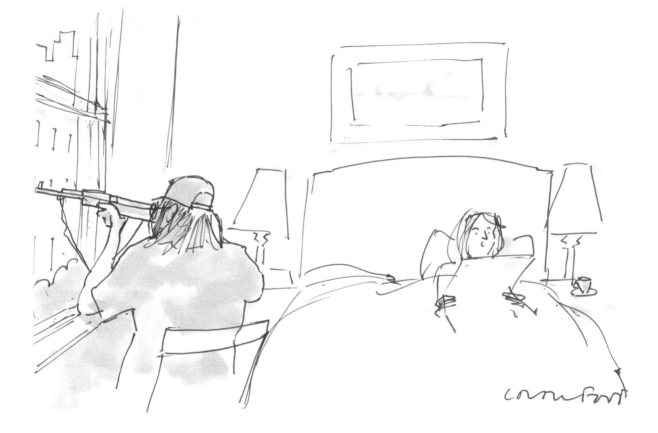

"I thought you liked hip-hop."

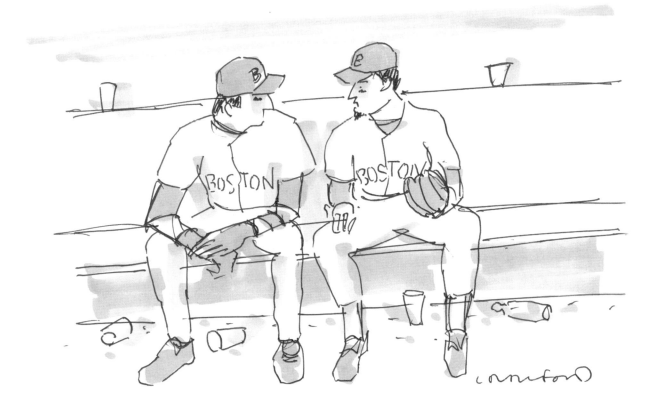

"Hookers? Tomorrow? I thought we were doing the Guggenheim."

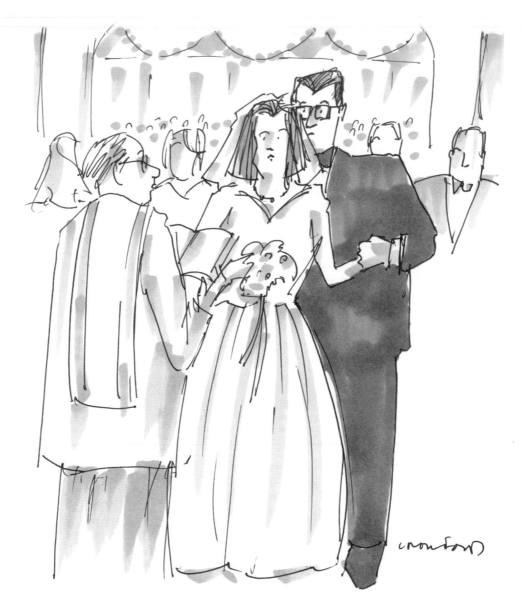

"... until death do you a favor."

P.C.
VEY

Self-portrait

How did you learn to draw that way?

BY MISTAKE.

My first cartoon . . .

VERY MUCH LIKE THE FOUR THOUSAND FIVE HUNDRED AND FIFTY-SIXTH ONE, ONLY OLDER.

Why cartooning?

SOMEBODY HAS TO DO IT.

When I'm not cartooning, I . . .

AM AVOIDING THINGS.

I admire . . .

THE VIBRANCY OF PEAS AND CARROTS.

How has your work, or the way you work, changed over time?

RATHER THAN SLAVE OVER IT I LABOR OVER IT.

I'm not crazy about . . .

THE PRICE OF WATERCOLOR PAPER.

Write a question to which you might answer "Absolutely not."

WOULD YOU MELT A POLAR ICE CAP FOR CASH?

Most cartoonists I know are . . .

OUT OF TOWN

Number the following 20 items in order of their importance in your life (1 being the most important):	
1 pancakes	_11_ light board
2 dictionary	_12_ sports
3 Band-Aids	_13_ tires
4 Wite-Out	_14_ politics
5 tropical fish	_15_ snow shovel
6 coffee	_16_ soap
7 music	_17_ ointments
8 dried fruit	_18_ swimsuit
9 ashtray	_19_ Google image search
10 soil	_20_ flashlight

Circle any items that you have never drawn:

roasted turkey	grim reaper	soup	gravestone
zebra	ball of yarn	fishing pole	lobster
piano	fried eggs	kite	ventriloquist dummy
silo (grain or missile)	rat	life preserver	noose
whale	pilgrim	badger	(Amish person)
back of a TV	ant	man with one leg	gun
cauldron	igloo	wiener dog	Mr. Potato Head
penguin	fire hydrant	windup toy	gorilla
army helmet	Tin Man	fruit hat	someone shaving
pig	trout	canoe	rabbi

When I'm having a hard time coming up with ideas, I . . .

WALK THROUGH A PLATE GLASS WINDOW.

What's the hardest part of cartooning?

WALKING THROUGH PLATE GLASS WINDOWS.

Draw something in this space that will help us understand your childhood:

How do you deal with rejection?

IN VERY COLORFUL WAYS.

Where do you keep your rejected cartoons?

IN A TIN BOX WITH KEROSENE SOAKED RAGS.

My advice to ___MY CAT___ would be:

START OVER.

Where do you see yourself in ten minutes?

STILL FILLING OUT THIS QUESTIONNAIRE.

And lastly, what are some things that make you laugh and why?

LONG WALKS ON THE BEACH, FINE WINE AND SUNSETS.

IF I DON'T LAUGH AT THEM WHO WILL?

Diced apple is to Waldorf salad as ___INK___ is to my cartoons. To me, looks like ___INK___	Circle the funniest word: pants slacks trousers (britches) Circle the funniest bird: chicken penguin pigeon (tufted titmouse)	True or false? __T__ I spend more than three hours a day working on cartoons. __T__ I have always wanted to be a cartoonist. __F__ I have never lived in New York City. I consider myself a __D__ person. (a) dog (b) cat (c) people (d) other ___MICROBIAL___ I am afraid of __D__ . (a) abandonment (b) commitment (c) rejection (d) bears For me cartooning is __49__% drawing and __51__% writing.

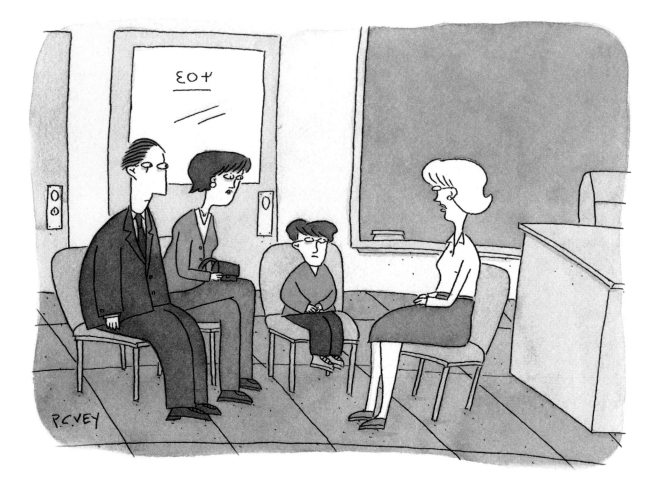

"He's at that awkward age when he tells his teachers
valuable information about his parents."

"These stem cells taste funny."

"If you ask me, Roger has the completely wrong attitude about gall bladder surgery."

"It's something I brought back from the doctor."

WOODCHUCK RUN OVER BY A DUMP TRUCK

RACCOON RUN OVER BY A SEMI

SQU... RUN O... S.U.V.

P.C.VEY

ROADKILL ZOO

BARBARA
SMALLER

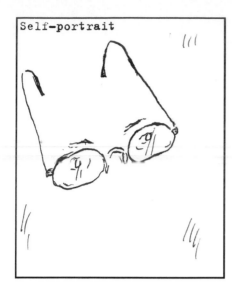

Self-portrait

How did you learn to draw that way?

by deduction, I start with an 8' by 12' block of limestone and take out everything that doesn't look like a cartoon.

My first cartoon . . .

was published in The National Lampoon during the latter part of the McKinley administration

Why cartooning?

can't type

When I'm not cartooning, I . . .

lie about on the couch, cradling the remote, thinking about how I should really be working on cartoons.

I admire . . .

Bob Mankoff, of course... oh, and Gandhi

How has your work, or the way you work, changed over time?

I used to use a 2B pencil but now that I'm successful I spring for the 4B

I'm not crazy about . . .

I'm not, I'm really not ... really .. I mean it

Write a question to which you might answer "Absolutely not."

Do you know the way to San Jose?

Most cartoonists I know are . . .

busy sublimating one thing or another

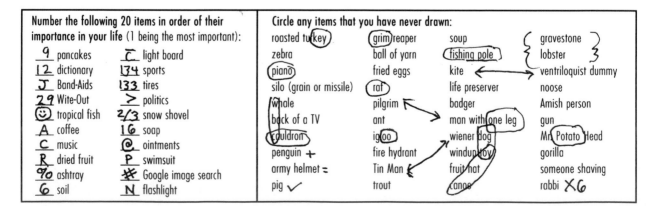

Number the following 20 items in order of their importance in your life (1 being the most important):

9 pancakes
12 dictionary
J Band-Aids
29 Wite-Out
☺ tropical fish
A coffee
C music
R dried fruit
90 ashtray
6 soil

⊂ light board
134 sports
133 tires
> politics
2/3 snow shovel
16 soap
@ ointments
P swimsuit
✳ Google image search
N flashlight

Circle any items that you have never drawn:

roasted turkey
zebra
piano
silo (grain or missile)
whale
back of a TV
cauldron
penguin +
army helmet =
pig ✓

grim reaper
ball of yarn
fried eggs
rat
pilgrim
ant
igloo
fire hydrant
Tin Man
trout

soup
fishing pole
kite
life preserver
badger
man with one leg
wiener dog
windup toy
fruit hat
canoe

gravestone
lobster
ventriloquist dummy
noose
Amish person
gun
Mr. Potato Head
gorilla
someone shaving
rabbi X6

When I'm having a hard time coming up with ideas, I . . .
I sit myself down at the computer and
Google up "ideas For New Yorker cartoons"
Thank goodness For technology.

What's the hardest part of cartooning?
Filing estimated taxes

How do you deal with rejection?
Hey, it just means more Cartoons for me.

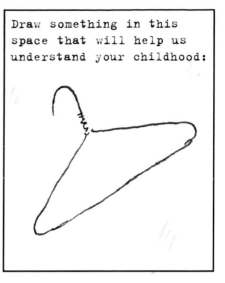
Draw something in this space that will help us understand your childhood:

Where do you keep your rejected cartoons?
they're filed under "Cartoons ahead of their time"

My advice to __the reader__ would be:
never take advice from a cartoonist (except, maybe about where
the best happy hours are)(well, maybe not best but the cheapest)

Where do you see yourself in ten minutes?
hopefully not still working on this questionnaire

And lastly, what are some things that make you laugh and why?
sex and death, sometimes I think sex is the funniest, and
sometimes I think it's the other way around.

Diced apple is to Waldorf salad as ___VIIIor___ is to my cartoons.	Circle the funniest word: pants (slacks) trousers britches	(True) or false? ___ I spend more than three hours ~~a day~~ working on cartoons. ___ I have ~~always~~ wanted to be a cartoonist. ___ I have ~~never~~ lived in New York City.	
To me, looks like the abyss, but not in a bad way.	Circle the funniest bird: (chicken) penguin pigeon tufted titmouse	I consider myself a ___ person. — yes I do ~~(a) dog~~ ~~(b) cat~~ ~~(c) people~~ (d) other ___	
		I am afraid yes, I am (a) abandonment (b) commitment (c) rejection (d) bears	For office use only:
		For me cartooning is __58.7__% drawing and __42.3__% writing.	

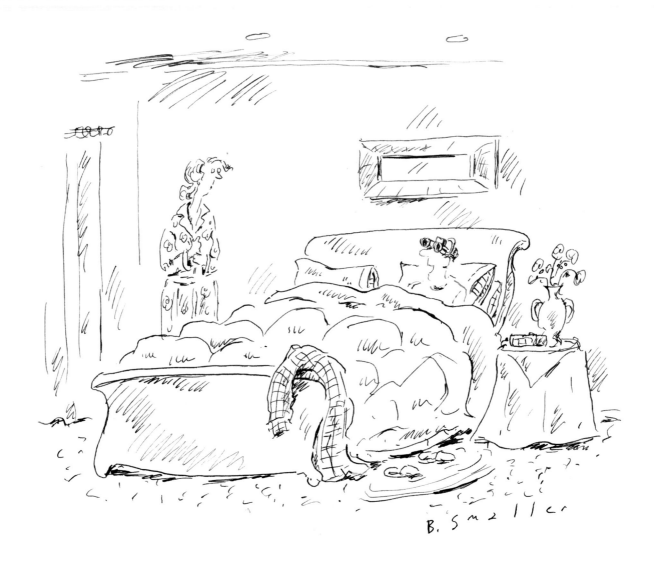

"They're night-vision goggles."

"I can afford to die or I can afford to be sick, but I can't afford to be sick and then die."

"No, Justin. I'm saving myself for college."

"Here's a lock of your hair, your first tooth, and your placenta."

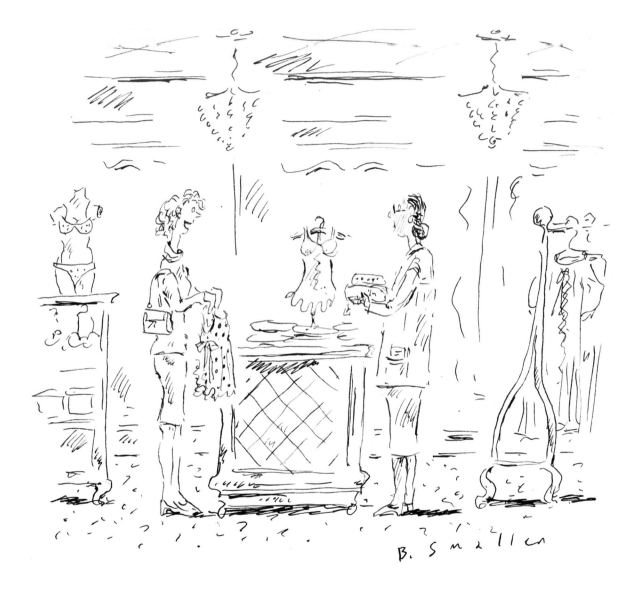

"Does it say 'I'm ovulating'?"

ARNIE
LEVIN

Self-portrait

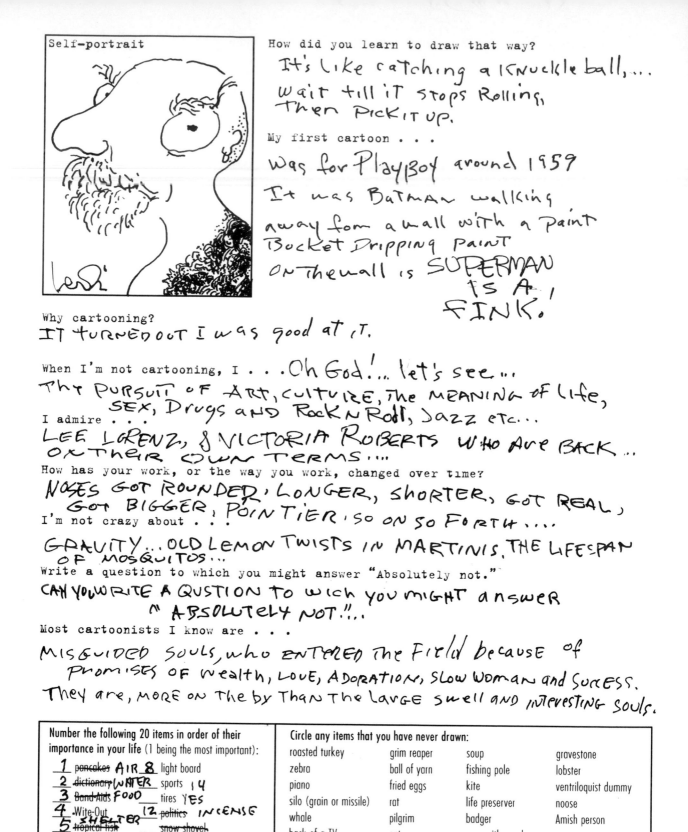

How did you learn to draw that way?
It's like catching a knuckle ball,... wait till it stops rolling, then pick it up.

My first cartoon . . .
was for Playboy around 1959. It was Batman walking away from a wall with a paint bucket dripping paint on the wall is SUPERMAN IS A FINK!

Why cartooning?
IT TURNED OUT I WAS good at iT.

When I'm not cartooning, I . . . Oh God!... let's see... The PURSUIT OF ART, CULTURE, THE MEANING OF LIFE, SEX, Drugs aND RocK N Roll, Jazz etc...

I admire . . .
LEE LORENZ, & VICTORIA ROBERTS WHO ARE BACK... ON THEIR OWN TERMS...

How has your work, or the way you work, changed over time?
NOSES GOT ROUNDED, LONGER, SHORTER, GOT REAL, GOT BIGGER, POINTIER, SO ON SO FORTH....

I'm not crazy about . . .
GRAVITY... OLD LEMON TWISTS IN MARTINIS, THE LIFESPAN OF MOSQUITOS...

Write a question to which you might answer "Absolutely not."
CAN YOU WRITE A QUSTION TO WICH YOU MIGHT ANSWER " ABSOLUTELY NOT."...

Most cartoonists I know are . . .
MISGUIDED SOULS, WHO ENTERED THE FIELD BECAUSE OF PROMISES OF WEALTH, LOVE, ADORATION, SLOW WOMAN AND SUCCESS. THEY are, MORE ON THE by THAN THE LARGE SWELL AND INTERESTING SOULS.

Number the following 20 items in order of their importance in your life (1 being the most important):

1 ~~pancakes~~ AIR _8_ light board
2 ~~dictionary~~ WATER sports _14_
3 ~~Band-Aids~~ FOOD tires YES
4 ~~Wite-Out~~ _12_ ~~politics~~ INCENSE
5 ~~tropical fish~~ SHELTER ___ ~~snow shovel~~
6 coffee _18_ soap _I GUESS..._
7 music _9_ ointments
16 ~~dried fruit~~ _13_ ~~swimsuit~~ ⊘
15 ~~ashtray~~ COFFEE _10_ ~~Google image search~~
12 soil _11_ ~~flashlight~~ MATCHES

Circle any items that you have never drawn:

roasted turkey	grim reaper	soup	gravestone
zebra	ball of yarn	fishing pole	lobster
piano	fried eggs	kite	ventriloquist dummy
silo (grain or missile)	rat	life preserver	noose
whale	pilgrim	badger	Amish person
back of a TV	ant	man with one leg	gun
cauldron	igloo	wiener dog	Mr. Potato Head
penguin	fire hydrant	windup toy	gorilla
army helmet	Tin Man	fruit hat	someone shaving
pig	trout	canoe	rabbi

When I'm having a hard time coming up with ideas, I . . .

What's the hardest part of cartooning?

SHIPPING

How do you deal with rejection?

DENIAL - WONDER - REBUTTAL
COMPOSURE...

Where do you keep your rejected cartoons?
IN PLAIN SIGHT - STACKS OF THEM
EVERY SO OFTEN I HEAR ONE OF THEM SINGING "PUT ME IN COACH, I'm
READY TO PLAY...

My advice to ___BLANK___ would be: BLANK

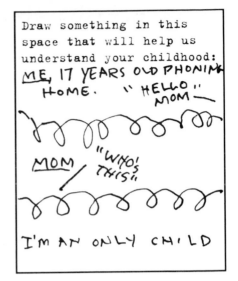

Draw something in this space that will help us understand your childhood:
ME, 17 YEARS OLD PHONING HOME. "HELLO"
MOM
MOM / "WHO'S THIS"
I'M AN ONLY CHILD

Where do you see yourself in ten minutes?
TRYING TO MAIL THIS...

And lastly, what are some things that make you laugh and why?
SOMEONE CARVING A PUMPKIN (a sadistic LAUGH)
AN EMAIL FROM A LAWYER IN HONGKONG, ASKING ME TO JOIN
IN on a SCHEME FOR Millions OF DOllARS...(JusT mAKES me HAPPY)
CURB YOUR ENTHUSIASM. (OUT LOUD)
A WHITE HOUSE PRESS CONFERENCE... (ANTICIPATED JOY)
OVERHEARING DIALOGUE OF A POLICEMAN GIVING DIRECTIONS TO SOMEONE...
PUTTING MY UNDERWEAR ON BACKWARDS, UNINTENTIONAL GUFFAW...

Diced apple is to Waldorf salad as
A CONCEPT is to my cartoons.

To me,

[ink blot] —

looks like
COPY OF ONE I RECEIVED

Circle the funniest word:
(pants)
slacks
trousers
britches

Circle the funniest bird:
chicken
(penguin) !
(pigeon)
tufted titmouse

True or false?
F I spend more than three hours a day working on cartoons.
F I have always wanted to be a cartoonist.
F I have never lived in New York City.

I consider myself a _llllll_ person. !
(a) dog (b) cat (c) people (d) other _____

I am afraid of _D_ .
(a) abandonment (b) commitment (c) rejection (d) bears

For me cartooning is 86 % drawing and 15 % writing.

For office use only:

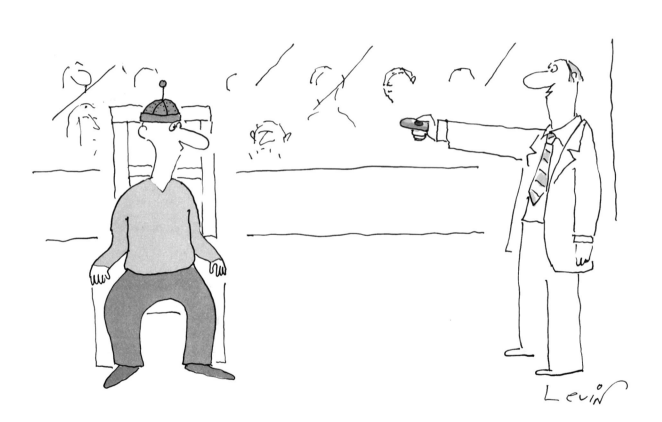

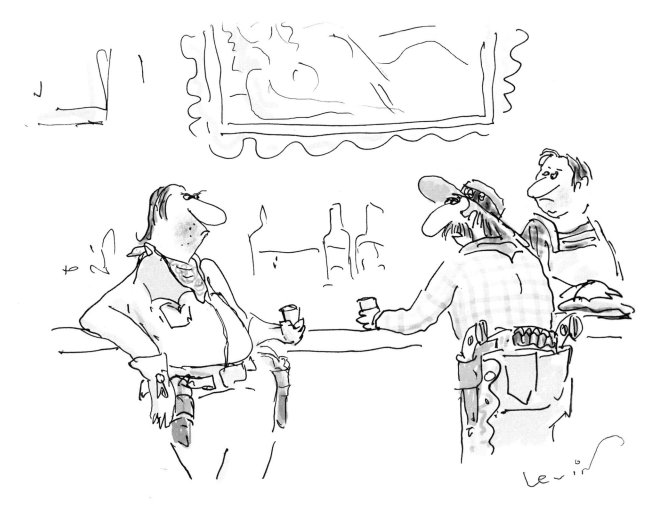

"*Perhaps I'm not hearing you right, stranger. Did you just call me 'cupcake'?*"

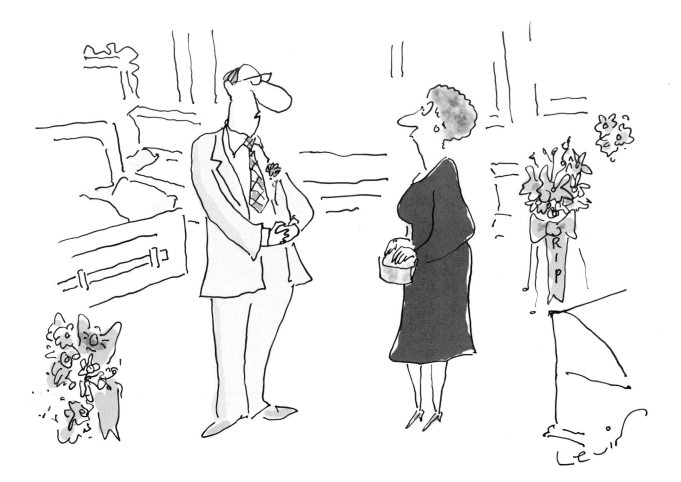

"Casket, coffin, or Tupperware?"

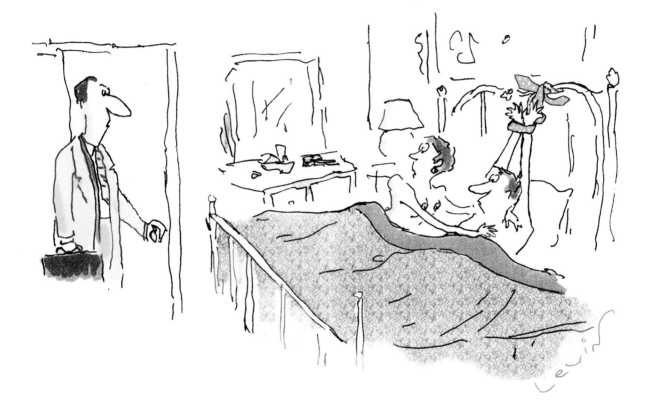

"My wife! My best tie!"

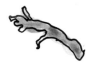
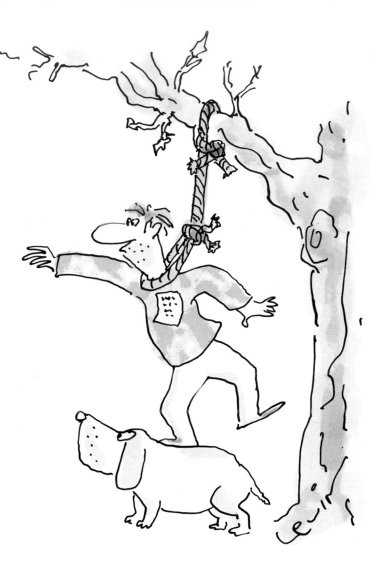

GAHAN
WILSON

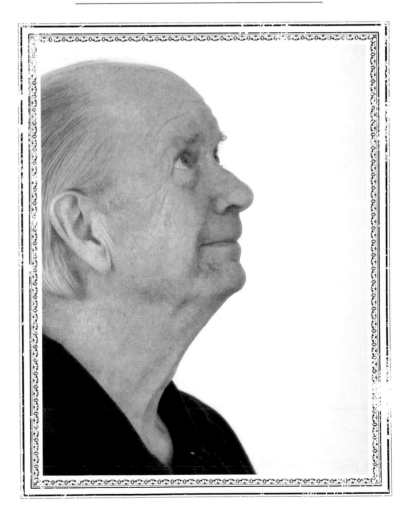

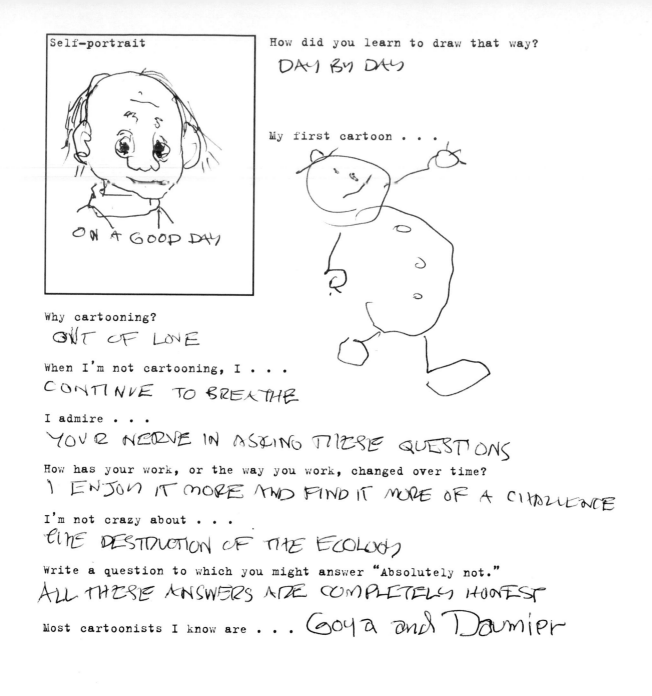

Self-portrait

ON A GOOD DAY

How did you learn to draw that way?
DAY BY DAY

My first cartoon . . .

Why cartooning?
OUT OF LOVE

When I'm not cartooning, I . . .
CONTINUE TO BREATHE

I admire . . .
YOUR NERVE IN ASKING THESE QUESTIONS

How has your work, or the way you work, changed over time?
I ENJOY IT MORE AND FIND IT MORE OF A CHALLENGE

I'm not crazy about . . .
THE DESTRUCTION OF THE ECOLOGY

Write a question to which you might answer "Absolutely not."
ALL THESE ANSWERS ARE COMPLETELY HONEST

Most cartoonists I know are . . . Goya and Daumier

Number the following 20 items in order of their importance in your life (1 being the most important):

6 pancakes 1 light board
2 dictionary ___ sports
7 Band-Aids ___ tires
___ Wite-Out ___ politics
___ tropical fish ___ snow shovel
4 coffee 3 soap
5 music ___ ointments
___ dried fruit ___ swimsuit
___ ashtray ___ Google image search
___ soil ___ flashlight

FROM HERE ON IT'S KIND OF A BLUR

Circle any items that you have never drawn:

roasted turkey	grim reaper	soup	gravestone
zebra	ball of yarn	fishing pole	lobster
piano	fried eggs	kite	ventriloquist dummy
silo (grain or missile)	rat	life preserver	noose
whale	pilgrim	badger	Amish person
back of a TV	ant	man with one leg	gun
cauldron	igloo	wiener dog	Mr. Potato Head
penguin	fire hydrant	windup toy	gorilla
army helmet	Tin Man	fruit hat	someone shaving
pig	trout	canoe	rabbi

I HAVE DRAWN ALL OF THESE

When I'm having a hard time coming up with ideas, I . . .

ARBITRARILY CHOOSE AND OBTECT OR NOTION AND STAY WITH IT UNTIL IT BECOMES FUNNY

What's the hardest part of cartooning?

TRYING TO EXPLAIN IT

How do you deal with rejection?

I CONTINUE

Where do you keep your rejected cartoons?

IN A PILE FOR LATER ON

My advice to _____ would be: I HAVE NO IDEA WHAT THIS QUESTION'S TRYING TO SAY

Where do you see yourself in ten minutes?

TAKING THIS TO THE P.O.

And lastly, what are some things that make you laugh and why?

DEPENDING ON MY MOOD, JUST ABOUT ANYTHING. I WILL ADMIT THE LAUGHTER IS NOW AND THEN BITTER, BUT USUALLY IT'S NICE. SOMETIMES DOWNRIGHT JOYFUL.

Diced apple is to Waldorf salad as _____ is to my cartoons.	Circle the funniest word:	True or false?
	pants	T I spend more than three hours a day working on cartoons.
To me,	slacks	T I have always wanted to be a cartoonist.
[ink blot] looks like A CAREFULLY DRAWN INK BLOT	trousers	F I have never lived in New York City.
	britches	I consider myself a _a c b d_ person. (a) dog (b) cat (c) people (d) other _____
	Circle the funniest bird: chicken penguin pigeon (tufted titmouse)	I am afraid of _bears when in the wild and am_ (a) abandonment (b) commitment (c) rejection (d) bears
		For me cartooning is ___% drawing and ___% writing.

For office use only:

IT KEEPS CHANGING

"Well, you certainly were right about the power of prayer, dear!"

"Sorry—this was supposed to be a map of Peru!"

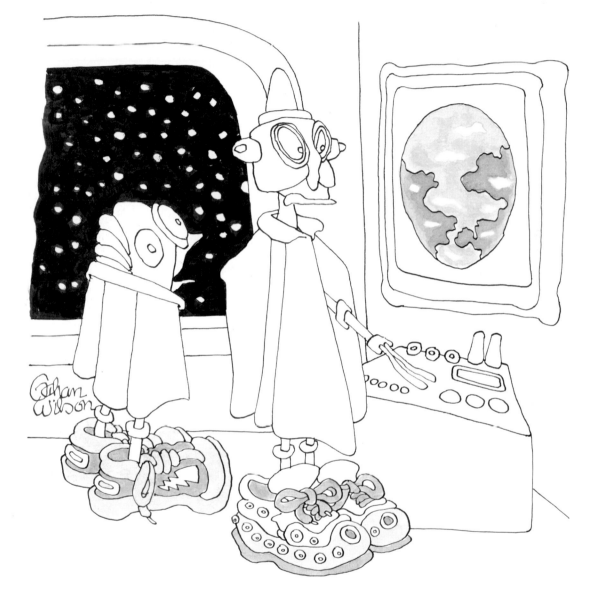

"But if we destroy the planet Earth, they'll stop making these great cheap shoes!"

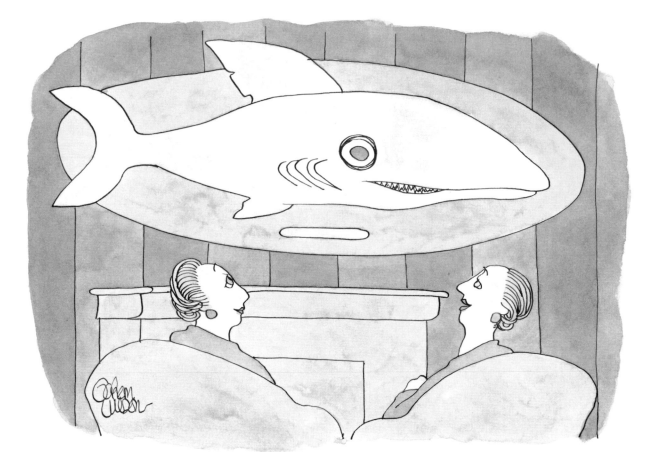

"I had it stuffed and mounted as a sentimental gesture since it was the one that ate most of Roger."

GLEN
Le LIEVRE

How did you learn to draw that way?

STEROIDS.

My first cartoon . . .

NEVER CALLS ME ANYMORE.

THIS SPACE IS EMPTY. SO HERE'S A PICTURE OF AN EASTER ISLAND STATUE GOING FOR A SWIM.

Why cartooning?

CLOONEY TURNED IT DOWN.

When I'm not cartooning, I . . .

REMAIN IN A STATE of CAT-LIKE READINESS.

I admire . . .

VAN GOGH. ANYONE WHO'D CUT OFF THEIR EAR AND SEND IT TO A PROSTITUTE IS A-OKAY IN MY BOOK.

How has your work, or the way you work, changed over time?

IT'S LOST MOST OF ITS HAIR AND ITS SEX DRIVE HAS DIMINISHED BY 50%.

I'm not crazy about . . .

SO I'M CRAZY NOW AM I?

Write a question to which you might answer "Absolutely not."

DID YOU JUST FART?

Most cartoonists I know are . . .

CAPABLE OF KILLING A MAN WITH THEIR BARE HANDS ——▶ MAN-IN-THE-STREET HANDS.

TYPICAL CARTOONIST (FEMALE)

Number the following 20 items in order of their importance in your life (1 being the most important):

1	pancakes	1	light board
1	dictionary	1	sports
1	Band-Aids	1	tires
1	Wite-Out	1	politics
1	tropical fish	1	snow shovel
1	coffee	1	soap
1	music	2	ointments
1	dried fruit	1	swimsuit
1	ashtray	1	Google image search
1	soil	1	flashlight

Circle any items that you have never drawn:

roasted turkey	grim reaper	soup	gravestone
zebra	ball of yarn	fishing pole	lobster
piano	fried eggs	kite	ventriloquist dummy
silo (grain or missile)	rat	life preserver	noose
whale	pilgrim	badger	Amish person
back of a TV	ant	man with one leg	gun
cauldron	igloo	wiener dog	Mr. Potato Head
penguin	fire hydrant	windup toy	gorilla
army helmet	Tin Man	fruit hat	someone shaving
pig	trout	canoe	rabbi

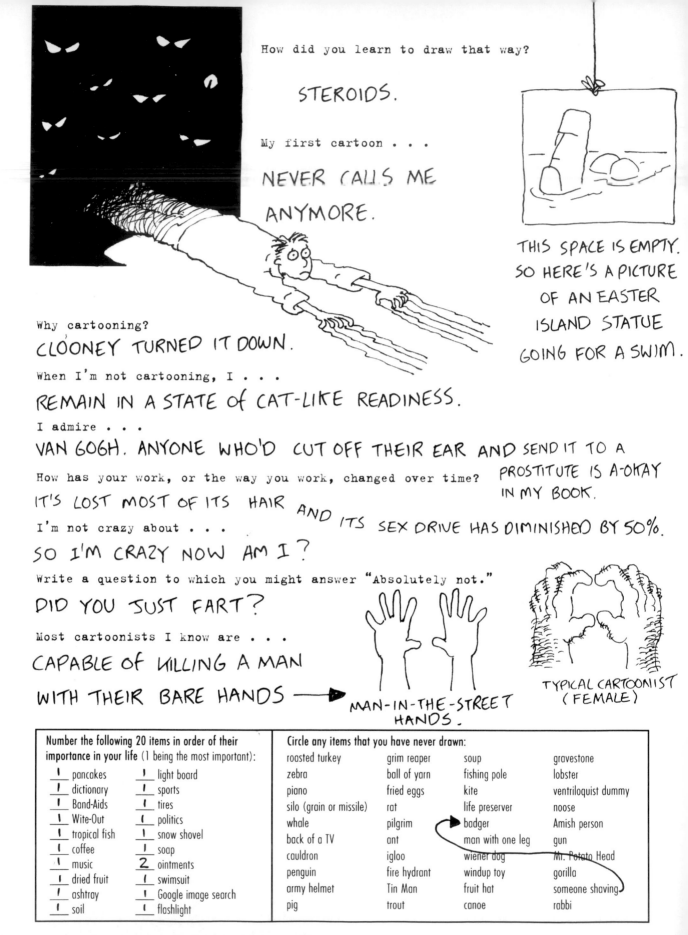

When I'm having a hard time coming up with ideas, I . . .

WILL BE SURE TO COME BACK TO THIS BOOK AND RIP-OFF THAT REALLY TERRIBLE EASTER ISLAND GAG.

Draw something in this space that will help us understand your childhood:

What's the hardest part of cartooning?

THE CLAVICLE.

How do you deal with rejection?

SACRIFICE A CHICKEN OVER THE MAGAZINE.

Where do you keep your rejected cartoons?

NEXT TO MY ENORMOUS HEN-HOUSE.

My advice to _A CHICKEN_ would be:

RUN!

Where do you see yourself in ten minutes?

STILL TRYING TO FIGURE OUT WHAT THE HELL THAT BLOT LOOKS LIKE...

And lastly, what are some things that make you laugh and why?

FEATHER ⇒ FOOT
TICKLES.

3/4" BEVIL IN EAR CANAL.
TICKLES.

DRINKING BIRD.
YOU DON'T WANT TO KNOW.

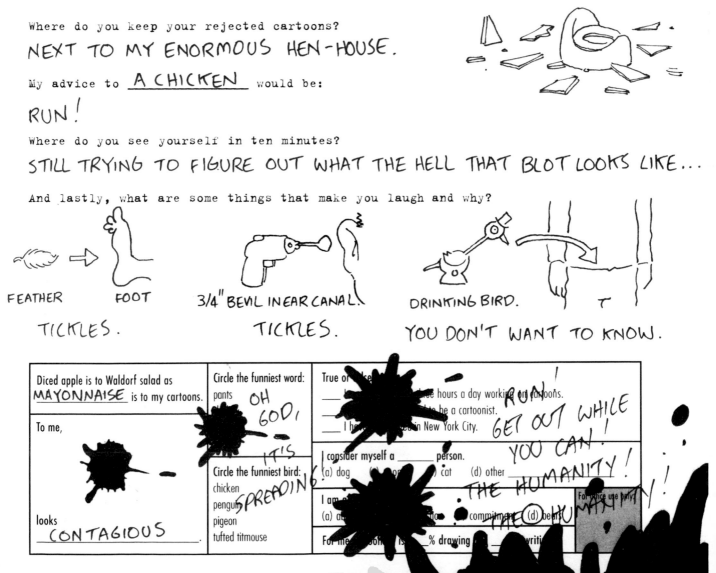

Diced apple is to Waldorf salad as **MAYONNAISE** is to my cartoons.

To me, looks _CONTAGIOUS_ .

Circle the funniest word: pants OH GOD, IT'S SPREADING!

Circle the funniest bird:
chicken
penguin
pigeon
tufted titmouse

True or false:

I consider myself a _____ person.
(a) dog cat (d) other _____

For office use only.

RUN! GET OUT WHILE YOU CAN! THE HUMANITY!

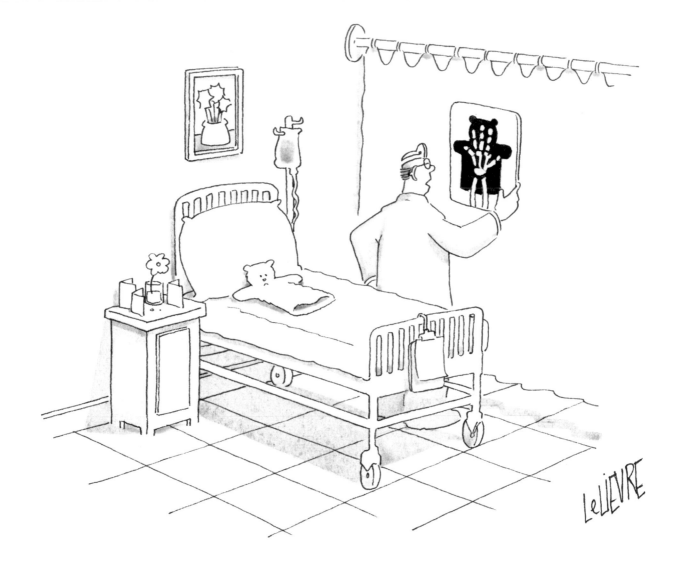

*"Well, we removed the growth, but the operation
has left you paralyzed from the neck down."*

"*You're lucky. I'm turning into my mother.*"

LeLIEVRE

"Lie to me again."

ALEX
GREGORY

Self-portrait

How did you learn to draw that way?

I spent twelve years in a Pakistani prison. The only drawing implements the guards allowed me were a Mac G4, a Wacom pen tablet, and Adobe Illustrator.

My first cartoon . . .

...was, sadly, intended to be a stunningly rendered photorealist portrait of a horse.

Why cartooning?

That's what I've been asking cartooning for years: *Why*?

When I'm not cartooning, I . . .

...spend time with my wife and children, read, eat, sleep, exercise, make love, travel, see friends, eat out, enjoy life... wait a minute...

I admire . . .

Nice buttocks, but I try not to be obvious about it. Sunglasses help.

How has your work, or the way you work, changed over time?

It's gotten more laborious and less instinctive. I've also learned to add extraneous details.

I'm not crazy about . . .

The false humility one finds all too often in this country's astronauts. I mean, when was the last time one of these clowns even made it out of the Earth's orbit?

Write a question to which you might answer "Absolutely not." "Absolutely?"

Most cartoonists I know are . . .

...noticeably taller than me. And <u>obsessed</u> with appearances.

Number the following 20 items in order of their importance in your life (1 being the most important):	
5 pancakes	2° light board
2 dictionary	15 sports
6 Band-Aids	13 tires
18 Wite-Out	10 politics
19 tropical fish	2° snow shovel
1 coffee	3 soap
2 music	7 ointments
4 dried fruit	11 swimsuit
2° ashtray	1 Google image search
14 soil	6 flashlight

Circle any items that you have never drawn:

roasted turkey	grim reaper	soup	gravestone
zebra	ball of yarn	fishing pole	lobster
piano	fried eggs	kite	ventriloquist dummy
silo (grain or missile)	rat	life preserver	noose
whale	pilgrim	badger	Amish person
back of a TV	ant	man with one leg	gun
cauldron	igloo	wiener dog	Mr. Potato Head
penguin	fire hydrant	windup toy	gorilla
army helmet	Tin Man	fruit hat	someone shaving
pig	trout	canoe	rabbi

When I'm having a hard time coming up with ideas, I . . .

Wait, I'm supposed to come up with
my own ideas? I think I may owe
my housekeeper a shitload of money.

Draw something in this space that will help us understand your childhood:

What's the hardest part of cartooning?

Getting the blood out of the grout
between the bathroom tiles.

How do you deal with rejection?

I remind myself that even though
she's really attractive, if my new
liver doesn't want to be a part of
my life, I'm better off without her.

Where do you keep your rejected cartoons?

I give them to the homeless. Nothing takes the edge off
an empty stomach like laughter.

My advice to _____ would be: "---------------."

Where do you see yourself in ten minutes?

Regretting what I did ten minutes ago.

And lastly, what are some things that make you laugh and why?

I am always amused by nunchucks. I can't recall ever hearing of a single incident where anyone has successfully used nunchucks to either defend himself or to attack someone else, yet they are illegal in three states. They can't be easily concealed, and pose as much of a danger to the weilder as to the target. Presumably, if nunchucks were in any way effective, all soldiers and cops would carry them. And yet, every day factories manufacture nunchucks. And every day some teenage boy covers his back and forearms in bruises in his futile quest to master the noble art of nunchuckery.

| Diced apple is to Waldorf salad as DICED APPLE is to my cartoons. | Circle the funniest word:
pants
slacks
trousers
britches | True or false?
F I spend more than three hours a day working on cartoons.
T I have always wanted to be a cartoonist.
F I have never lived in New York City. |
| To me,

looks like | Circle the funniest bird:
chicken
penguin
pigeon
tufted titmouse | I consider myself a __d__ person.
(a) dog (b) cat (c) people (d) other _____

I am afraid of _b+d_ . (commitment to bears)
(a) abandonment (b) commitment (c) rejection (d) bears

For me cartooning is _100_% drawing and _100_% writing. |

For office use only:

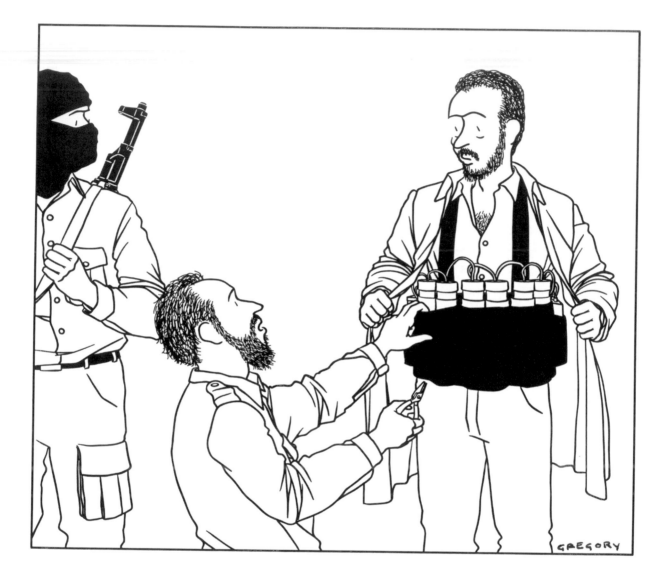

"Too snug?"

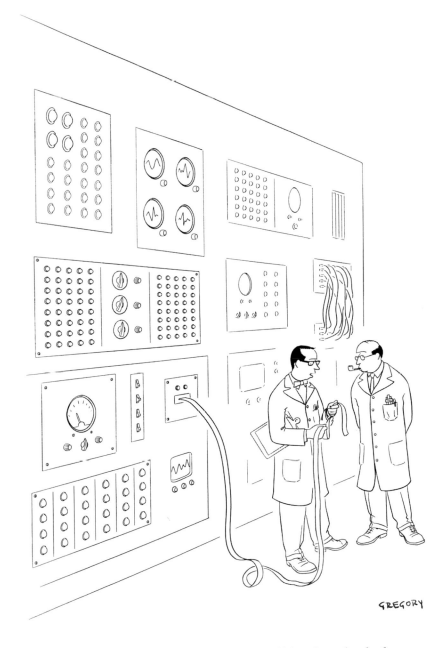

"*The results are impressive, but it'll be decades before we can transmit and receive pornography.*"

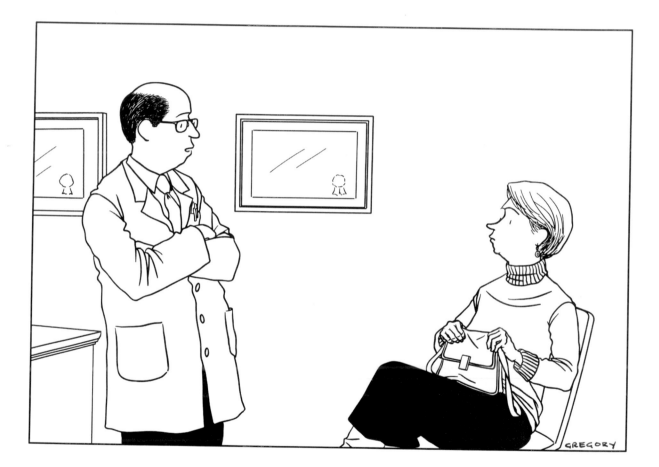

*"With the latest advances in cosmetic surgery, I can make
a fifty-five-year-old grandmother look like a thirty-five-year-old transsexual."*

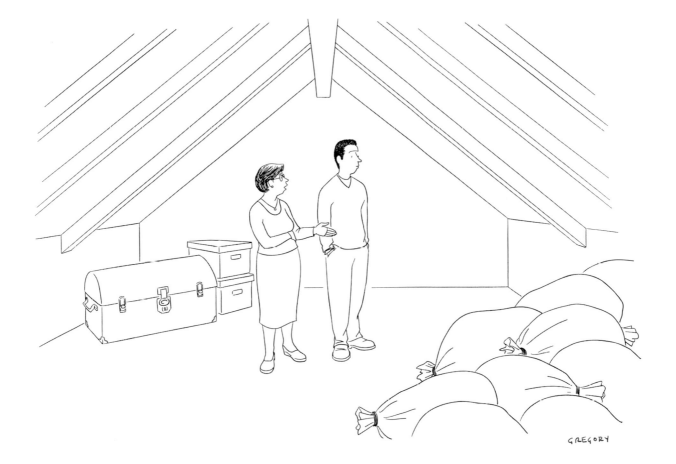

"We saved all your old diapers."

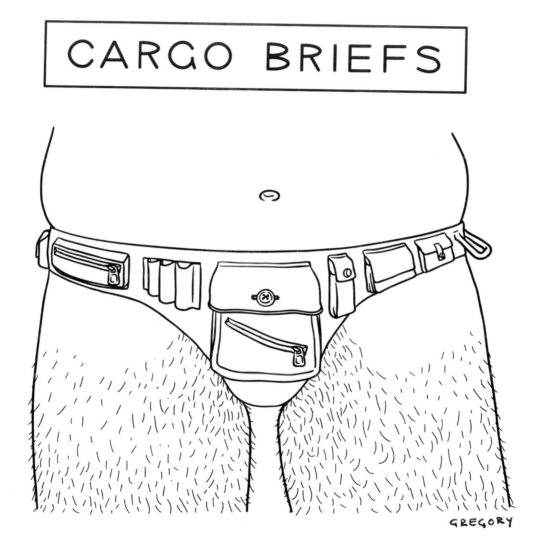

J.C.
DUFFY

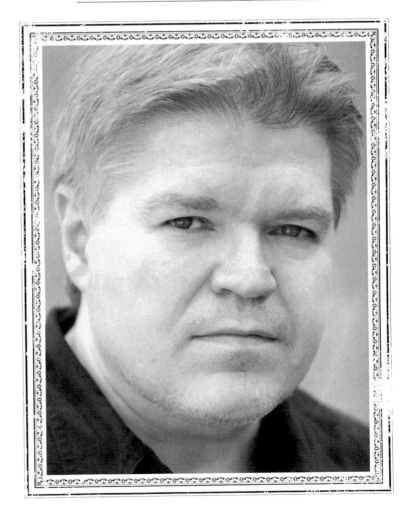

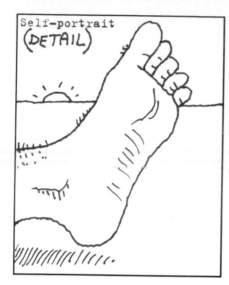

Self-portrait
(DETAIL)

How did you learn to draw that way?

ACTUALLY, I'VE ALWAYS AIMED FOR A KIND OF PHOTO-REALISM, BUT THIS IS WHAT COMES OUT.

My first cartoon . . .

I DON'T REMEMBER (I BARELY REMEMBER MY LAST CARTOON).

Why cartooning? BECAUSE IT'S THERE! (OR IS THAT MOUNTAIN-CLIMBING?)

When I'm not cartooning, I . . .
ROAM THE STREETS IN SEARCH OF ANSWERS TO LIFE'S MYSTERIES, BUT I SETTLE FOR A MARTINI.

I admire . . .
THE DIMPLES BEHIND A WOMAN'S KNEES, AND GANDHI.

How has your work, or the way you work, changed over time?
IT'S GOTTEN SHAKIER AND LARGER, AS I'VE GOTTEN OLDER AND BLINDER. THANKS FOR ASKING.

I'm not crazy about . . .
QUESTIONNAIRES!

Write a question to which you might answer "Absolutely not."
"SPARE CHANGE?"

Most cartoonists I know are . . .
DISTURBED INDIVIDUALS MASQUERADING BEHIND A CLOAK OF NORMALCY.

Number the following 20 items in order of their importance in your life (1 being the most important):	
8 pancakes	17 light board
3 dictionary	6 sports
13 Band-Aids	11 tires
4 Wite-Out	10 politics
16 tropical fish	18 snow shovel
2 coffee	9 soap
1 music	14 ointments
12 dried fruit	19 swimsuit
20 ashtray	5 Google image search
15 soil	7 flashlight

Circle any items that you have never drawn:

roasted turkey	grim reaper	soup	gravestone
zebra	ball of yarn	fishing pole	lobster
piano	fried eggs	kite	ventriloquist dummy
silo (grain or missile)	rat	life preserver	noose
whale	pilgrim	badger	Amish person
back of a TV	ant	man with one leg	gun
cauldron	igloo	wiener dog	Mr. Potato Head
penguin	fire hydrant	windup toy	gorilla
army helmet	Tin Man	fruit hat	someone shaving
pig	trout	canoe	rabbi

(LATER TODAY I WILL DRAW AN AMISH PERSON IN A CAULDRON.)

When I'm having a hard time coming up with ideas, I . . .

PROCEED ANYWAY... SOMETIMES I GET LUCKY.

Draw something in this space that will help us understand your childhood:

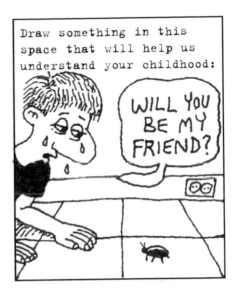

WILL YOU BE MY FRIEND?

What's the hardest part of cartooning?

MAKING A LOT OF DOUGH, AND DRAWING CATS.

How do you deal with rejection?

ALCOHOL AND MEANINGLESS SEX.

Where do you keep your rejected cartoons? THE LOUVRE. (THEY KNOW WHAT'S GOOD!)

My advice to BOB MANKOFF would be: BUY EVERYTHING I SUBMIT TO THE NEW YORKER.

Where do you see yourself in ten minutes? I DON'T USUALLY PLAN THAT FAR AHEAD, BUT I MAY BE IN THE BATHROOM THROWING UP AFTER REVEALING SO MUCH ABOUT MYSELF.

And lastly, what are some things that make you laugh and why?

A MAN SLIPPING ON A BANANA PEEL... A MORON THROWING A CLOCK OUT THE WINDOW IN ORDER TO SEE TIME FLY... A CHICKEN (FUNNY ALREADY!) CROSSING THE ROAD, BUT ONLY WHEN IT'S "TO GET TO THE OTHER SIDE"... OBVIOUSLY, I'M EASILY AMUSED.

Diced apple is to Waldorf salad as BESTIALITY is to my cartoons.	Circle the funniest word: pants (slacks) trousers britches	True or false? T I spend more than three hours a day working on cartoons. F I have always wanted to be a cartoonist. T I have never lived in New York City.
To me, ![blot] looks like BEETLE BAILEY.		I consider myself a __D__ person. (a) dog (b) cat (c) people (d) other __GERM__
	Circle the funniest bird: chicken (penguin) pigeon tufted titmouse	I am afraid of __D__. (a) abandonment (b) commitment (c) rejection (d) bears
		For me cartooning is **30** % drawing and **70** % writing.

For office use only: OFFICE, SCHMOFFICE.

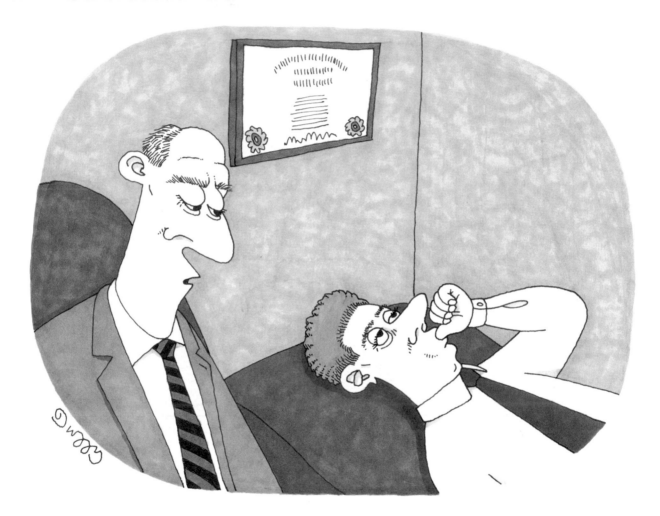

*"Yes, Mr. Hargraves, thumb-sucking can be cured.
But first let's talk about what your other hand is doing."*

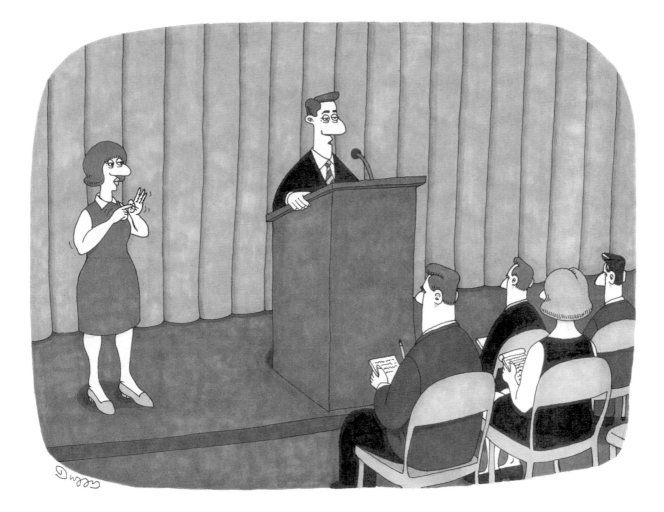

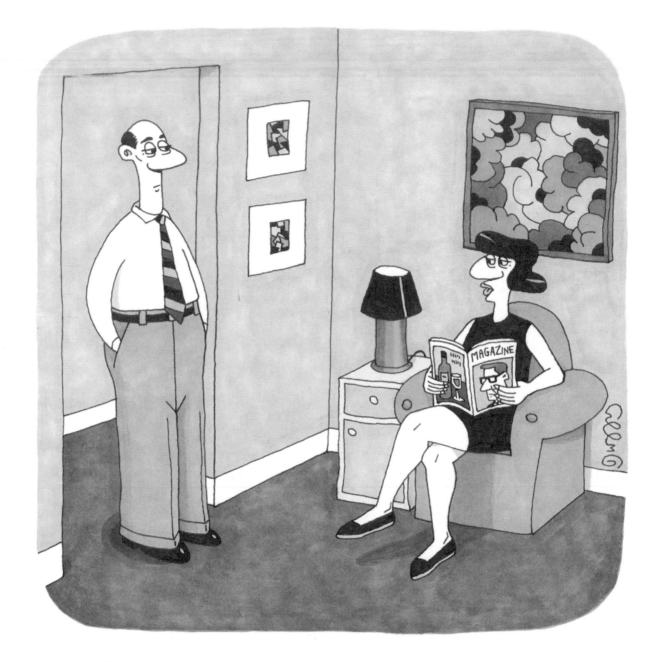

"I think your tailor has seriously miscalculated your rise, Herbert."

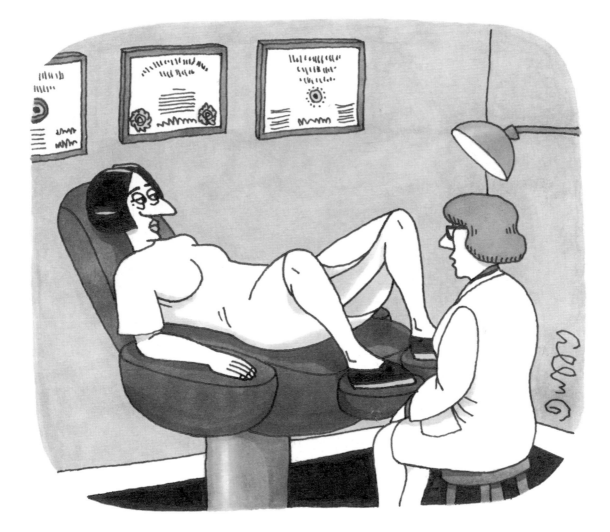

"I spy London, I spy France . . . neither of which rhymes with 'yeast infection.'"

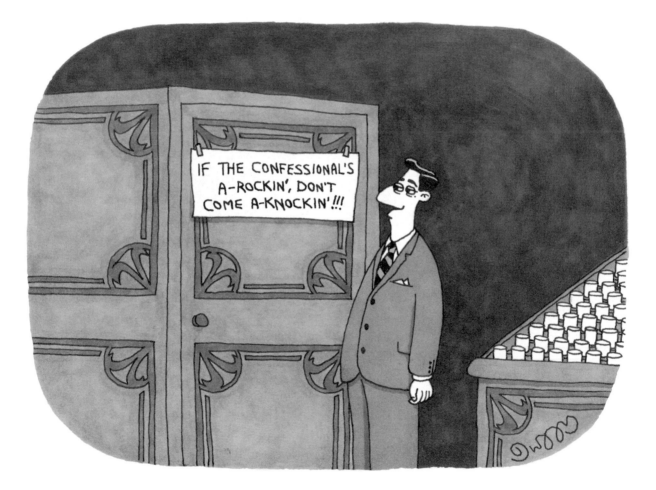

CAROLITA
JOHNSON

Self-portrait

(as one of my cartoons)

How did you learn to draw that way?

By not being able to draw the way I'd planned to draw.

My first cartoon a dog comic strip, in the 7th grade called "Snurfuls". Something like this!

(and passed around during science class)

Why cartooning?

what's left?

When I'm not cartooning, I . . .

wonder how to do a cartoon about not cartooning.

I admire . . .

people who get away with murder (metaphorically speaking, of course.)

How has your work, or the way you work, changed over time?

Finally getting paid to draw!

I'm not crazy about . . .

Lipstick, candy, pain, diamonds, infants, neat hair.

Write a question to which you might answer "Absolutely not."

"Would you ever change to please your parents?"

Most cartoonists I know are . . .

living in Brooklyn, pretending it's better than Manhattan, ha ha ha.

carmen

Number the following 20 items in order of their importance in your life (1 being the most important):		
20 pancakes	2 light board	
3 dictionary	11 sports	
6 Band-Aids	20 tires	
4 Wite-Out	20 politics	
20 tropical fish	13 snow shovel	
5 coffee	7 soap	
9 music	8 ointments	
20 dried fruit	10 swimsuit	
12 ashtray	1 Google image search	
6 soil	5 flashlight	

for guests

Circle any items that you have never drawn:

roasted turkey	grim reaper	soup	gravestone
zebra	ball of yarn	fishing pole	lobster
piano	fried eggs	kite	ventriloquist dummy
silo (grain or missile)	rat	life preserver	noose
whale	pilgrim	badger	Amish person
back of a TV	ant	man with one leg	gun
cauldron	igloo	wiener dog	Mr. Potato Head
penguin	fire hydrant	windup toy	gorilla
army helmet	Tin Man	fruit bat	someone shaving
pig	trout	canoe	rabbi

When I'm having a hard time coming up with ideas, I . . .

get out of the house and get walking.

What's the hardest part of cartooning?

Starting again when I've stopped for some reason.

And I now have four!
I only wanted four!

Draw something in this space that will help us understand your childhood:

(9 yrs. old)

0°

Someday I'll have as many flashlights as I want...

How do you deal with rejection?

Never giving up.
Visiting the batting cage at Coney Island and naming all the softballs after the rejector(s). (They know who they are...)

Where do you keep your rejected cartoons?

In a pile under another pile.

My advice to __anyone__ would be:

Don't look for trouble, it'll find you, and (important!) when it does, refer it to someone else.

Where do you see yourself in ten minutes?

On the subway.

And lastly, what are some things that make you laugh and why?

Men named Dick. Birds called "tits." Edgar Allen Poe. Very serious people. Saint Hildegarde's remedy for leprosy*. My own jokes, and people who think that's wrong.
Why? → Because they can't help it.

been

Diced apple is to Waldorf salad as __india ink__ is to my cartoons.

To me,

looks like __an inkspot getting shot in the head.__

Circle the funniest word:
(pants)
slacks
trousers
britches

Circle the funniest bird:
chicken
penguin
pigeon
(tufted titmouse)

True or false?
F I spend more than three hours a day working on cartoons.
T I have always wanted to be a cartoonist.
F I have never lived in New York City.

I consider myself a _____ person.
(a) dog (b) cat (c) people (d) other _____

I am afraid of _____.
(a) abandonment (b) commitment (c) rejection (d) bears

For me cartooning is 50 % drawing and 50 % writing.

For office use only:
ha!

*St. Hildegarde's recipe for leprosy control includes "medium stercoris gallinarum."

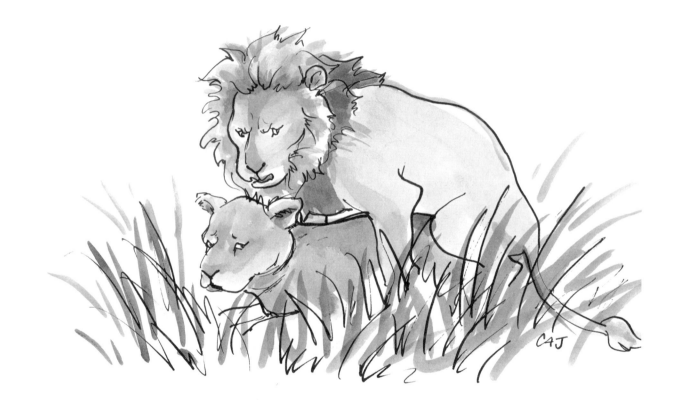

"Those pervs from National Geographic *are filming us again."*

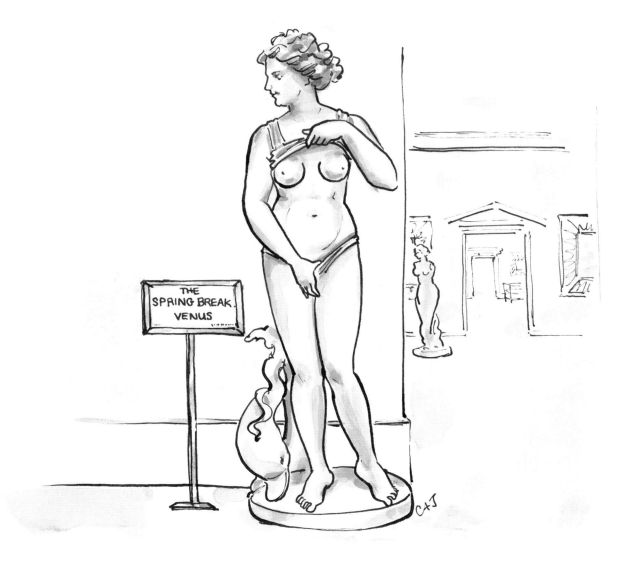

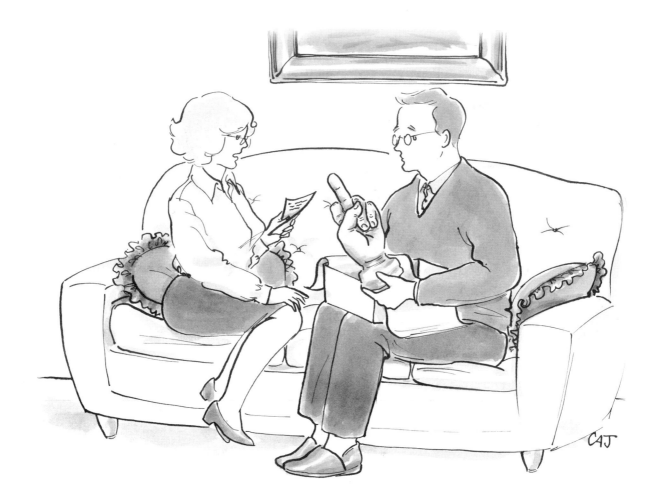

"It's from Marcus at sculpture camp."

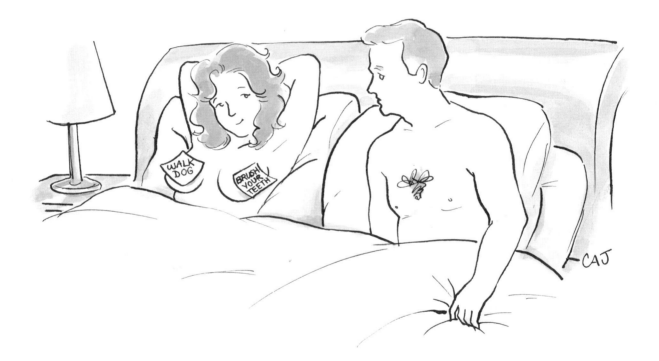

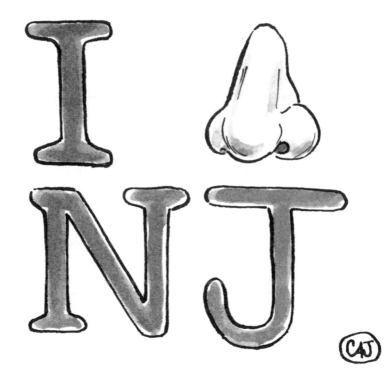

ARIEL
MOLVIG

Self-portrait

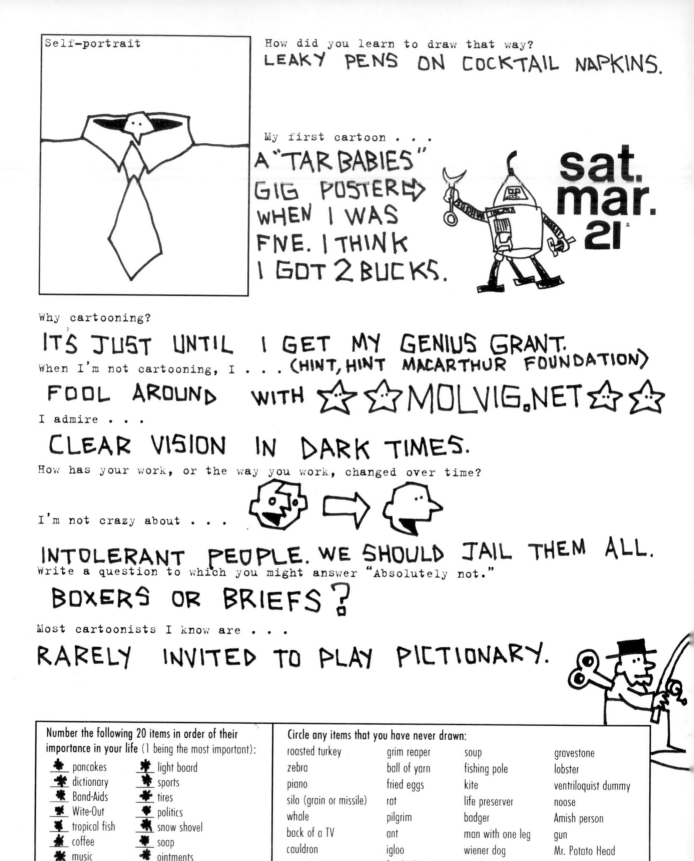

How did you learn to draw that way?
LEAKY PENS ON COCKTAIL NAPKINS.

My first cartoon . . .
A "TAR BABIES" GIG POSTER⇒ WHEN I WAS FIVE. I THINK I GOT 2 BUCKS.

sat.
mar.
21

Why cartooning?
IT'S JUST UNTIL I GET MY GENIUS GRANT.
When I'm not cartooning, I . . . (HINT, HINT MACARTHUR FOUNDATION)
FOOL AROUND WITH ☆ ☆ MOLVIG.NET ☆ ☆

I admire . . .
CLEAR VISION IN DARK TIMES.

How has your work, or the way you work, changed over time?

I'm not crazy about . . .

INTOLERANT PEOPLE. WE SHOULD JAIL THEM ALL.
Write a question to which you might answer "Absolutely not."
BOXERS OR BRIEFS?

Most cartoonists I know are . . .
RARELY INVITED TO PLAY PICTIONARY.

Number the following 20 items in order of their importance in your life (1 being the most important):

✱ pancakes	✱ light board
✱ dictionary	✱ sports
✱ Band-Aids	✱ tires
✱ Wite-Out	✱ politics
✱ tropical fish	✱ snow shovel
✱ coffee	✱ soap
✱ music	✱ ointments
✱ dried fruit	✱ swimsuit
✱ ashtray	2 Google image search
1 soil	✱ flashlight

✱TIE FOR THIRD

Circle any items that you have never drawn:

roasted turkey	grim reaper	soup	gravestone
zebra	ball of yarn	fishing pole	lobster
piano	fried eggs	kite	ventriloquist dummy
silo (grain or missile)	rat	life preserver	noose
whale	pilgrim	badger	Amish person
back of a TV	ant	man with one leg	gun
cauldron	igloo	wiener dog	Mr. Potato Head
penguin	fire hydrant	windup toy	gorilla
army helmet	Tin Man	fruit hat	someone shaving
pig	trout	canoe	rabbi

When I'm having a hard time coming up with ideas, I . . .

LOOK INTO MY
MAGIC KALEIDOSCOPE.

EYEHOLE

Draw something in this space that will help us understand your childhood:

What's the hardest part of cartooning?

DAMN PAPARAZZI.

How do you deal with rejection?

A PILLOW IS A GREAT WAY
TO HIDE AN REJECTION.

Where do you keep your rejected cartoons?

IN A SHOEBOX LABELED "HATS & MITTENS."

My advice to __ANYONE__ would be:

ANYONE LISTENING TO MY ADVICE IS BEYOND THE
HELP OF ADVICE.

Where do you see yourself in ten minutes?

TAKING THAT CALL FROM THE MACARTHUR PEOPLE.

And lastly, what are some things that make you laugh and why?

A KICK TO SOMEONE ELSE'S GONADS. LAUGHTER IS AN
INSTINCTUAL REFLEX OF RELIEF THAT ONE'S OWN
GONADS ARE UNSCATHED. ANYTHING FUNNY IS A
METAPHORICAL GONAD ASSAULT.

Diced apple is to Waldorf salad as __BAD PUNS__ is to my cartoons.

To me,

looks like __NAKED LADIES__.

Circle the funniest word:
(pants)
slacks
trousers
britches

Circle the funniest bird:
chicken
(penguin)
pigeon
tufted titmouse

True or false?

F I spend more than three hours a day working on cartoons.

T/F I have always wanted to be a cartoonist.

T I have never lived in New York City.

I consider myself a __(d)__ person.
(a) dog (b) cat (c) people (d) other _____

I am afraid of __d (AND THEIR NOSES ARE HARD TO DRAW)__
(a) abandonment (b) commitment (c) rejection (d) bears

For office use only:

For me cartooning is __10__% drawing and __10__% writing.

AND __20%__ WISHING AND __20%__ HOPING
AND __30%__ THINKING AND __10%__ PRAYING

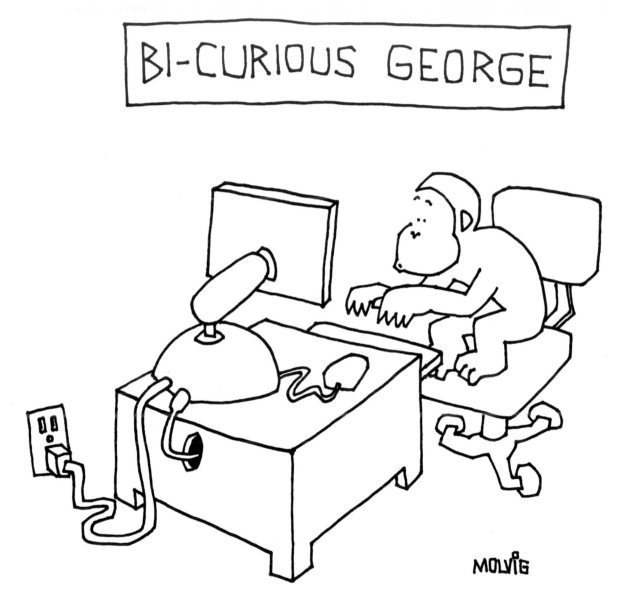

MICHAEL
SHAW

Self-portrait: as a boy.

bOY

SLAW

How did you learn to draw that way?

Bob Mankoff once told me there are "good/good" cartoonists and "good/bad" cartoonists— and that I am a "good/bad" cartoonist. I believe my style is an acquired affliction— much like irritable bowel.

My first cartoon . . .

The first drawing I ever received payment for (shown right) appeared in "The Athenian— Greece's Largest English Language Magazine". This was in 1980, while engaged in a one-year lay-over during my artist's Eurail Pass tour of Europe and squandering my graduate student loan. I received 2,000 drachmas that was soon exchanged for a jeroboam of industrial strength ouzo. I still have the original drawing. And a lingering fear of ouzo.

Why cartooning?

The start-up costs are minimal— paper, pen, and postage.

When I'm not cartooning, I toil at a "day job" as a copywriter, primarily for catalogs. Lands' End fans out there might remember me as the guy who took his family down Route 66 in a Bambi Airstream. I also wrote the Cartoon Bank catalog, so go online at www.cartoonbank.com and request yours today!

I admire . . .

Many, many people— but I would not let them suspect. I do admire my wife for putting up with me. And here's a shout-out to my fellow crusty Missourian, Mr. George Booth! James Thurber remains my favorite dead cartoonist.

How has your work, or the way you work, changed over time?

My original "finishes" were drawn on copier paper with a Bic Roller Pen. I have since upgraded to archival quality materials. Also, I think I have conquered my annoying habit of not drawing necks. (See figure 3.)

I'm not crazy about . . .

The suburbs— that's why I live there.

FIG 3 →

Write a question to which you might answer "Absolutely not."

Did you rape Mayella Ewell?

Most cartoonists I know are . . .

I don't know any cartoonists on a familiar basis. In fact, I really don't know anyone on a familiar basis. Truth is, I'm not a very pleasant person to be around. I'm pre-occupied, self-obsessed, and totally addicted to the narcotic rush of selling cartoons to The New Yorker. Why? Just because it validates my miserable existence! (P.S.— I have the biggest crush on Victoria Roberts!)

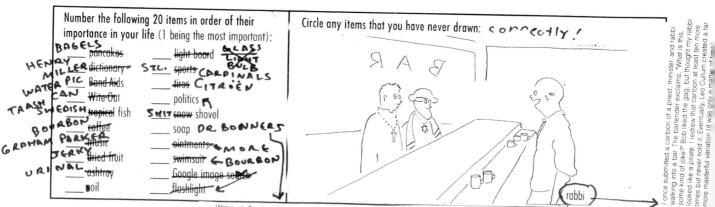

Number the following 20 items in order of their importance in your life (1 being the most important):

BAGELS
HENRY MILLER pancakes
___ dictionary
WATER PIC Band Aids
TRASH CAN Wite-Out
SWEDISH tropical fish
BOURBON coffee
GRAHAM PARKER music
JERKY dried fruit
URINAL ashtray
___ soil

___ light board GLASS LIGHT BULB
STL. sports CARDINALS
___ tires CITROËN
___ politics
SHIT snow shovel
___ soap DR. BONNERS
___ ointments ← MORE
___ swimsuit ← BOURBON
___ Google image search
___ flashlight

Circle any items that you have never drawn: correctly!

BAR
rabbi

I once submitted a cartoon of a priest, minister, and rabbi walking into a bar. The bartender exclaims, "What is this, some kind of joke?" Bob liked the gag, but thought my rabbi looked like a pirate. I redrew that cartoon at least ten more times but never sold it. Eventually, Leo Cullum created a far more masterful variation (it was only a matter of time).

Wake up 7am, really sleepy from late night drawing cartoons, got to go to work. Jump in shower and squirt big shot of Dr. Bonner's Peppermint Soap in scrubby thing. Lather up face, let sting eyes! Run down and sting pee pee too! You awake are ready to go! All One Get Out And Go To Work Or You'll Be Late! Eat cold Pop Tart in car. OK? OK!

When I'm having a hard time coming up with ideas, I . . .

I always have a hard time coming up with ideas. Reading the scriptures— "My Life and Hard Times" usually helps. Page 56 (opened at random) "This guy," he explained to the others, jerking a thumb at me, "was nekked." I smell a gag line!

Draw something in this space that will help us understand your childhood:

NA NA NA NA NAA NAA!

bad hand ↗

What's the hardest part of cartooning?

Drawing with an effortless insoußiance that is uniquely mine and passes muster with the ghost of Mr. Ross —

↖ ood and →

How do you deal with rejection?

Think reproductively . My rejection rate would send even the most optimistic of souls into despair. But compared to the chances of the average sperm succeeding in its mission, my odds are quite good.

Where do you keep your rejected cartoons?

In the resubmit pile.

My advice to ___MYSELF___ would be:

Don't give up the day job — just yet.
 OR
Don't call me — I'll call you.

Where do you see yourself in ten minutes?

Reconsidering these responses.

And lastly, what are some things that make you laugh and why?

I laugh at things that aren't meant to be funny. EWTN is hilarious.
My motto— "Tragedy plus time equals comedy— but who has time anymore?"
My favorite joke— "What did the sadist do to the masochist? Nothing."

THINKING ABOUT

Diced apple is to Waldorf salad as diced reality is to my cartoons.	Circle the funniest word: pants slacks trousers britches **KNICKERS!**	True or false? ● I spend more than three hours a day ~~working on~~ cartoons. T I have always wanted to be a cartoonist. T I have never lived in New York City.
To me, [drawing] looks like Mrs. Ritterhouse.	Circle the funniest bird: chicken penguin pigeon tufted titmouse	I consider myself a _____ person. (a) dog (b) cat (c) people (d) other **drawn**
		I am afraid of _fear itself._ (a) abandonment (b) commitment (c) rejection (d) bears
		For me cartooning is **5** % drawing and **20**% writing.

For office use only: seething brain ti¥ss

→ a grotesque mutated melange! → 75% thinking

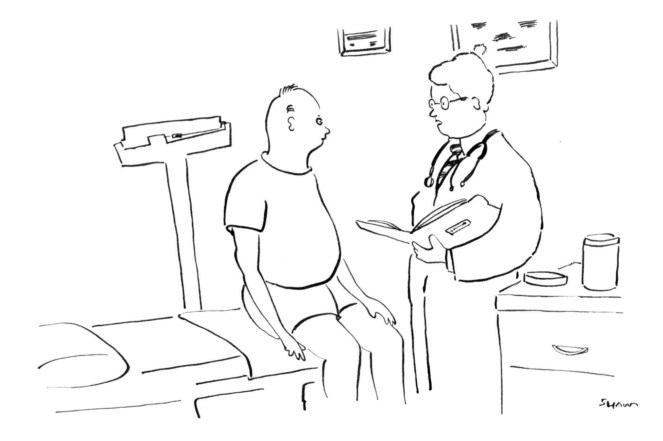

"Now, this is going to feel like I'm sticking my finger up your ass."

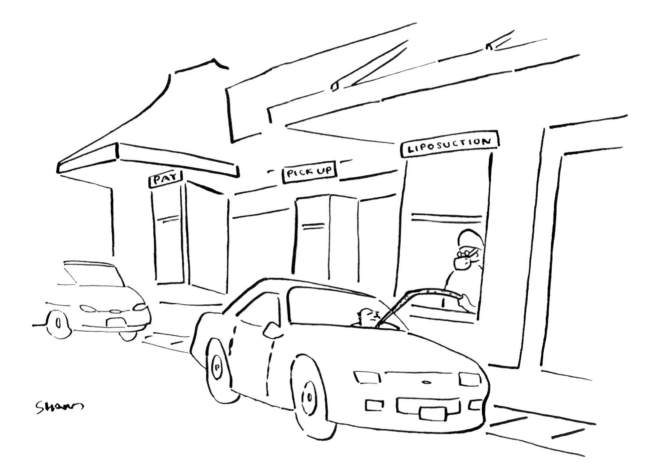

"Stop and I'll shoot."

Half-price tighty-whitey day at the MoMA

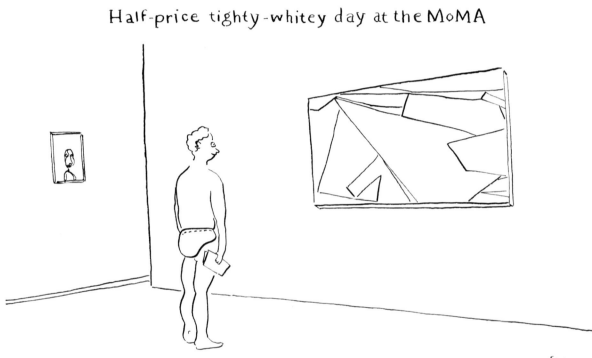

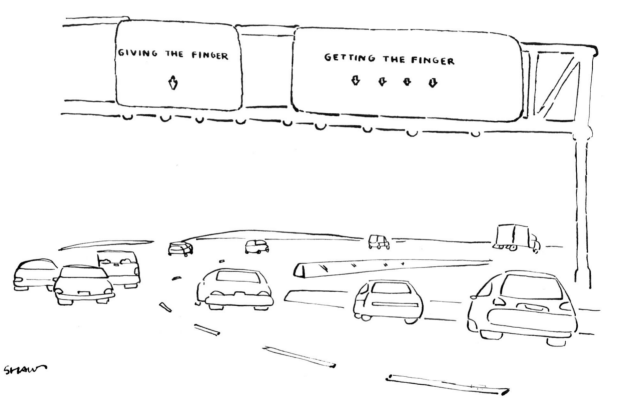

ERIC
LEWIS

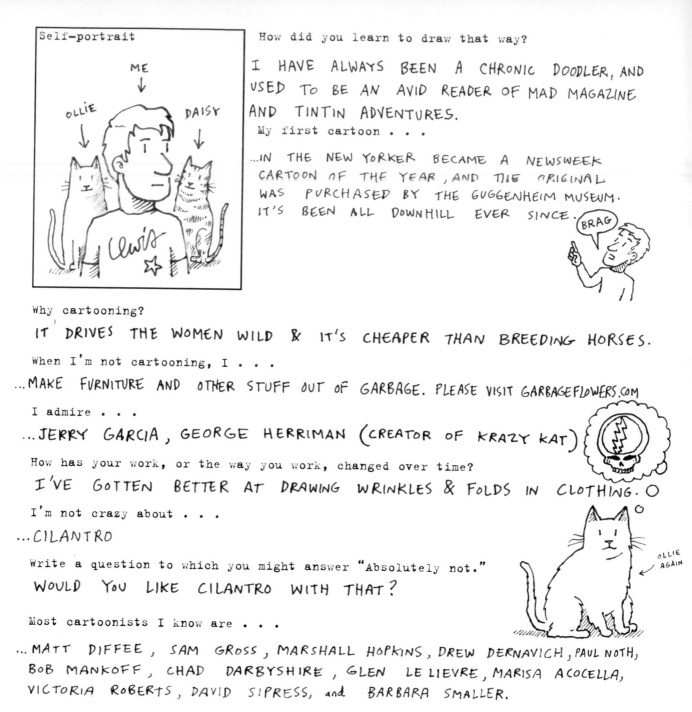

Self-portrait

OLLIE ↓ · ME ↓ · DAISY ↓

Clwis ☆

How did you learn to draw that way?

I HAVE ALWAYS BEEN A CHRONIC DOODLER, AND USED TO BE AN AVID READER OF MAD MAGAZINE AND TINTIN ADVENTURES.

My first cartoon . . .

...IN THE NEW YORKER BECAME A NEWSWEEK CARTOON OF THE YEAR, AND THE ORIGINAL WAS PURCHASED BY THE GUGGENHEIM MUSEUM. IT'S BEEN ALL DOWNHILL EVER SINCE.

BRAG

Why cartooning?

IT DRIVES THE WOMEN WILD & IT'S CHEAPER THAN BREEDING HORSES.

When I'm not cartooning, I . . .

...MAKE FURNITURE AND OTHER STUFF OUT OF GARBAGE. PLEASE VISIT GARBAGEFLOWERS.COM

I admire . . .

...JERRY GARCIA, GEORGE HERRIMAN (CREATOR OF KRAZY KAT)

How has your work, or the way you work, changed over time?

I'VE GOTTEN BETTER AT DRAWING WRINKLES & FOLDS IN CLOTHING.

I'm not crazy about . . .

...CILANTRO

Write a question to which you might answer "Absolutely not."

WOULD YOU LIKE CILANTRO WITH THAT?

OLLIE AGAIN ←

Most cartoonists I know are . . .

...MATT DIFFEE, SAM GROSS, MARSHALL HOPKINS, DREW DERNAVICH, PAUL NOTH, BOB MANKOFF, CHAD DARBYSHIRE, GLEN LE LIEVRE, MARISA ACOCELLA, VICTORIA ROBERTS, DAVID SIPRESS, and BARBARA SMALLER.

Number the following 20 items in order of their importance in your life (1 being the most important):

8	pancakes	7	light board
15	dictionary	19	sports
10	Band-Aids	11	tires
1	Wite-Out	2	politics
18	tropical fish	17	snow shovel
13	coffee	12	soap
4	music	16	ointments
9	dried fruit	6	swimsuit
20	ashtray	3	Google image search
5	soil	14	flashlight

Circle any items that you have never drawn:

roasted turkey	grim reaper	soup	gravestone
zebra	ball of yarn	fishing pole	lobster
piano	fried eggs	kite	~~ventriloquist dummy~~
silo (grain or missile)	rat	life preserver	noose
whale	pilgrim	~~badger~~	Amish person
back of a TV	ant	man with one leg	gun
cauldron	igloo	wiener dog	Mr. Potato Head
penguin	fire hydrant	windup toy	gorilla
army helmet	~~Tin Man~~	fruit hat	~~someone shaving~~
pig	trout	canoe	rabbi

When I'm having a hard time coming up with ideas, I . . .

...TURN ON CNN OR FLIP THROUGH THE MOST RECENT ISSUE OF PEOPLE MAGAZINE.

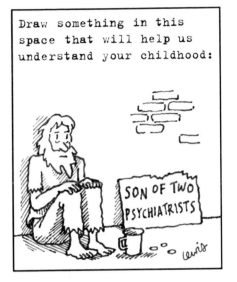

Draw something in this space that will help us understand your childhood:

SON OF TWO PSYCHIATRISTS

What's the hardest part of cartooning?

COMING UP WITH IDEAS. THAT'S WHY I ALWAYS CARRY A TINY NOTEPAD IN MY BACK POCKET. IF I THINK OF SOMETHING FUNNY, I WRITE IT DOWN IMMEDIATELY.

How do you deal with rejection?

CRYING, BREAKING WINDOWS, AND THEN, A LONG HOT BUBBLE BATH.

Where do you keep your rejected cartoons?
IN A SWISS SAFE-DEPOSIT BOX.

My advice to <u>GEORGE W. BUSH</u> would be:
WRITE A FORMAL LETTER OF APOLOGY TO THE PLANET.

Where do you see yourself in ten minutes?
I NEVER LOOK THAT FAR INTO THE FUTURE.

And lastly, what are some things that make you laugh and why?

MY CATS - OLIVER & DAISY. BECAUSE THEY'RE NEVER PHONY OR CONTRIVED, AND YET THEY DO GOOFY THINGS. FOR EXAMPLE, DAISY NURSES ON MY EARLOBES.

Diced apple is to Waldorf salad as "<u>I DON'T GET IT.</u>" is to my cartoons.

To me, [inkblot] ▬ looks like <u>MY MOTHER</u>.

Circle the funniest word:
pants
(slacks)
trousers
britches

Circle the funniest bird:
chicken
(penguin)
pigeon
tufted titmouse

True or false?
F I spend more than three hours a day working on cartoons.
T I have always wanted to be a cartoonist.
F I have never lived in New York City.

I consider myself a __B__ person. (CAT)
(a) dog (b) cat (c) people (d) other _____

I am afraid of <u>C & D</u>: BEING REJECTED BY A BEAR
(a) abandonment (b) commitment (c) rejection (d) bears

For me cartooning is _20_ % drawing and _80_ % writing.

For office use only:

"Hold that thought. I have to go take a number five."

"Arrg. Just our luck!"

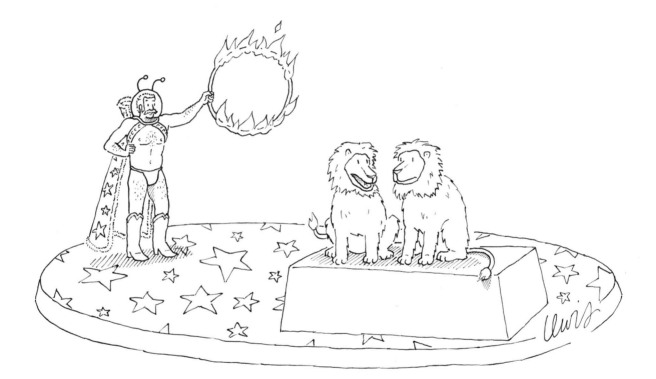

"If I ever start showing signs of Stockholm syndrome, kill me."

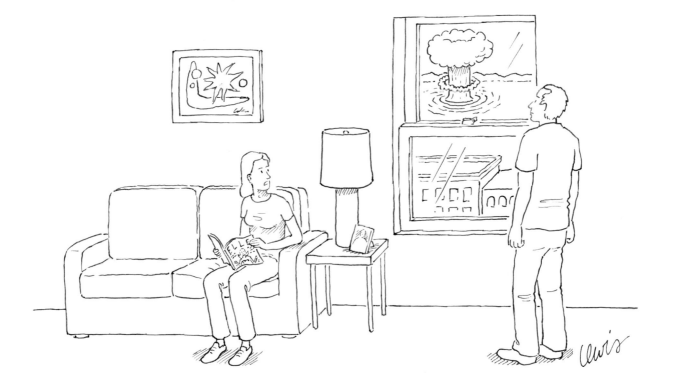

"Tell me you didn't just pronounce it 'nucular.'"

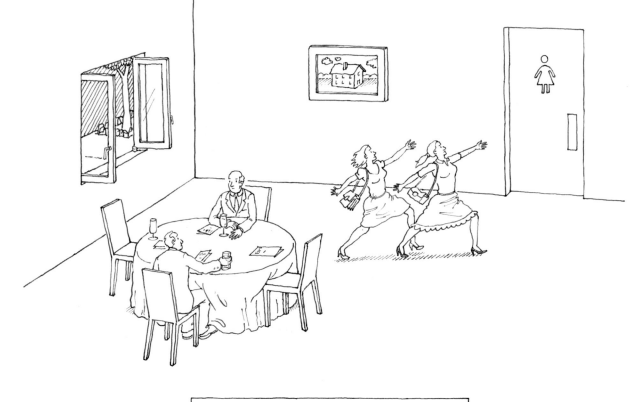

WOMEN'S SYNCHRONIZED PEEING

P.S.
MUELLER

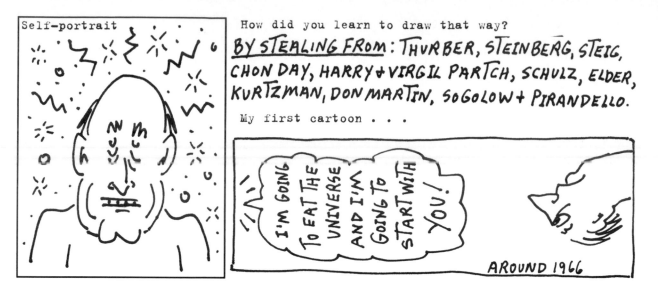

Self-portrait

How did you learn to draw that way?

<u>BY STEALING FROM</u>: THURBER, STEINBERG, STEIG, CHON DAY, HARRY & VIRGIL PARTCH, SCHULZ, ELDER, KURTZMAN, DON MARTIN, SOGOLOW + PIRANDELLO.

My first cartoon . . .

I'M GOING TO EAT THE UNIVERSE AND I'M GOING TO START WITH YOU!

AROUND 1966

Why cartooning?

MY FAMILY **HATES** <u>TAILORS</u>.

When I'm not cartooning, I . . .

DRINK COFFEE—LOTS OF COFFEE, AND THEN, WHEN I'M COMPLETELY STOKED UP, I GO BIRDING WITH MY WIFE, THE ENABLER.

I admire . . .

MY OWN BOUNDLESS CAPACITY FOR COFFEE AND MY WIFE'S PATIENCE.

How has your work, or the way you work, changed over time?

FOR YEARS MY WORK WAS INFLUENCED BY DRUGS AND ALCOHOL, BUT DISCOVERED TAX LAW, WHICH, ODDLY ENOUGH, HAS BECOME LIKE DRUG TO ME.

I'm not crazy about . . .

ALL THOSE FERAL KIDS THEY KEEP TRAINING FOR SHOW BUSINESS.

Write a question to which you might answer "Absolutely not."

ABSOLUTELY?

Most cartoonists I know are . . . HAUNTING, LIKE A HILARIOUS LATE NIGHT BREEZE, BUT ALSO LONESOME IN A NON-COWBOY WAY, YET READY AT A MOMENT'S NOTICE TO STOP AND CONSIDER FOAM. HEROES!

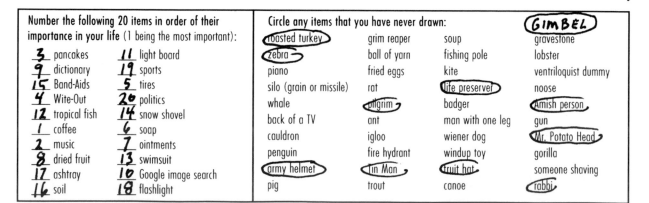

Number the following 20 items in order of their importance in your life (1 being the most important):

3 pancakes	11 light board
9 dictionary	19 sports
15 Band-Aids	5 tires
4 Wite-Out	20 politics
12 tropical fish	14 snow shovel
1 coffee	6 soap
2 music	7 ointments
8 dried fruit	13 swimsuit
17 ashtray	10 Google image search
16 soil	18 flashlight

Circle any items that you have never drawn:

roasted turkey	grim reaper	soup	GIMBEL
zebra	ball of yarn	fishing pole	gravestone
piano	fried eggs	kite	lobster
silo (grain or missile)	rat	life preserver	ventriloquist dummy
whale	pilgrim	badger	noose
back of a TV	ant	man with one leg	Amish person
cauldron	igloo	wiener dog	gun
penguin	fire hydrant	windup toy	Mr. Potato Head
army helmet	Tin Man	fruit hat	gorilla
pig	trout	canoe	someone shaving
			rabbi

When I'm having a hard time coming up with ideas, I . . .

PULL OUT A SNIFTER AND POUR A BIT OF ANCIENT COGNAC INTO IT. THEN I SIT QUIETLY AND THINK ABOUT THE WORD "SNIFTER."

What's the hardest part of cartooning?

HAVING TO THINK ABOUT THE WORD "SNIFTER" MOST OF THE TIME INSTEAD OF ACTUALLY MAKING FUNNY DRAWINGS.

How do you deal with rejection?

I TEND TO TELL EDITORS THAT, FINE, I'LL JUST TAKE MY MACARTHUR GENIUS GRANT AND GO SQUAT IN A FIELD SOMEWHERE IN THE FORMER YUGOSLAVIA, GODDAMMIT!

Where do you keep your rejected cartoons?

ROLLED AND TUCKED INTO MY VAST COLLECTION OF ANTIQUE BOOTS.

My advice to <u>PARIS HILTON</u> would be: MAKE ROOM REALLY, REALLY SOON FOR THE NEXT PARIS HILTON, AND STOP GIVING US ALL THAT LOOK!

Where do you see yourself in ten minutes?

STUMBLING AROUND IN THE RORSCHACH CORNER A FEW INCHES BELOW HERE. IT LOOKS OMINOUS.

And lastly, what are some things that make you laugh and why?

THE RUMSFELD SQUINT — IT'S JUST FLAT OUT COMICAL THE WAY HE BRINGS IT RIGHT TO THE EDGE OF THAT CRAZY OLD MAN THING. AND CATS, ALWAYS CATS — BECAUSE IN THE ABSENCE OF PREY THEY'RE QUITE HAPPY TO ATTACK THEIR OWN LITTLE CHARADES.

Draw something in this space that will help us understand your childhood:

OL' MUGS

Diced apple is to Waldorf salad as **VINAIGRETTE** is to my cartoons.

To me,

![ink blot] looks like SPILLED COGNAC.

Circle the funniest word:

pants
slacks
(trousers)
britches

Circle the funniest bird:

(chicken)
penguin
pigeon
tufted titmouse

True or false?

✓ I spend more than three hours a day working on cartoons.
✓ I have always wanted to be a cartoonist.
✓ I have never lived in New York City.

I consider myself a **C** person.
(a) dog (b) cat (c) people (d) other _____

I am afraid of **A**.
(a) abandonment (b) commitment (c) rejection (d) bears

For me cartooning is **12.5**% drawing and **27**% writing.

For office use only:

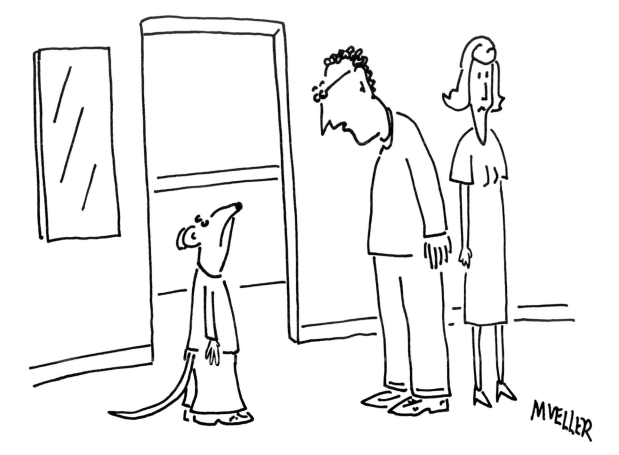

"*I'm sorry, but the fact that your birth parents weren't married does appear to make you a rat bastard.*"

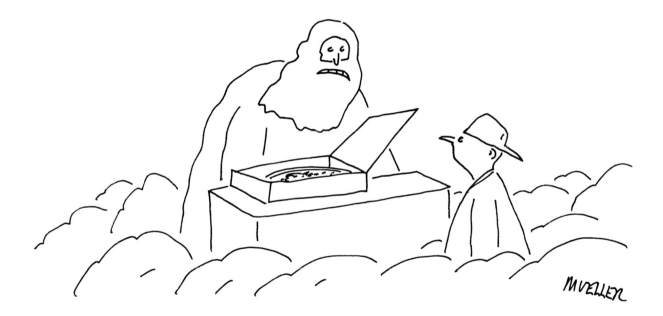

"It's got pineapple on it. You'll have to go to hell."

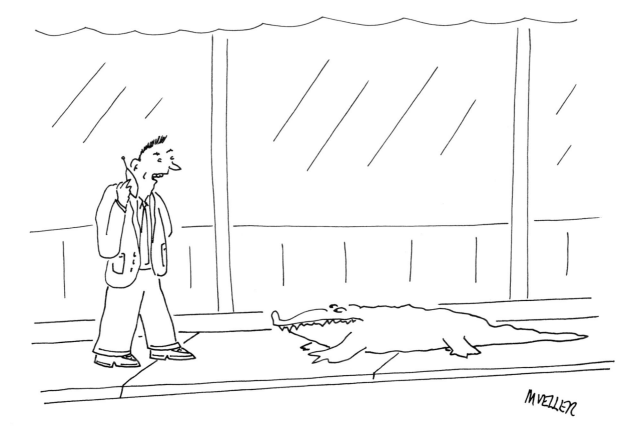

"I can't talk right now—I'm about to do something really stupid."

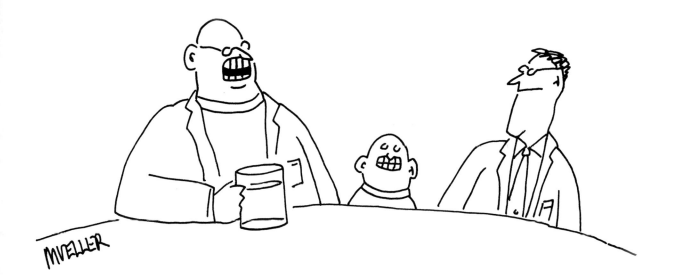

"Billy's going to be my new liver someday."

CRACK HOE

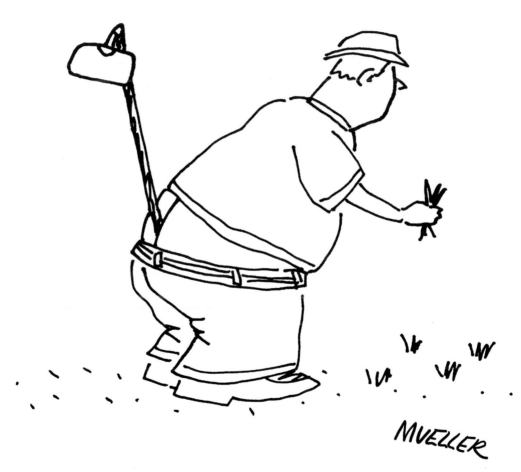

MUELLER

DAVID
SIPRESS

Self-portrait

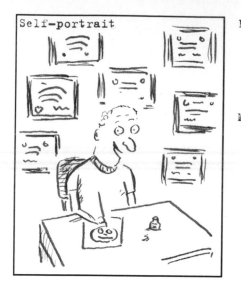

How did you learn to draw that way?

At one time, I drew a lot better. But with hard work and dedication, I learned to draw worse.

My first cartoon . . .

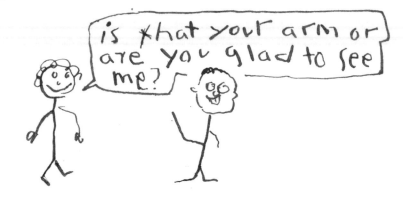

is xhat your arm or are you glad to see me?

Why cartooning?

Because it's there.

When I'm not cartooning, I . . . live a rich, full life.

I admire . . . anyone who has a regular job - how the hell do they do it ???

How has your work, or the way you work, changed over time?

Since I started selling to the New Yorker I spend a lot more time in my studio. On the other hand, I take a lot more naps.

I'm not crazy about . . .

death.

Write a question to which you might answer "Absolutely not."

Would you please write a question to which you might answer, "Absolutely not?"

Most cartoonists I know are . . . not astronauts.

Number the following 20 items in order of their importance in your life (1 being the most important):	
3662 pancakes	2241 light board
457 dictionary	37,606 sports
12,106 Band-Aids	722 tires
1 Wite-Out	17,288 politics
2836 tropical fish	337 snow shovel
37 coffee	93,784 soap
5582 music	4 ointments
66 dried fruit	4288 swimsuit
1787 ashtray	12 Google image search
1788 soil	9655 flashlight

Circle any items that you have never drawn:

roasted turkey	grim reaper	soup	gravestone
zebra	ball of yarn	fishing pole	lobster
piano	fried eggs	kite	ventriloquist dummy
silo (grain or missile)	rat	life preserver	noose
whale	pilgrim	badger	Amish person
back of a TV	ant	man with one leg	gun
cauldron	igloo	wiener dog	Mr. Potato Head
penguin	fire hydrant	windup toy	gorilla
army helmet	Tin Man	fruit hat	someone shaving
pig	trout	canoe	rabbi

Now draw ever item

When I'm having a hard time coming up with ideas, I . . . take off all my clothes, slather myself with truffle oil, sprinkle my entire body with herbs and spices, and go for a walk in Central Park - that usually works.

What's the hardest part of cartooning?

See next question.....

How do you deal with rejection?

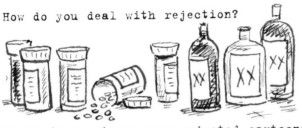

Where do you keep your rejected cartoons?

France.

My advice to the New Yorker would be: buy one cartoon a week from me, every week, until I die.

Where do you see yourself in ten minutes?

Still working on this stupid questionnaire.

And lastly, what are some things that make you laugh and why?

This is not an answer to this question. I can't think of an answer to this question. I just felt like drawing a dog with a guy's head.

Draw something in this space that will help us understand your childhood:

"You're a loser."
"You're a failure."
"You'll never amount to anything."

"It's a motivational technique I learned from my father."

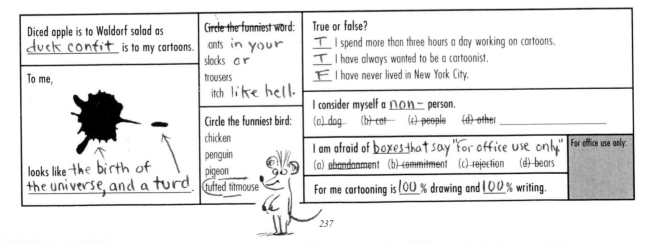

Diced apple is to Waldorf salad as duck confit is to my cartoons.	Circle the funniest word: ants in your slacks or trousers itch like hell.	True or false?
To me, [ink blot] looks like the birth of the universe, and a turd.	Circle the funniest bird: chicken penguin pigeon (tufted titmouse)	T I spend more than three hours a day working on cartoons. T I have always wanted to be a cartoonist. F I have never lived in New York City.

I consider myself a non- person.
(a) dog (b) cat (c) people (d) other _____

I am afraid of boxes that say "for office use only."
(a) abandonment (b) commitment (c) rejection (d) bears

For me cartooning is 100 % drawing and 100 % writing.

For office use only:

*"From everything you're describing, son, it sounds to
me like you've just had your first boner."*

SIPRESS

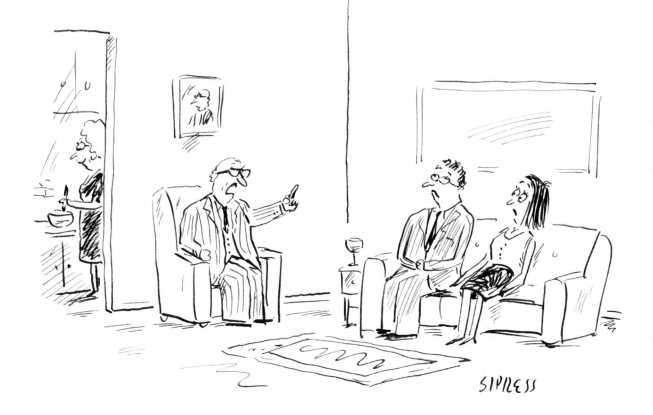

"I came to this country with nothing but the hair on my back."

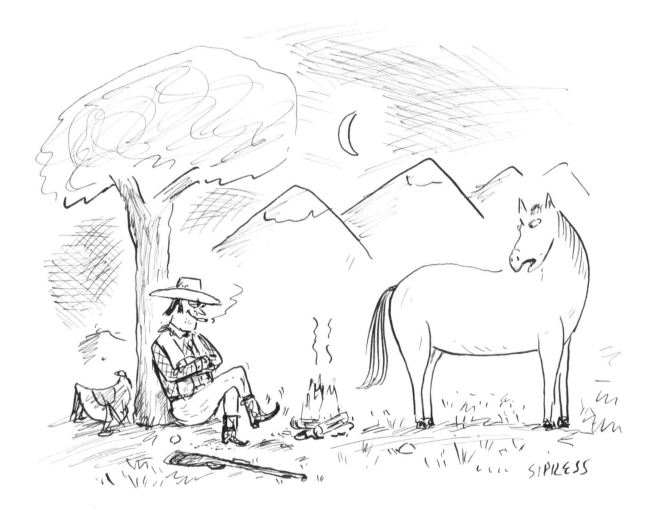

"Don't even think about it, cowboy."

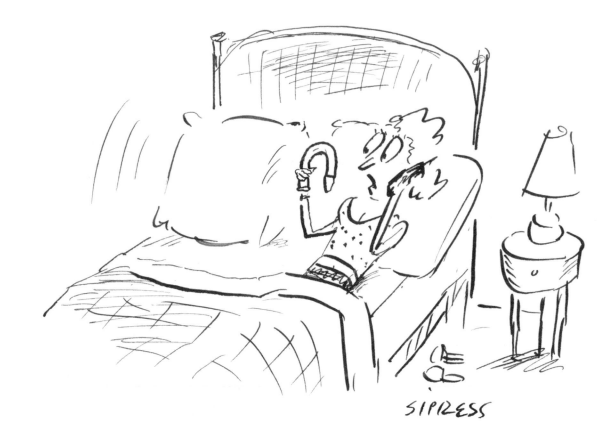

"Hello . . . technical support?"

JACK
ZIEGLER

Self-portrait

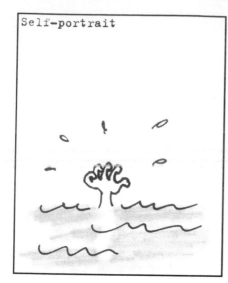

How did you learn to draw that way?

I EASED INTO IT AFTER ABOUT THIRTY YEARS OF DRAWING EVERYTHING WRONG.

My first cartoon . . .

WAS BANNED BY ONE OF THE EARLY POPES WHO PLACED A FATWA ON MY LIFE (YES, THE POPES COULD DO THAT IN THOSE DAYS!). THE FATWA WAS LIFTED AFTER I LEARNED LATIN AND BECAME A VATICAN LOBBYIST.

Why cartooning? IT WAS SAFER THAN ROBBING GAS STATIONS (MY FIRST VOCATION).

When I'm not cartooning, I . . . DUST.

I admire . . . STEINBERG, PICASSO, STEIG, HENRY MILLER, GEO. BOOTH, ALAN DUNN, B. KLIBAN, M.K. BROWN, ANDRE FRANCOIS, WAYNE THIEBAUD, RICK GRIFFIN, HARVEY KURTZMAN, MOBIUS, ETC., ETC.

How has your work, or the way you work, changed over time?
THE PEOPLE IN MY DRAWINGS ARE FATTER AND CARRY MORE CASH THAN THEY USED TO.

I'm not crazy about . . . THE IMPRESSIONISTS. IS THERE ANYONE ELSE OUT THERE WHO HAS JUST ABOUT HAD IT WITH THE IMPRESSIONISTS?

Write a question to which you might answer "Absolutely not." "IF YOU DON'T MIND, COULD YOU PLEASE FILL OUT THIS QUESTIONNAIRE?"

Most cartoonists I know are . . . PROVIDE THE VOICES INSIDE MY HEAD.

Number the following 20 items in order of their importance in your life (1 being the most important):

11 pancakes	4 light board
3 dictionary	19 sports
10 Band-Aids	13 tires
2 Wite-Out	20 politics
16 tropical fish	7 snow shovel
5 coffee	8 soap
1 music	14 ointments
17 dried fruit	15 swimsuit
18 ashtray	12 Google image search
6 soil	9 flashlight

Circle any items that you have never drawn:

roasted turkey	grim reaper	soup	gravestone
zebra	ball of yarn	fishing pole	lobster
piano	fried eggs	kite	ventriloquist dummy
silo (grain or missile)	rat	life preserver	noose
whale	pilgrim	badger	Amish person
back of a TV	ant	man with one leg	gun
cauldron	igloo	wiener dog	Mr. Potato Head
penguin	fire hydrant	windup toy	gorilla
army helmet	Tin Man	fruit hat	someone shaving
pig	trout	canoe	rabbi

When I'm having a hard time coming up with ideas, I . . .
WAIT UNTIL TOMORROW.

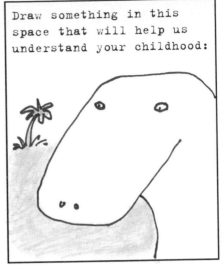

Draw something in this space that will help us understand your childhood:

What's the hardest part of cartooning? CHOKING DOWN THE CURDS AND WHEY.

How do you deal with rejection? I GO OUT AND HUNT DOWN SMALL CREATURES IN THE FOREST.

Where do you keep your rejected cartoons? IN A 30-DRAWER ANTIQUE FILE CABINET THAT WEIGHS HUNDREDS OF POUNDS.

My advice to MADONNA would be: TO STOP DRESSING LIKE ME.

Where do you see yourself in ten minutes? MIXING MYSELF A VODKA MARTINI STRAIGHT UP WITH OLIVES AFTER A HARD DAY'S WORK OF FILLING OUT THIS GODDAMN QUESTIONNAIRE.

And lastly, what are some things that make you laugh and why?

DAVID CARUSO IN ANY EPISODE OF "CSI: MIAMI"; ANY "SEINFELD" RERUN FEATURING JERRY STILLER; DANE COOK; CERTAIN FRIENDS WHO SHALL BE UNNAMED. WHY? BECAUSE THEY'RE FUNNY.

Diced apple is to Waldorf salad as THE PARKING METER is to my cartoons.

To me, 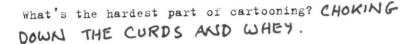 — looks like RICHARD NIXON

Circle the funniest word:
(pants)
slacks
trousers
britches

Circle the funniest bird:
(chicken)
penguin
pigeon
tufted titmouse

True or false?
T I spend more than three hours a day working on cartoons. → BUT IT DEPENDS ON WHICH DAY.
F I have always wanted to be a cartoonist. IT'S A NIGHTMARE COME TRUE.
F I have never lived in New York City.

I consider myself a D person. SHOULDN'T THAT BE "ANOTHER" — AS IN "ANOTHER PERSON"?
(a) dog (b) cat (c) people (d) other

I am afraid of D — BUT ONLY AT NIGHT.
(a) abandonment (b) commitment (c) rejection (d) bears

For me cartooning is 50% drawing and 50% writing.

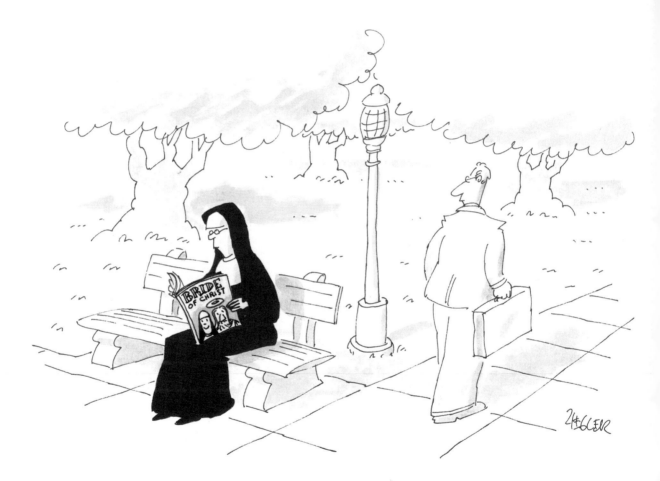

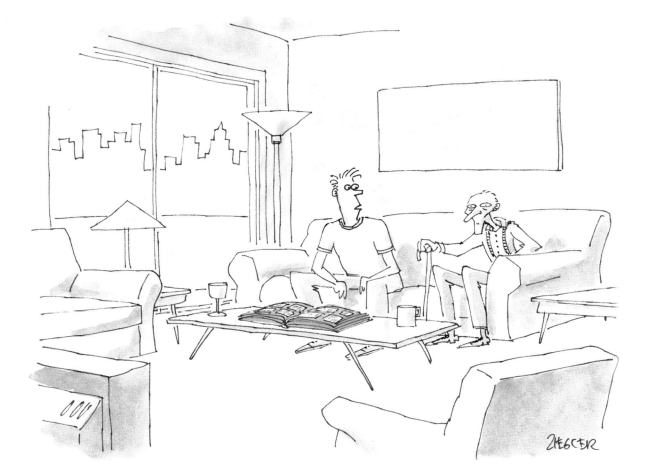

"*What's the deal, Gramps? You couldn't get any color film at Auschwitz?*"

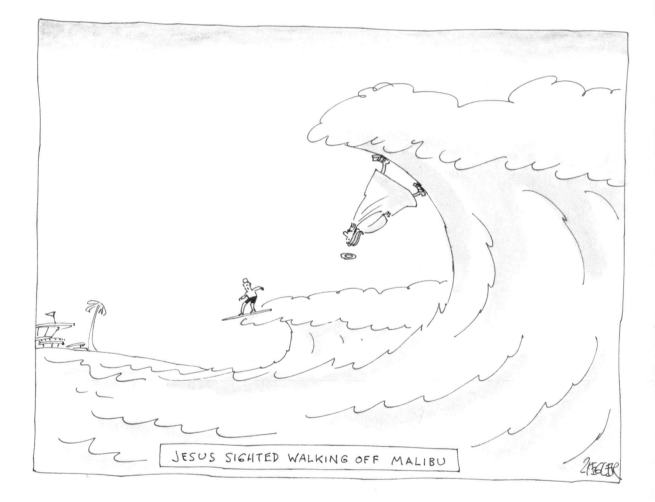

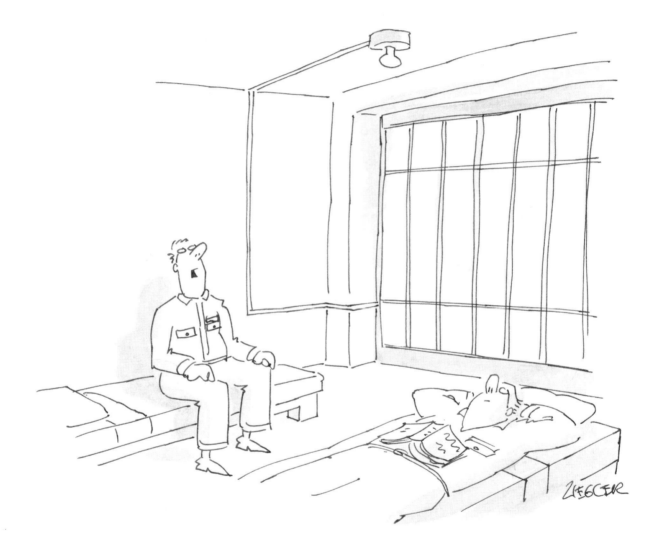

"As an ex-priest, I'm having a hard time adjusting to these noncathedral ceilings."

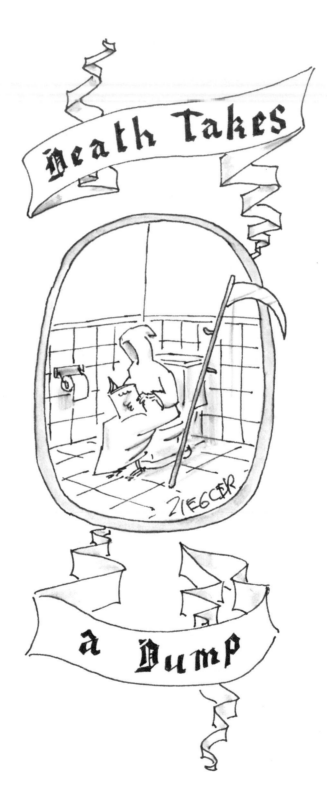

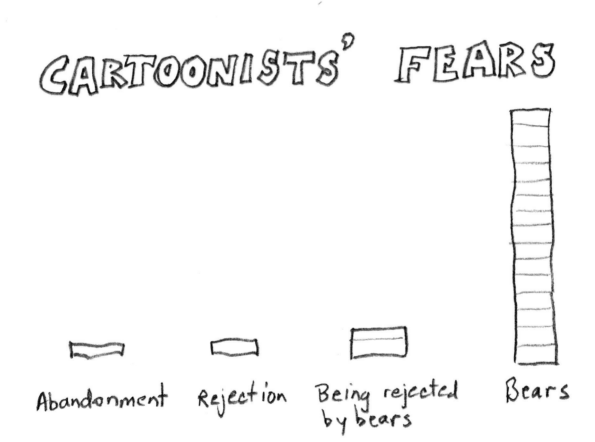

ACKNOWLEDGMENTS

First of all, I'd like to thank my fellow cartoonists, who are, as you've seen here, extremely creative and consistently funny. What you don't see is how professional they are. They're precise, hardworking, and fast. And this book wouldn't have happened if that weren't the case. I particularly want to mention a few of my colleagues who helped me above and beyond what you see in these pages: Sam Gross, Marisa Acocella Marchetto, Drew Dernavich, Glen Le Lievre, David Sipress, Chad Darbyshire, Pete Mueller, and Zach Kanin.

I sincerely appreciate the support and enthusiasm of Bob Mankoff, David Remnick, and Pam McCarthy, who "got it" from the get-go, and who graciously gave their blessing on this reckless endeavor.

My agent, David Kuhn, deserves a round of applause befitting a magician. And Billy Kingsland deserves a raise, probably, and a corner office. Oh wait, he already has one of those. None of this would have happened the way it did if not for the vision of Patrick and Cassie, the prolonged and patient efforts of Tom Keefe, or the generous support of Tanya Erlach, who pushes me and is quick to help me pull. And thanks to my mom, who didn't help me at all with this book but did other things at other times that helped.

Thanks to the team at Simon Spotlight Entertainment: Ryan, Cara, Michael, Jen, Jen, Jen, Nekiesha, Katherine, and especially Tricia, who hit

the ground running with me on this and kept me from tripping over any-
thing.

If this book is like a tetherball, and I like to think it is, all the people
I've mentioned stepped up to take a swat. Some provided big close-fisted
haymakers that sent the book through several revolutions, and others
made little whiffy slaps just to keep it spinning, but all of these strikes of
differing strengths were in the same direction and combined to get this
thing wrapped up tight and in record time. I want to acknowledge my
debt to them here publicly so I won't have to buy them fruit baskets.

ABOUT THE CONTRIBUTORS

MARISA ACOCELLA MARCHETTO lives in New York City and has been a cartoonist for *The New Yorker* since 1999. Her work also appears regularly in *Glamour* and the *New York Times*. She is the author of *Just Who the Hell Is She, Anyway?* and the recently released *Cancer Vixen*, the story of her eleven-month, ultimately triumphant bout with breast cancer. She's often found hobnobbing with the city's rich and glamorous at her restaurateur husband's eat-and-be-seenery, looking for material.

PAT BYRNES lives in Chicago. He has been contributing cartoons to *The New Yorker* since 1998. He is also currently developing several stage musicals, including *Flop!*, *My Dead Irish Mother*, and *Despairadise*. He has two anthologies of his cartoons out: last year's *What Would Satan Do?* and *Because I'm the Child Here and I Said So*, which came out this spring. Beyond that, he leads a surprisingly quiet life, especially for someone with a daughter in diapers and a wife who's a politician.

TOM CHENEY was born in Norfolk, Virginia, and raised in northern New York state. He was a 1985 recipient of the Scripps-Howard Outstanding Cartoonist Award for his work in magazine cartooning. He has an extensive line of humorous greeting cards published by Nobleworks, Inc., and he's a contributing artist and writer for *Mad* magazine. He has been contributing cartoons to *The New Yorker* since 1978. He now lives in Hawaii, of all places.

MICHAEL CRAWFORD was born in Oswego, New York, was educated at the University of Toronto, and currently lives in Manhattan. He has been a professional cartoonist since 1975 and has contributed to *The New Yorker* since 1983. In addition to being a cartoonist, Michael is also a painter. His work has been exhibited in New York and Boston. He is often seen buzzing around town on a mint green Vespa.

LEO CULLUM is a recently retired airline pilot. He started cartooning in 1971 when he was on a temporary furlough and sold his first cartoon to the Air Line

Pilots Association's magazine. His first in *The New Yorker* was published in 1977. He has also done work for *Barron's* and *Harvard Business Review*. A graduate of Holy Cross (English major), Leo lives in southern California with his wife, two daughters, and two dogs.

C. COVERT DARBYSHIRE was born on an unusually cold day in 1972 on Long Island, New York. His first cartoon appeared in the pages of *The New Yorker* on an unusually warm day in July 2001. The time in between those two dates has been described by many who know him as "unfocused, tedious, and wasteful." When not obsessively Googling himself, he writes and directs films and culture-piercing TV spots in Austin, Texas. He is still married to his first wife, Marion; they have two young children, and a dog and a cat that also live in their house.

DREW DERNAVICH has been contributing cartoons to *The New Yorker* since 2002. He works for other publications too, but who really cares? His work has a recognizable woodcut look to it. That isn't too surprising when you learn that his day job is engraving tombstones. It's true. Drew etches portraits and other pictures onto gravestones, and has more than a thousand to his credit in New England. He lives in the Boston area with his wife, Lori.

J.C. DUFFY writes and draws two syndicated newspaper comic strips, *The Fusco Brothers* and *Go Fish*. Prior to the debut of the former in 1989, he worked in newspaper illustration and had an extensive line of greeting cards and related products. His books include *Moot Points* and four *Fusco Brothers* collections. His cartoons began appearing regularly in *The New Yorker* in 1998. He lives in Philadelphia.

MORT GERBERG, a regular contributor to *The New Yorker* since 1965, has written or illustrated thirty-seven books of humor for adults and children. His book *Cartooning: The Art and the Business* is a leading instructional reference work in the field. He has drawn syndicated newspaper comic strips and taught cartooning at Parsons School of Design in New York. He lives in Manhattan's Upper West Side.

ALEX GREGORY is a husband, father, and TV writer in Los Angeles. He has written for *The Late Show with David Letterman*, *Frasier*, *King of the Hill*, and *The Larry Sanders Show*. He was nominated for a Writers Guild Award for best writing in television animation. His first cartoon appeared in *The New Yorker* in 1999. He does his cartoons entirely on the computer, which is kind of weird.

SAM GROSS was born in New York City, where he still lives today. He started cartooning in 1962 after a previous stint as an accountant. He first appeared in *The New Yorker* in 1969. Sam is also the former cartoon editor of *National Lampoon* and *Parents* magazine. He has edited numerous cartoon collections, and his own work has been collected and published in several books here and overseas. When the cartoonists go out to lunch, Sam figures out the bill. We think it's because he misses being an accountant.

WILLIAM HAEFELI grew up in Philadelphia but now lives in sunny Los Angeles just around the corner from the Rancho La Brea Tar Pits. Early in life he studied art and psychology, and he barely escaped a career in advertising before becoming a cartoonist. His first cartoon appeared in *The New Yorker* in 1998.

CAROLITA JOHNSON is fairly new to *The New Yorker*. Her first cartoon appeared in 2003. Before that she lived for many years in Paris, where she studied obscure subjects; designed and repaired mosaic floors; and worked in software development, in translation, and in the fashion business both behind and in front of the camera (also occasionally beside and off to the left). She's now in Manhattan doing cartoons and illustration, still modeling, and working on her blog.

GLEN LE LIEVRE has been contributing cartoons to *The New Yorker* since 2004. Originally from Australia, he has been living in the United States—sometimes legally—since 1996. He draws at night, and luckily has an ad agency job that allows him to sleep during the day. He shares an apartment in New York with his wife and a smaller, better toilet-trained version of himself, as well as a couple thousand roaches.

ARNIE LEVIN has contributed cartoons and covers to *The New Yorker* since 1974. He also has lots of tattoos. The National Cartoonists Society has twice named him the gag cartoonist of the year. His books include *The Money Book: A Smart Kid's Guide to Savvy Savings and Spending*, *The Gigantic Baby*, *Homer and the House Next Door*, and *I Hate Messages*. He is also an award-winning animator and teaches at the School of Visual Arts in New York. He lives in Sea Cliff, New York.

ERIC LEWIS made his debut in *The New Yorker* in 2000, his proudest accomplishment since being named the second-best fourth-grade chess player in Connecticut. He's also quite proud of having contributed three jokes to *Saturday*

Night Live's Weekend Update with Norm MacDonald in the 1994–95 season. He currently works as an industrial designer and is the inventor of Garbage Flowers and other objects of art using recycled materials. He lives in New York City.

ROBERT MANKOFF sold his first cartoon to *The New Yorker* in 1977. He now has three jobs: cartoonist, cartoon editor at *The New Yorker*, and president of Cartoonbank.com, the cartoon licensing company he started in 1992, now a wholly owned division of *The New Yorker*. He reports that if he gets fired from all three positions, he'll be able to clean up on unemployment insurance. He's done a bunch of books, blah blah blah. He lives in Hastings-on-Hudson, New York. Probably in some kind of crazy mansion.

ARIEL MOLVIG has only just started at *The New Yorker*. His first cartoon was published in 2005. Before that he worked as a carpenter, roofer, solicitor, waiter, cashier, futon maker, and actor/model in Japan. Cartooning is just the latest in a long line of odd jobs. He has presented a paper to the sixth annual International Association of Bioethics conference in Brasilia, and performed in the world premiere of Orson Welles's lost play *Bright Lucifer*. He is a recipient of the James M. Engber Award for Excellence. He lives in Madison, Wisconsin.

P.S. MUELLER lives in Madison, Wisconsin. He has been drawing and selling cartoons continually since he was a teenager in the late sixties. His cartoons have appeared in dozens of alternative and mainstream publications. His first in *The New Yorker* appeared in 1998. In recent years Mueller has assumed a second identity as news anchor Doyle Redland and can be heard five days a week on various radio stations throughout the United States and Canada as he loudly pronounces the *Onion* Radio News.

JOHN O'BRIEN has written and/or illustrated more than fifty books for children, including *The Twelve Days of Christmas* and *I Like the Way You Are*. He has published numerous cartoons in and illustrated many covers for *The New Yorker* since making his debut in 1987. He lives in New Jersey, where he plays the banjo, sings, and spends his summers working as a lifeguard.

DANNY SHANAHAN tended bar at The Bitter End in Greenwich Village before becoming a full-time cartoonist in the early eighties. His first *New Yorker* cartoon was published in 1988. He is an avid tennis player and had a

running feature for Tennis USA called "Dropshots." His work has appeared in several compilations, and he has published several collections of his own, including the two most recent collections, *Innocent, Your Honor* and *I'm No Quack*, about lawyers and doctors, respectively. He lives in Rhinebeck, New York, with his wife and two sons.

MICHAEL SHAW lives a life of fairly quiet suburban desperation in the Cincinnati suburbs along with a spouse, two children, four dogs, and a cat. A copywriter by day, for catalogs such as Lands' End and for Cartoonbank.com, he pursues the cartoon muse when the moon rises. He has been a contributor to *The New Yorker* since 1999.

DAVID SIPRESS attended the master's program in Soviet studies at Harvard University for two years before leaving to pursue a career as a cartoonist. His cartoons have been everywhere, and in *The New Yorker* since 1998. In addition to authoring eight books of cartoons, he is also the writer, producer, and host of *Conversations with Cartoonists*, an ongoing series of performances featuring cartoon-based humor and interviews with great *New Yorker* cartoonists. He lives in Brooklyn with his wife, Ginny Shubert, a public interest lawyer.

BARBARA SMALLER was born and raised outside of Chicago, where she honed her craft through many, many venues, including nursing school, a job as a night guard at the Art Institute of Chicago, and stand-up comedy. Along the way her drawings have appeared in various publications, among them *National Lampoon* and *Barron's*. Her first cartoon in *The New Yorker* was in 1996. She currently lives with her husband and daughter in New York City.

MICK STEVENS lives in Florida, but in a good way. He has applied his skills to various cartooning odd jobs—strips, greeting cards, and animation. After years of submitting cartoons and amassing an impressive collection of rejection slips, he finally sold a cartoon to *The New Yorker* in 1979. Stevens is now published in *The New Yorker*, *Barron's*, *Playboy*, *Yahoo! Internet Life*, and elsewhere. When he's not cartooning, he plays his saxophone and irons his Hawaiian shirt collection.

MIKE TWOHY has been a contributor to *The New Yorker* since 1980. He received an MFA degree in painting from the University of California, Berkeley, and is the creator of the syndicated daily panel *That's Life*. He lives near Berkeley, California, with his wife and two children.

P.C. VEY has worked as a cartoonist for several magazines. He was a mainstay of the old *National Lampoon*, and his work regularly appears in the *Wall Street Journal*, the *New York Times, Playboy, Mad*, and other magazines. He started publishing in *The New Yorker* in 1993. He is also the author and illustrator of the books *Cats Are People Too* and *How to Be Your Cat's Best Friend*. He lives in New York City. The "P.C." doesn't stand for "personal computer" or "politically correct."

KIM WARP is a Seattle native and now lives in Virginia Beach, Virginia, with her husband, Rufe; her two daughters, Sara and Kate; and their three cats, Lucy, Whiskers, and Angel. She has been cartooning for *The New Yorker* since 1999. Her work has also appeared in *Barron's, Harvard Business Review, Reader's Digest, USA Weekend*, and many other publications. In 2000 she was the winner of the National Cartoonists Society Reuben Award for best gag cartoonist.

CHRISTOPHER WEYANT has been a cartoonist for *The New Yorker* since 1998. His cartoons have also appeared in such publications as *Barron's*, the *Wall Street Journal*, the *San Francisco Examiner*, the *Christian Science Monitor*, and others. He is also the editorial cartoonist for the Washington, D.C. newspaper the *Hill*. Originally from New Jersey, he now lives in Los Angeles with his wife, Anna; their daughter, Kate; and their African tortoise, Taxi.

GAHAN WILSON has published fifteen collections of cartoons, including *Still Weird* and *Even Weirder*, and is the author of two novels and a book of short stories. He has also created animated programs for television. His cartoons have graced pretty much every magazine there is. They started appearing in *The New Yorker* in 1976. He is the recent recipient of the prestigious Caniff Award from the National Cartoonists Society. He lives in Sag Harbor, New York.

JACK ZIEGLER is a ramblin' man. Bicoastal, but never at the same time. He was born in New York City but has since lived in San Francisco and Las Vegas. Jack began cartooning in 1972 and first had a cartoon published in *The New Yorker* in 1974. His most recent book for children is *Mr. Knocky*. He has also published six collections of drawings, including *The Essential Jack Ziegler* and his latest, *Olive or Twist?: A Book of Drinking Cartoons*. He has recently moved again, this time to Sharon, Connecticut.

COPYRIGHT INFORMATION